TWENTIETH CENTURY
BRITISH ART *from the*
AHMANSON
COLLECTION

BIOLA UNIVERSITY
ART GALLERY 2012

Lyrica Taylor

TABLE OF CONTENTS

DIRECTOR'S FOREWORD

Americans seem to find unending allurement in experiences related to the tiny island across the Atlantic that substantially contributed to the formation of our national identity (as well as many other nations throughout the world). The influences are of course language, which is shared yet distinct, our common-law tradition, representative type of government and many social practices. Examples abound from the popularity of English tea, Shakespearean drama, Dickens' characters, British accents, and Liverpool musicians to the British Monarchy and films like the recent Oscar-winning *The King's Speech*. There exists a continual fascination with all things British.

More specifically, a particular period in British history seems to garner our utmost attention, from my observation. For various reasons we return to the era of interwar England through the end of World War II over and over again. It is a period in the not- too-distant past enabling us to identify with various cultural situations but far enough removed from contemporary life to allow for a bit of nostalgia. This was the glorious England of Charles Williams, J.R.R. Tolkien, C.S. Lewis, Dorothy Sayers and T.S. Elliot, of Evelyn Waugh, Benjamin Britten, Ralph Vaughan Williams, and Sir Winston Churchill. It was a time of chivalry, courage, moral valor, and good triumphant over evil.

In the visual arts, critic John Ruskin, the Victorian thinker, left his mark on many of the artists in this exhibit, including the group that came to be known as the Medieval Modernists. These artists believed, in the words of Ruskin, that "art is the seeking of ideal truth" replete with social and moral dimensions. It is a curious comfort to discover in the Ahmanson collection significant modernists (whose early influence helped create London's current international art scene) who did not shy away from regularly depicting profound Christian themes in their work. In contrast, one has to look long and hard to discover explicit Christian imagery in twenty-first-century British art.

This bygone British era, which has in many ways inspired a thoughtful, imaginative Christianity abroad, produced artists who reached for truth, beauty, harmony and a rich substantiality, one that has withstood the test of time. That most of the works in this exhibition depict explicit biblical themes, many directly connected to church commissions, reveals the centrality of ritual, liturgy and faith deeply woven into the structural foundation of English life. This England is a far cry from the society we observe today, a generation that for the most part has moved away from the church as one of the vital influences of life.

Twentieth Century British Art from the Ahmanson Collection is a powerful reminder that we must tightly grasp those eternal truths that matter most. Caught up in the cauldron of energized, accelerated cultural innovation and the incessant pressure for something new, it is easy to forget glory. The artists in the Ahmanson collection portrayed the holy and visualized the sacred in order to grace both the cathedral and the private refuge. These images helped create sacred spaces where the reality of God's presence was manifest. Author Thomas Howard suggests that the culminating moment in sanctified places occurs when we understand that, "The veil between time and eternity is drawn aside, and we are 'here', in a past eternity when the counsels of God conceived our salvation, and at Golgotha, and in the Upper Room, and in heaven with the seraphim." This is the heart of the Gospel and of Christian sacred space, a space we have endeavored to establish in this unique exhibition.

It was years ago now that my wife and I were traveling across Europe. Our journey took us to a dank old castle in Prague that had been transformed into the national art museum. Walking long, dark corridors filled with life-sized crucifixes, I was suddenly struck with an overwhelming presence of the holy. The images seemed to emit a powerful sensation of the deepest compassion. As an Evangelical Christian I tended to discount religious imagery, seeing it merely as a long-ago concession for the illiterate. I will never forget that afternoon when my eyes were opened to see biblical art from a new perspective.

Too few collectors build bodies of art based on Christian themes. The Ahmansons are a rare exception. The works assembled on this occasion represent an ongoing visual phenomenon in the history of Christianity that is seldom the focus of a major exhibition. Mrs. Ahmanson gently insists that to understand our current situation we must know what happened in the past. The effort of Howard and Roberta Ahmanson to preserve and share twentieth century Christian British art is but one of many causes to which they are devoted.

Biola University is honored to host *Twentieth Century British Art from the Ahmanson Collection*. It would be impossible to realize an exhibition of this caliber without the generous support of people like Howard and Roberta Ahmanson. The university is deeply grateful to them for their patronage in this special *Year of the Arts*. In addition, it is imperative to acknowledge the many hours of research, curatorial decision-making and scholarship of Lyrica Taylor. Lyrica's thoroughness and insight bring a striking visual and spiritual experience to those attending the show. Finally, it has been a privilege to work with Ann Hirou, the Ahmansons' Director of Special Projects. Her diligence and patience have made this experience one of great joy.

Barry Krammes
Director, Biola University Art Gallery

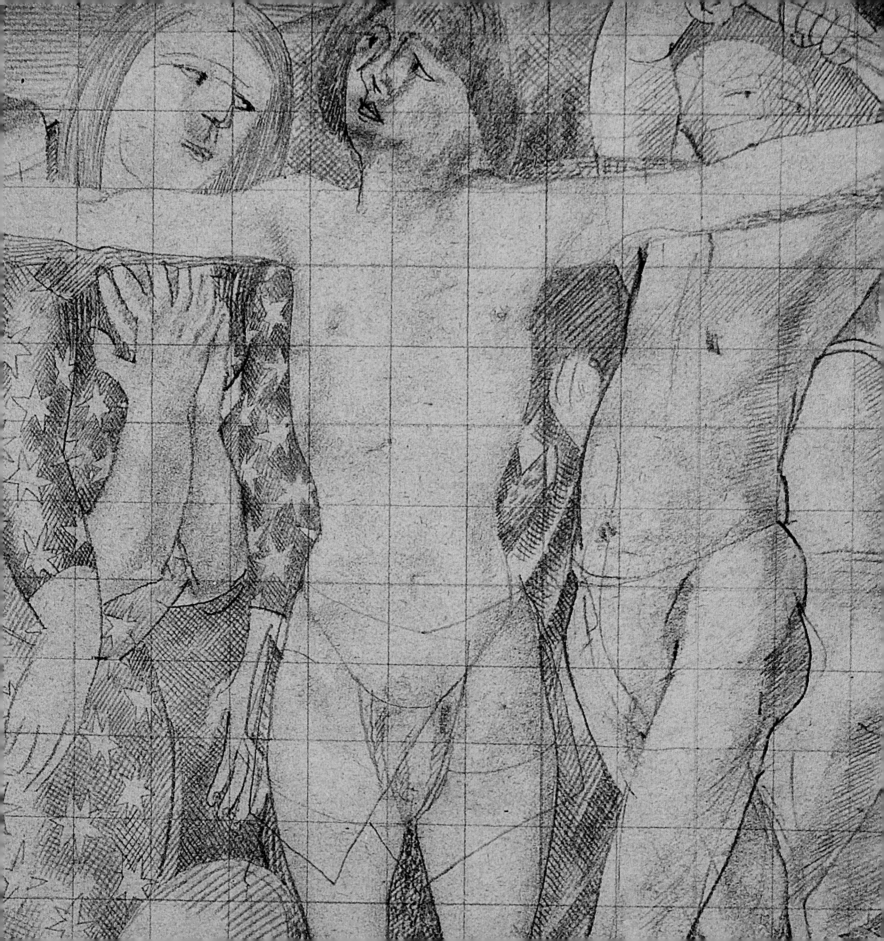

BRITISH ART OF THE TWENTIETH CENTURY FROM THE AHMANSON COLLECTION

Biblical images are not the first thing that comes to mind when one hears the term "Twentieth century Art." But, the works in this show are evidence that some of the best British artists of roughly the first half of the twentieth century did indeed draw on biblical images to convey their vision.

Beyond that "surprise," the viewer may wonder what a couple in Southern California is doing collecting British art, mostly painting and a few sculptures, primarily from the decades just before they were born. The answer is both simple and complex. On the most basic level, my husband Howard and I were deeply influenced by C.S. Lewis and J.R.R. Tolkien, and, in my case, add T.S. Eliot, Dorothy Sayers, and G.K. Chesterton. Then come the complexities. Howard grew up in a family that collected art; I discovered that I loved art, particularly painting, when I was in the 8th grade in a public school in Iowa. So, when we started traveling to explore the world, partly because we were just plain curious and partly because we wanted to understand the world so as to be better stewards, I was particularly drawn to art museums and churches, and Howard, sometimes eagerly, sometimes less so, came along.

Then came Stanley Spencer. An idiosyncratic man who read the Bible daily, went to church regularly, had doubts about certain teachings of St. Paul, believed in free love, divorced the mother of his two daughters for another woman, and then did not consummate that new relation, Spencer (d. 1959) was one of the great British artists of the first half of the twentieth century. We were asked to sponsor the first big show of Spencer's work in the United States, "Stanley Spencer: An English Vision," which opened at the Smithsonian's Hirshhorn Museum in 1997. Before we agreed to do the show, I visited Spencer sites in England and traveled to museums there and in Australia. I was impressed by how important it was to him to embrace the Bible and paint its images in contemporary British settings. Curious to understand his context, I researched other artists of his period, which led to looking at the work of his contemporaries, which led to collecting their work, which led to this show.

Lyrica Taylor has done a masterful job curating this exhibition and writing the catalogue. Biola University has been a gracious host for the project. As you will see, central to the vision of these artists is a kind of spareness, a bleakness born of the suffering of two world wars. Their colors are muted, their vision restrained. Yet, they turn to biblical images to understand their grief. So, for the first time in Southern California, visitors will get a glimpse of that vision. Their work provides an example of how our inner vision — what we understand to be true and real — shapes our daily lives, our work, and the world around us.

Whether the artists — from Spencer, Gill, Epstein, Sutherland, and Hepworth to Burra, Nolan, Craigie Aitchison, or Le Brun (the only one of these artists who is still living) — are believers or not, biblical images are part of their largest vision. Their work is living testimony to the continuing power of the Bible to confront and shape the human imagination.

It is our joy to be able to share their vision with you.

Roberta Green Ahmanson
Casa des los Peregrinos
25 November 2011
Corona del Mar

Stanley Spencer
Study for the Deposition, 1954-55 (detail)
Graphite on paper, 15 x 10.5 inches

RELIGION AND TWENTIETH CENTURY BRITISH ART

Visual artists in twentieth century Great Britain created innovative and imaginative works of art in an outstanding range of media and stylistic approaches. *Twentieth Century British Art from the Ahmanson Collection* represents an exceptional opportunity to view twenty-eight such works by fourteen noteworthy artists who explored the role of Christianity in visual art throughout the century in Great Britain. Beginning by setting the stage with three works from the Victorian era, the exhibition travels to the interwar period of the 1920s and 1930s, the Second World War, the post-war era, the later twentieth century, and concludes with recent works from the early twenty-first century. Several of the works suggest the renewed interest in religious art from the middle years of the twentieth century, which was brought about by the horrors of the First World War and the demand for new churches following the widespread destruction of the Second World War, with Coventry Cathedral perhaps the most notable highlight of the architectural reconstruction of Britain. The exhibition explores a diverse range of media, including major paintings, drawings, prints, and sculpture by some of the most important and beloved twentieth century British artists, such as Stanley Spencer, Eric Gill, Jacob Epstein, Barbara Hepworth, Edward Burra, and Graham Sutherland.

A major goal of the exhibition is to deepen an understanding of the vital role the visual arts and beauty played in shaping human experience and awareness of the sacred in an era that witnessed unprecedented devastation and suffering. This exhibition represents an opportunity to explore the complex ways artists and patrons responded visually to crises, both through works associated with ecclesiastical commissions, such as Graham Sutherland's *Head of Christ* (1964), and through deeply personal responses to tragedies, such as Barbara Hepworth's *Madonna and Child* (1953). In a century that saw a Modernist push towards abstraction, many English artists maintained figurative representation and a revival of narrative as vital modes of expression, creating powerful works that invited their viewers to engage the Bible and its message. The artists represented in this exhibition hold in common a desire to explore the sacred in art as a means of expressing their deepest feelings, exploring the mysteries of the physical and spiritual realms, responding passionately to life's experiences, and endeavoring to make sense out of the fragmented pieces of earthly existence. They rethought the concept of beauty as something not merely sentimental or simply visually pretty or pleasing, but instead as a catalyst for restoration and rebuilding, community and wholeness, and inspiration and imagination, signifying a spiritual reality. These works reveal an attempt to draw near and experience the holy, the presence of God.

While the artworks all directly engage Christian themes, from images of the Creation to images of the resurrected and enthroned Christ, the artists themselves come from a variety of religious backgrounds, from the Anglican-Methodist background of Stanley Spencer, to the Catholic backgrounds of Graham Sutherland and Eric Gill, to the Jewish background of Jacob Epstein, as well as multiple artists of an undefined or unclear religious persuasion. These works exemplify how artists of the twentieth century in Great Britain resist categorization or a direct line of artistic development and instead maintain an individualism inherent in British art. They respond to a plethora of global sources (from the arts of Mexico to the arts of the Early Italian Renaissance) while maintaining a love for native references (such as Stanley Spencer's village of Cookham), creating a complex, innovative, and exciting spectrum of styles.

The presentation of *Twentieth Century British Art from the Ahmanson Collection* is particularly timely with regards to the recent scholarly renewal of interest in the importance of the history of religion in the visual arts in Great Britain. For

example, author Tara Hamling, in her books *Art Re-formed: Re-assessing the Impact of the Reformation on the Visual Arts* (2007) and *Decorating the 'Godly' Household: Religious Art in Post-Reformation Britain* (2011), has thoughtfully reexamined the impact of the Reformation on the visual arts in Britain as not simply and exclusively destructive but also as a catalyst for a dynamic and creative cultural transformation. In addition, Tate Britain recently presented in 2011-12 an exhibition, *John Martin: Apocalypse*, that reassesses the dramatic paintings and prints of apocalyptic destruction and biblical catastrophe by this major, and yet neglected, nineteenth-century British artist. These are just two examples of ways recent research has engaged with the long and rich history of religion in the visual arts in Great Britain, from the lavishly illustrated Medieval manuscripts of the Book of Kells and the Lindisfarne Gospels, to the masterful twentieth-first-century video installation altarpieces of Bill Viola in St. Paul's Cathedral.

It is my hope that this exhibition will encourage further exploration of the place of religious art in twentieth century Britain. I would like to express my great thanks to Howard and Roberta Ahmanson for the opportunity to engage with the beautiful works of British art in their collection and to share in their excitement in presenting the works at the Biola University Art Gallery.

Lyrica Taylor

Suggested reading:

David Bindman (General Editor), *The History of British Art, Volume 1 (600-1600), Volume 2 (1600-1870),* and *Volume 3 (1870-Now)* (New Haven: Yale University Press, 2008).

Gabriele Finaldi, *The Image of Christ* (London: National Gallery Company Limited, 2000).

Robert Hoozee, ed, *British Vision: Observation and Imagination in British Art, 1750-1950* (Brussels: Mercatorfonds and Ghent: Museum voor Schone Kunsten, 2007).

Rowena Loverance, *Christian Art* (Cambridge, Massachusetts: Harvard University Press, 2007).

Frances Spalding, *British Art Since 1900* (London: Thames and Hudson, 1986).

Beth Williamson, *Christian Art: A Very Short Introduction* (Oxford: Oxford University Press, 2004).

Born in Edinburgh, David Roberts started his artistic career as a house painter and theatrical scene painter. He moved to London in 1822 in order to advance his artistic career, and exhibited artwork at the Royal Academy of Arts (the premier institution in Great Britain founded to foster and encourage a national school of art). Roberts later became President of the Society of British Artists in 1831 and a Royal Academician in 1841. Roberts became known as one of the greatest artist-travelers and topographical painters and illustrators of the Victorian age, creating views of locations and monuments in England, Scotland, France, Germany, Italy, and the Low Countries.

The artist David Wilkie encouraged Roberts to visit Spain, writing in 1828 that Spain was "the wild unpoached game reserve of Europe" for artists and art collectors.[1] The Peninsular War (fought during the Napoleonic Wars between France and the allied powers of Spain, the United Kingdom, and Portugal for control of the Iberian Peninsula) had ended in 1814, resulting in a time of peace in Spain. While Italy had been the favored destination of British artists, collectors, and travelers on the Grand Tour, Spain had fewer tourists and the sensation of novelty critical to the rapidly expanding art market in England.[2]

Roberts began his travels in Spain in October 1832 and his trip lasted over a year. He visited many of the main cities in Spain, including Madrid, Toledo, Granada, Malaga, Seville, and Gibraltar, as well as a few sites in Morocco. He drew series of ruins and monuments, and found Moorish art and the Gothic style particularly inspirational. Roberts brought back sketches and studies from the various locations in Spain to use as the basis for studio work, rather than creating finished paintings on site. He completed many paintings and exhibited them at the Royal Academy between 1835 and 1837, achieving great success, and resulting in his invitation to become an Associate Royal Academician in 1838. Roberts also created three series of lithographs of his Spanish drawings for new illustrated publications between 1835 and 1837, which helped to establish his reputation as a leading topographical artist.[3] In Spain, Roberts wrote from Cordoba, "Those who could have appreciated the richness of its architecture have generally gone to Italy or Greece. My portfolio is getting rich, the subjects are not only good, but of a very novel character."[4] The "novel character" which Roberts observed was an important factor in making them ideal for the new illustrated publications that began to emerge in the 1830s in England. In 1837, Roberts published thirty-seven large format lithographs of views of Spanish monuments in *Picturesque Sketches of Spain during the Years 1832 and 1833*, which sold 1,200 copies in only two months, establishing Roberts's international artistic status.[5] Roberts's Spanish illustrations became so famous that the author Richard Ford, in his celebrated 1845 *A Handbook for Travelers in Spain*, referred to one aspect of Burgos Cathedral as "forming a picture by Roberts." Indeed, an 1846 review of books on Spain stated that even Spanish artists were second to Roberts, calling one of the major contemporary painters from Madrid "an imitator, at a respectful distance, of David Roberts, whose charming landscapes and architecture have long been to his continental colleagues at once a model and a stumbling-block."[6]

Roberts visited Burgos Cathedral in December 1833 during his travels in Spain. Burgos is a city located in the central north of Spain along the main Medieval and modern pilgrimage route to Santiago de Compostela. The cathedral was begun in 1221 by King Ferdinand the Saint and Bishop Don Mauricio. The plan of the three-story cathedral is based on a Latin cross. It was later enlarged in the fifteenth and sixteenth centuries with a rose window, three doorways in the west front entrance, two tall towers with spires, a grand cloister, the magnificent dome over the crossing, and numerous chapels, including the famous Capilla de los Condestables,

or Chapel of the Constables, the main chapel located behind the Great Altar. The architecture of the cathedral of Burgos shows the influence of French Gothic art and architecture in Spain.[7] Roberts made numerous sketches of the interior and exterior of the cathedral and its surroundings during his week-long stay. In a letter written in Burgos, Roberts related, "there had been some severe fighting between the English and the French [in Burgos], and the storming of the castle which cost Wellington a number of men. The castle is now a heap of ruins, but the cathedral is one of the finest in Spain. There I stopped a week, and made a good many drawings."[8]

The subject of Roberts's *Burgos Cathedral* (signed and dated at the lower left) is the entrance to the Chapel of the Constables, and thus serves as a very fitting first entry in an exhibition concerned with the subjects of religious art and sacred space. The Chapel of the Constables (also known as the Chapel of the Purification) is located in the center of the ambulatory. The Constable of Castile and his wife commissioned the ornate chapel at the end of the fifteenth century. The chapel is noted for its ribbed-vault ceiling and for the dramatic light which floods in through the Flemish stained-glass windows with their stone tracery. In Roberts's painting of the chapel, tiny figures stand in small groups, standing and kneeling in prayer, their diminutive scale emphasizing the incredible height of the cathedral with its immense stained glass window and doorway. Ecclesiastical figures process through the entryway to the chapel holding a banner. Rich colors lend to the majesty and awe of the ceremony underway. Rich red accents lead the viewer's eyes through the scene, from the red robes draped over a balustrade at the lower left, to the red shawls of the women kneeling in prayer at the center foreground, to the red carpet and banner surrounding the seated enthroned figure (mostly likely the bishop) above the women, and finally to the red highlights around the sculpture in niches on either side of the entryway.

Roberts emphasized the foreignness of this scene of a Catholic church to his chiefly Anglican audience by showing the Catholic women with their heads covered with shawls, catering to the contemporary British fascination in the visual arts with Orientalism. A large painting hangs to the right of the throne, and the atmospheric vagueness adds to the majesty of the scene and lends it a sublime quality not unlike the paintings of the British artist John Martin. Like Roberts, Martin's vast canvases of dramatic Old and New Testament subjects emphasized tiny figures overwhelmed in a landscape.

Roberts took great imaginative license in rendering the entrance to the Chapel of the Constables in *Burgos Cathedral*. When comparing the painting by Roberts to a later watercolor of the same location in Burgos Cathedral by another nineteenth-century British artist, Henry Thomas Schafer, *Burgos Cathedral, Spain* (n.d.), it becomes evident that Roberts greatly altered the scene before him. Roberts extended the staircase leading up to the entryway, as well as the staircase leading up to the enthroned figure. He collapsed the space between the entryway and the altar in the Chapel, bringing the altar dramatically forward. He also extended the overall length of the stained glass window by having it begin much lower down on the wall in order to emphasize its great height and that of the ribbed vaulting. While Schafer used clear definitive lines in his watercolor to create an organized and understandable space, Roberts chose instead to create a space of mystery in which it is difficult to make out the sculptures and the faces of the robed figures, and which demonstrates the beautiful fluidity of oil painting.

The freedom with which Roberts rendered the interior of the cathedral may have been partly due to his method of sketching. A contemporary wrote of Roberts's artistic method:

> He seemed to have the faculty of photographing objects on his eye, for I have again and again been with him while he was sketching very elaborate structures

David Roberts (1796-1864)
Burgos Cathedral, 1838
Oil on panel, 16 x 12.5 inches

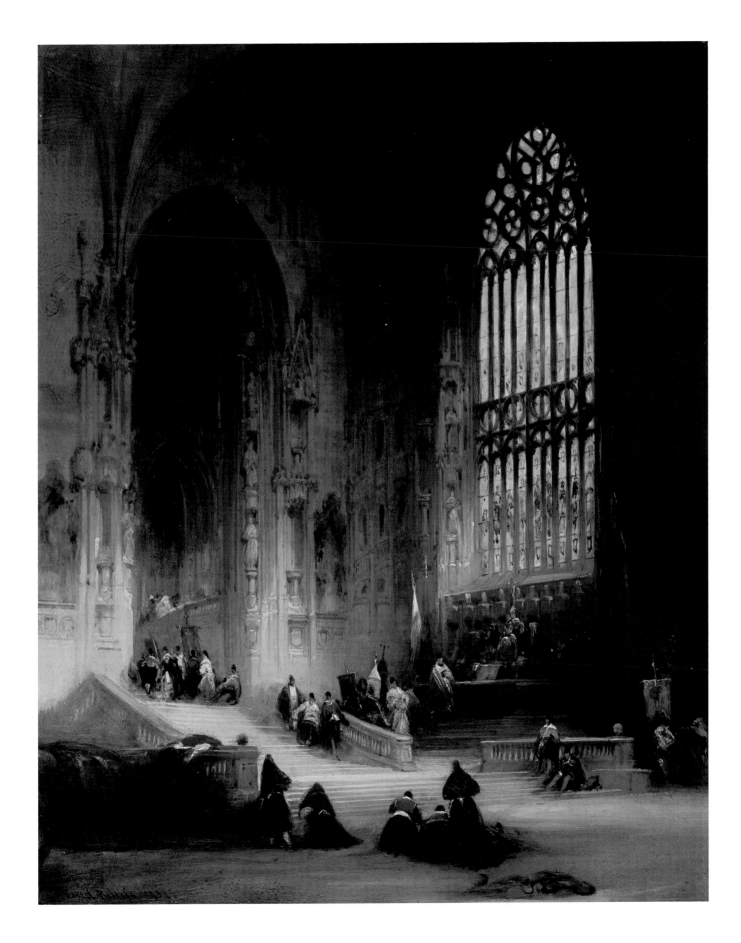

or very extensive views, and he took in a large mass at one glance, not requiring to look again at that portion until he had it completed in his sketch. Other artists caught only small bits at a time and required to be renewing their glances continually. Roberts, by this extraordinary faculty, either natural or acquired, got over more than double their work with half their labor.[9]

Another contemporary praised Roberts's freedom of rendition as well as his careful observation of architectural and topographical detail:

> Mr. Roberts is an artist possessing talents of the highest class; in his works profound art and the most scientific display of detail are equally perceptible; not as subservient the one to the other, but as cooperating to produce a perfect whole. He exhibits the breadth and magnificence of architectural subjects with a precision which satisfies the beholders of their truth, and at the same time with a degree of taste and feeling which prevents their taking the character of a dry elevation.[10]

This quote thus explains the vital role Roberts played in the establishment of topographical art as a serious genre in English art, with thousands of engravings beginning to be published in countless annuals. The 1844 *Quarterly Papers on Architecture* stated, "Artists and engravers shortly became perfectly competent to delineate every variety of building with all the united charms of accuracy and poetical effect; and, what may be termed the romance of architecture, obtained a considerable influence on the public."[11] In 1869, an English artist wrote, "Our school of architectural art having once fairly established itself, the extension of its range of subjects was inevitable…the barrier between England and the Continent was broken up, and modern traveling — an art in itself — began."[12]

Another painting by Roberts related to *Burgos Cathedral* is his *Entrance to the North Transept, Cathedral of Burgos* (1835) that presents a similarly dramatic viewpoint of the mysterious cathedral interior. *Entrance to the North Transept* depicts the Cathedral's Escalera Dorada, or Golden Staircase, with its stonework, gilded iron, and balustrades surmounted by winged dragon-like creatures. Comments on this painting by a contemporary of Roberts give insight into how an English Anglican viewer read this exotic interior of a Spanish Catholic cathedral, the viewer suggesting that a young priest was "casting clandestine glances" at a group of young women near the staircase, and observing how Roberts had depicted the "magnificent decorative style of the cathedral, pictures, statues, tracery, scrolls, mullions, altar form cippi, pillars, fantastic abaci, cornices, entablatures, [and] friezes."[13] Another contemporary observer of this painting emphasized the mystery of the cathedral's dark interior: "the fantastically decorated staircase and other rich details is extremely picturesque, while the skill with which the greater portion is thrown into shade lends a peculiar mystery to the scene."[14]

Roberts's travels in Spain and Morocco in the early 1830s inspired his interest in traveling even more widely to new locations. In 1838 he began an extensive trip to the Holy Land and Egypt. Roberts was one of the first British artists to travel to the Orient, and his travels to these exotic locations gave him a rich source for his paintings and prints, including *Views in the Holy Land* (published in six volumes from 1842 to 1849). For these books, Roberts used the newly developed printing method of chromolithography, a new method for creating multi-colored prints which sought to look as much like an original oil painting as possible. In his illustrations, he depicted the immense proportions of Egyptian temples, dramatic landscapes of deserts and mountains, and detailed building interiors and scenes of local life. One of Roberts's acquaintances, the Victorian novelist William Thackeray, wrote of the artist,

> He traveled for years in Spain; he set up his tent in

the Syrian desert; he has sketched the spires of Antwerp, the peaks of Lebanon, the rocks of Calton Hill, the towers and castles that rise by the Rhine; the airy Cairo minarets, the solemn Pyramids and vast Theban columns, and the huts under the date-trees along the banks of the Nile. Can any calling be more pleasant than that of such an artist?[15]

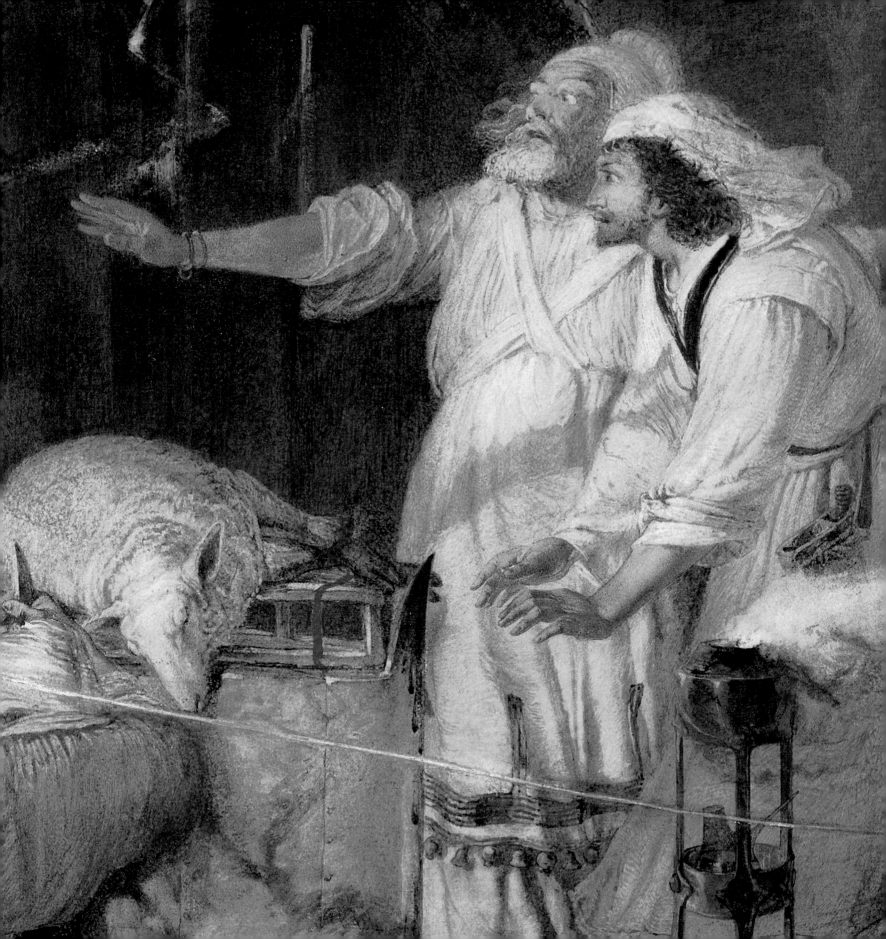

A Scottish painter and poet, William Bell Scott received his artistic training at the Trustees' Academy in Edinburgh and was taught engraving by his father.[16] He exhibited his artwork in Edinburgh in the 1830s and moved to London in 1837 where he associated with the genre painters of the Clique, a British group of painters in the 1830s who had first met as students at the Royal Academy Schools and who met weekly to sketch a chosen subject, discuss their work, and socialize. The other members of the Clique included Augustus Egg, Richard Dadd, John Phillip, Henry Nelson O'Neil, and William Powell Frith. In London, Bell Scott exhibited his work at the British Institution and the Royal Academy, and submitted (unsuccessfully) a cartoon for the New Palace of Westminster. In 1843 he became the master of the Government School of Design at Newcastle-upon-Tyne, and remained there for twenty years, visiting London each summer.

Bell Scott was associated with the Pre-Raphaelite Brotherhood and was a lifelong friend of Dante Gabriel Rossetti. Seven British artists established the Pre-Raphaelite Brotherhood in 1848 with the aim of renewing British art. The three main members of the group included William Holman Hunt, John Everett Millais, and Dante Gabriel Rossetti.[17] The writer and artist John Ruskin championed the group, writing that they "may…lay in our England the foundations of a school of art nobler than the world has seen for 300 years."[18] Although most of the Pre-Raphaelites were colleagues at the Royal Academy, they intensely disagreed with the direction contemporary academic art was taking in England, and famously belittled the Royal Academy's founding president and leading eighteenth-century portrait painter, Sir Joshua Reynolds, as "Sir Sloshua." Instead, the members of the Pre-Raphaelite Brotherhood endeavored to follow the art of Late Medieval and Early Renaissance Europe (until the time of Raphael) with artwork that included a minute description of detail,

truth to nature, a palette of brilliant colors, and noble, religious, or moralizing subjects. In following these characteristics of the Medieval and Renaissance periods, the members of the Brotherhood were particularly reacting against the political upheaval, mass industrialization, and social problems of mid-nineteenth-century England. Like the Pre-Raphaelites, Bell Scott believed in working directly from nature and always carried a sketchbook with him. Also like the Pre-Raphaelites, Bell Scott greatly admired the engravings of Albrecht Dürer. He owned a fine collection of Dürer's prints and wrote a book on Dürer in 1870. He created oil paintings and watercolors of biblical and historical scenes and landscape paintings in the Pre-Raphaelite style. In Newcastle-upon-Tyne, he provided a vital connection between the Pre-Raphaelites in London and their patrons in the northeast of England.

Bell Scott painted the watercolor *The Rending of the Veil* (signed "William B. Scott" at the lower left) in 1867-68, and exhibited this work at the Royal Academy Summer Exhibition in 1869 and at the Royal Scottish Academy in 1870. The artist took the subject from the account of the Crucifixion of Jesus in the Gospel of Matthew and specifically illustrates the verses of Matthew 27:50-51, "And when Jesus had cried out again in a loud voice, He gave up his spirit. At that moment the curtain of the temple was torn in two from top to bottom. The earth shook, the rocks split." The curtain is also later referred to in Hebrews 10:19-22,

> Therefore…since we have confidence to enter the Most Holy Place by the blood of Jesus, by a new and living way opened for us through the curtain, that is, His body, and since we have a great priest over the house of God, let us draw near to God with a sincere heart and with the full assurance that faith brings, having our hearts sprinkled to cleanse us from a guilty conscience and having our bodies washed with pure water.

William Bell Scott (1811-1890)
The Rending of the Veil, 1867-68 (detail)
Watercolor, gouache, and bodycolor on paper, 24 x 30 inches

While innumerable artists throughout the history of Western art have depicted the events leading up to Christ's death and resurrection, very few artists have portrayed the account of the thick veil in the temple being torn in two. In a letter, Bell Scott commended this work as his "best watercolor."[19] A contemporary of Bell Scott, the poet Algernon Swinburne, published verses regarding the watercolor in the literary magazine the *Athenaeum* after Bell Scott's death in 1890:

> Calvary: dark in the darkling air
> That shrank for fear of a crowning crime
> Three crosses rose on the hillside bare
> Shewn scarce by grace of the lighting's glare
> That clove the veil of the temple through
> And smote the priest on the threshold there.[20]

In his watercolor, Bell Scott has captured the incredible drama and action of this intense moment by using rich colors and a grand scale for his work. He described the colors of this watercolor as "intense as possible" with "golden columns and the whole interior with the veils or curtains crimson, blue, the floor marble."[21] Bell Scott depicted both the Crucifixion with the three crosses in the upper right, as well as the central image of the curtain splitting in two, visually connecting the events, and showing how Christ's sacrifice took away the sin that separated God's people from Him. The artist also depicted the sun, which hovers slightly above the three crosses, as a dark, dull red, and nearly blotted out, referring to an earlier verse in the chapter (Matthew 27:45), "From noon until three in the afternoon darkness came over all the land." A sacrificial lamb bound on the Altar with its blood spilling onto the grating beneath foreshadows Christ's ultimate sacrifice on the Cross. Smoke rises from a gold incense burner in front of the young priest with red hair and beard at the right, who in his shock has dropped a pan used for carrying hot coals. A sprig

of an olive branch is located just to the right of the pan. The three different postures of the three priests skillfully communicate their overwhelming fear and astonishment: the priest on the left has fallen down and cowers, shielding his eyes from the brilliant light emanating through the split in the curtain and desperately grasping a horn of the Altar; the middle priest has his arms fully outstretched and his eyes wide open in wonder; and the priest on the right stares with an intense gaze, his hands held out in front of him, frozen in the act of just having sacrificed the lamb. Two bolts of lightning (similar to the depiction of light in earlier British apocalyptic works by John Martin and Francis Danby) shoot out towards the priests and the viewer. The priests have all taken their sandals off, showing that they are in the sacred space of the temple; the three pairs of red and green sandals can be found at the lower right of the painting on the marble floor.

The many details of the interior of the temple and of the priests' garments in *The Rending of the Veil* convey Bell Scott's antiquarian and archaeological interests and reflect the contemporary British fascination with the architecture and history of the newly accessible Holy Land.[22] Like the Pre-Raphaelites, Bell Scott used typological symbolism throughout this work, depicting people, objects, and events from the Old Testament that anticipate or foreshadow the coming of Christ.[23] Bell Scott depicted the interior of Herod's Temple (20 B.C. to A.D. 70), which was begun during King Herod the Great's reign (37 to 4 B.C.). According to the first-century Jewish historian Josephus, Herod's Temple was constructed on the site of the Temple of Solomon that was destroyed by the Babylonian conquest. The Romans under the command of Titus in turn destroyed Herod's Temple during the second Jewish revolt in A.D. 70. The priests in *The Rending of the Veil* are situated in the Court of Priests and are placed by the Altar (which is depicted much smaller than its recorded height and width, and is identifiable by the "horns" on each corner and

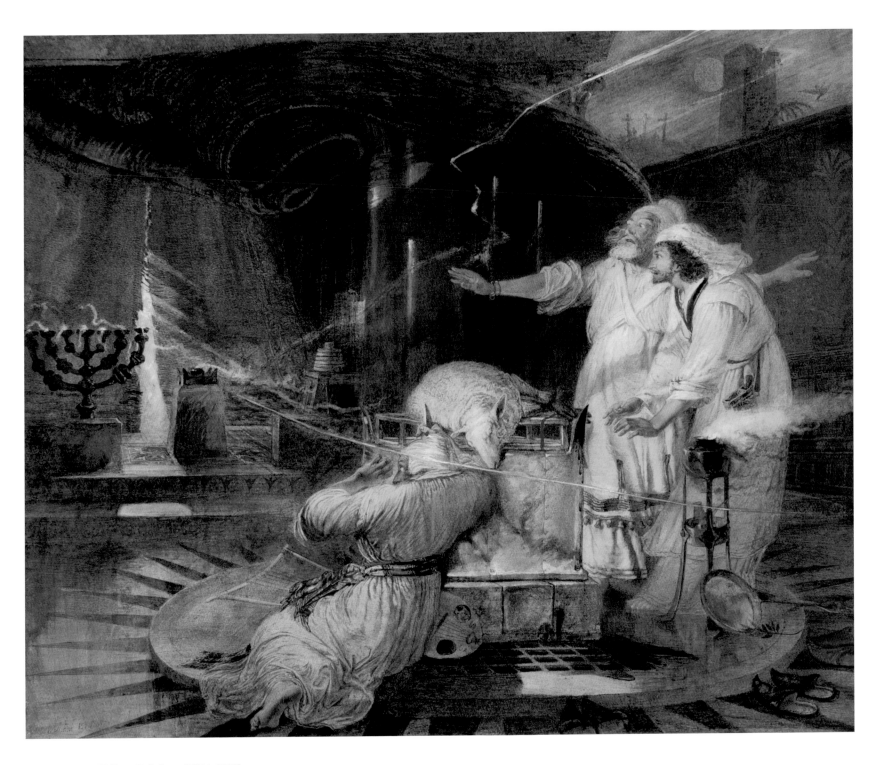

William Bell Scott (1811-1890)
The Rending of the Veil, 1867-68
Watercolor, gouache, and bodycolor on paper, 24 x 30 inches

its drainage grating below). Bell Scott has also greatly diminished the number of steps that lead up to the Porch. Beyond the priests, Bell Scott seems to have combined the spaces of the Porch and the Holy Place, and shows a veil or curtain blowing violently out towards the viewer in a great gust of wind, separating the imaginatively combined Porch/Holy Place from the Court of Priests. The artist used deep, rich colors on this curtain, perhaps alluding to the four colors used for the curtain of the Tabernacle (Exodus 26:1, "finely twisted linen and blue, purple and scarlet yarn"). The lifted curtain reveals the double row of Corinthian columns around the interior of the temple, with their green and red ornamentation.

Inside the Holy Place, Bell Scott depicted the Seven-branched Lamp Stand (Great Menorah) with smoke rising from it at left. The Lamp Stand typifies Christ as the light of the world. The Altar of Incense (a place for burning incense) is located at the center near the entrance to the Holy of Holies and has a horn at each corner. Smoke rises from the Altar of Incense and symbolizes the prayers of God's people. The Altar typifies Christ who intercedes as High Priest. At right is the Table of the Bread of the Presence, which typifies Christ as the bread of life. The placement of all of these objects follows the placement mentioned in Scripture. The priests all look beyond these objects towards the brilliant light emanating from the tear in the Veil that hangs before the entrance to the Holy of Holies. This curtain allowed the High Priest to navigate the entry between the Holy Place and the Holy of Holies without exposing the sacred place. However, Bell Scott depicted the tear in the curtain as going from bottom to top, rather than top to bottom, as mentioned in the text. The artist likely visually depicted the tear in the curtain as beginning at the bottom of the curtain because in his watercolor the top of this inner veil is covered by the outer curtain that separates the combined Porch/Holy Place from the Court of Priests, and that is blowing out towards the viewer.

The dress of the three priests also generally follows the descriptions given in the Old Testament. Each priest wears a white (presumably linen) long-sleeved tunic, white head coverings (also presumably linen), and sashes crossed around their chests and belted around their waists. Although the sash of the priest who has fallen down is colored with blue, purple, scarlet, and linen, like that mentioned for the High Priest in the Old Testament (Exodus 28:8), the rest of his attire does not correspond with that of the High Priest as described in the Old Testament. The priest who cowers at the left sits beside a lute, an instrument played in the Temple.

The Rending of the Veil is a superb example of the new way in the nineteenth century in which an "exhibition watercolor" challenged oil painting through a dramatic depiction of a religious subject. Although the long history of British watercolor painting is particularly well known for delicate miniature paintings and manuscript illuminations, in the early nineteenth century, watercolor painting began to transition from objects mainly displayed in albums and portfolios to paintings meant to be displayed on the wall. The "exhibition watercolor" became an art form in itself, attracting leading artists such as J.M.W. Turner. Dedicated watercolor exhibitions in London began in 1805. Although watercolors had been previously permitted at Royal Academy exhibitions, artists complained that the watercolors were badly lit and displayed to disadvantage, besides being ineligible for submission for Royal Academy membership. Paintings at the new watercolor exhibitions were of a grand size, framed in gold, and painted in brilliant colors, as is Bell Scott's *The Rending of the Veil*. These new exhibition watercolors deliberately challenged oil paintings not only through landscapes and botanical subjects, but also through history paintings (paintings of biblical, historical, mythological, and literary subjects), and the newly popular narrative and genre subjects. Bell

Scott's watercolor *The Rending of the Veil* is a bravura display of the artist's technical skills in a medium in which it is difficult to correct or disguise mistakes, to control the wet washes, and to plan compositional stages.[24] Watercolor painting, with a Pre-Raphaelite-like linear technique, remained central to Bell Scott's career and artistic approach throughout his life.

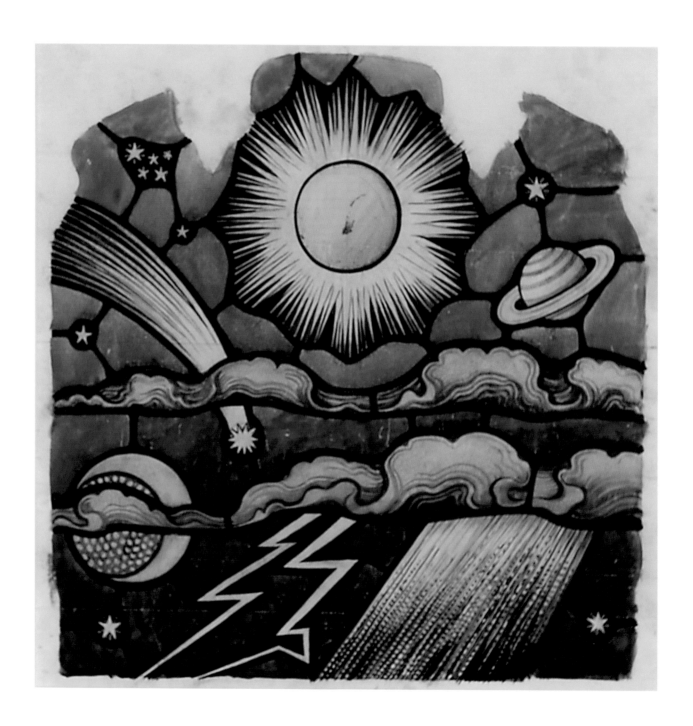

ROMAINE WALKER designer, 1854-1940
and CLAYTON & BELL stained glass firm

The watercolor *The Creation* was designed c.1885 for the London church of St. Saviour's, Pimlico, by the architect and interior designer William Henry Romaine Walker (1854-1940) and was made by the English stained glass firm Clayton & Bell. St. Saviour's is an Anglican church in the parish of the City of Westminster, and was designed in the Gothic style and consecrated in 1864. In the 1880s, Romaine Walker (the son of the first Vicar of St. Saviour's) extensively remodeled and restored the interior of the church. He designed the font, the reredos, and the major east stained glass window, which depicts the main figure of Christ in Majesty surrounded by saints, prophets, Old Testament figures, and angels, with scenes from the Creation below, and the Agnus Dei and angels above. Amazingly, the stained glass window *The Creation* survived two World Wars and can still be seen in situ at St. Saviour's.[25]

The subject of this watercolor is the fourth day of creation, as stated in Genesis 1:14-19,

> And God said, "Let there be lights in the vault of the sky to separate the day from the night, and let them serve as signs to mark sacred times, and days and years, and let them be lights in the vault of the sky to give light on the earth." And it was so. God made two great lights—the greater light to govern the day and the lesser light to govern the night. He also made the stars. God set them in the vault of the sky to give light on the earth, to govern the day and the night, and to separate light from darkness. And God saw that it was good. And there was evening, and there was morning—the fourth day.

The artist may have combined both the first day of Creation with the fourth day of Creation, as beneath the imagery of the watercolor is written (under the mat) "Pimlico S. Saviours/Bottom No 1. Light." The first day of Creation is described in Genesis 1:3-5,

> And God said, "Let there be light," and there was light. God saw that the light was good, and he separated the light from the darkness. God called the light "day," and the darkness he called "night." And there was evening, and there was morning—the first day.

In his watercolor, Walker used dark black lines to show the lead joining the panes of colored glass as is seen in the finished stained glass window. He depicted the drama and action of Creation through the bold lines used to portray many of the "lights in the vault of the sky": the majestic sun, a crescent moon, a plunging shooting star, jagged lightning, rain pouring from menacing thunderclouds, and the planet Saturn with its beautiful rings.

The ability to study *The Creation* up close allows for helpful insight regarding the complex process of creating a stained glass window. The translucency of the watercolor medium is particularly appropriate in suggesting what the final stained glass window will look like. The term "stained glass" is a general term for colored windows (most often church windows) that combine architectural and decorative elements. The addition of metallic oxides at the molten stage of glass-making adds color to the glass. Vitreous paint of metallic oxides can also be painted onto a base glass before firing the glass in a kiln, holding the metallic oxides in place. Areas of light wash can also provide variety of texture and modeled effects. (Another means of coloring, used from the sixteenth century, was the application of enamel pigment onto the surface of the glass, which was then heated in a kiln so that the applied paint melts and fuses with the surface of the glass, making it possible to paint a design on the glass similar to painting a composition on a canvas. However, this technique takes away from the design function of the lead and lacks the transparency of the other former method.)

When a stained glass window is commissioned, the artist creates a full-size drawing according to the measurements of

Romaine Walker (1854-1940) and Clayton & Bell
The Creation, c.1885
Watercolor, graphite, and ink on paper, 18 x 18 inches

the window opening. The artist then draws on tracing paper the lines where the lead-lines are to go. The artist uses this drawing to calculate the dimensions for the separate pieces of glass, and may mark them with choice of color. This drawing is then placed underneath a sheet of plate glass, and the artist paints the lines onto the surface of the glass to indicate where the lead-lining will go. After the pieces of glass are cut, they are assembled on the sheet of plate glass and temporarily held in place by melted beeswax. This allows the artist to place the whole grouping of the pieces of glass onto an easel and examine it against the light and make any changes before the final painting and leading together. The artist assembles the separate pieces of glass and holds them in place by strips of lead (used because of its weatherproof, durable, and flexible qualities) that provide the outlines of the design. The glass panels are inserted in the window opening from the bottom to the top and are slotted into grooves in the stonework.

Traditionally, a hierarchy of placement determined the positioning of windows in churches, with certain locations, such as the east end, treated with special significance. Over the centuries, window size, importance, and composition have developed along with changing architectural styles. Some of the earliest fragments of figural windows date from sixth-century Ravenna (S. Vitale). In the Medieval era, Gothic architectural techniques allowed for very large window areas, creating some of the most splendid surviving examples in church architecture. Medieval patrons placed stained glass on a level of equal importance with wall, panel, and manuscript painting and sculpture. The delicacy of the stonework stressed the increased transparency of the windows, and walls became viewed as great curtains of glass. By the fourteenth and fifteenth centuries, designs for windows were commissioned from well-known artists and made by separate workshops. During the Italian Renaissance, the naturalism of Italian Renaissance painting encouraged pictorialism in stained glass window design, with windows designed to complement great fresco cycles and to bring attention to the centrality of the liturgy. During the Reformation, major stained glass windows of religious programs were mostly abandoned, and many stained glass windows thought to depict idolatrous images were destroyed. Secular and heraldic subjects greatly replaced religious imagery, and during the seventeenth and eighteenth centuries, stained glass windows were given the status of a decorative rather than a fine art. Windows commissioned in Europe in these centuries tended to copy contemporary oil paintings and used enamel paints.

Many scholars consider the highest achievements in stained glass to be those of the Gothic era in Europe and the nineteenth-century Gothic Revival in England. In the nineteenth century, the Church Building Act of 1818 in England created more than 600 new churches, and over 80,000 windows were created. Gothic Revival artists desired to understand and return to Medieval techniques, including a focus on the relationship between colored glass and the design function of the leads. Artists, architects, and scholars, such as A.W.N. Pugin, produced comprehensive histories describing the stylistic phases and subject matter of European glass and studied Gothic church buildings. The Victoria and Albert Museum (founded in 1852 as the South Kensington Museum) collected stained glass on a comprehensive basis from the mid-nineteenth century, and stained glass was exhibited at international exhibitions throughout the nineteenth century. While many workshops had up to 300 employees, some firms, such as Morris, Marshall, Faulkner & Co., founded by English artist William Morris in 1861, focused on treating the stages of the creation of stained glass windows as an artistic whole and used window designs by Pre-Raphaelite artists.

The Gothic Revival was the time period during which the watercolor *The Creation* was designed for St. Saviour's. The firm of Clayton & Bell was one of the major firms in England

that moved from directly copying Gothic windows, while still keeping them as their ideal, and creating windows with flowing linear patterns, simple and strong designs, a pictorial approach, carefully drawn details, and vibrant colors. John Richard Clayton (1827-1913) and Alfred Bell (1832-1895) founded the firm of Clayton & Bell in 1857 with the goal of improving stained-glass design. Both Clayton and Bell had worked as draftsmen for the architect George Gilbert Scott. While Clayton was influenced by the Pre-Raphaelite Movement, Bell looked more directly to Medieval artwork. British architects commissioning work from the firm of Clayton & Bell included George Gilbert Scott and G. E. Street. Examples of their work can be found in Ely Cathedral, St. John's College Chapel, Cambridge, and King's College Chapel, Cambridge. Clayton & Bell window designs and finished windows were also shipped internationally to the United States, Australia, New Zealand, France, Germany, India, Sweden, Turkey, and Russia.[26] Clayton & Bell created the stained glass window *The Creation* for St. Saviour's, Pimlico, during the same decade that Queen Victoria issued their firm a royal warrant, a mark of recognition that their firm supplied stained glass to the monarch. The bold geometrical shapes of the panes of glass in *The Creation*, separated by the vivid black lines of the leading, show the new direction taken in stained glass design in the mid to late nineteenth century in England by firms such as Clayton & Bell. *The Creation* demonstrates how Clayton & Bell used designs of elegant combinations of tonal shading with delicate linear touches to allow for the transmission of light and to emphasize the bold lead lines.

Because glass transmits rather than reflects light, stained glass windows have been felt by artists and architects to particularly contribute to the spiritual ambience of a church's interior. The symbolism and transformative nature of the colored light coming into a church was an important component of Medieval aesthetics, with parallels drawn to the Old Testament identification of light with goodness, wisdom, and the power and protection of God, and the New Testament identification of light as the nature of Christ and the beauty of the light suggesting the beauty of God's very nature. Suger, the Abbot of Saint-Denis in the mid-twelfth century, wrote of how the radiant color and light in the church at Saint-Denis allowed the church to be a foretaste of the Heavenly Jerusalem. In *The Creation*, this centuries-long desire to create a beautiful ecclesiastical interior through the use of stained glass may have been influenced by the personal faiths of Clayton and Bell. Throughout his life, Richard Clayton was actively involved in the Anglican Church, and Alfred Bell served as Vicar's Warden at Hampstead Parish Church (Church of England) for many years. Bell designed his house in Hampstead to have a prayer room, where he and his family met for prayers each morning.[27] The windows they created for St. Saviour's, Pimlico, transform the church's interior into a sacred space and give the effect of painting with colored light. Perhaps *The Creation* in St. Saviour's gives a similar foretaste of the Heavenly Jerusalem, as written about centuries earlier by Abbot Suger, through its transformation of radiant light.

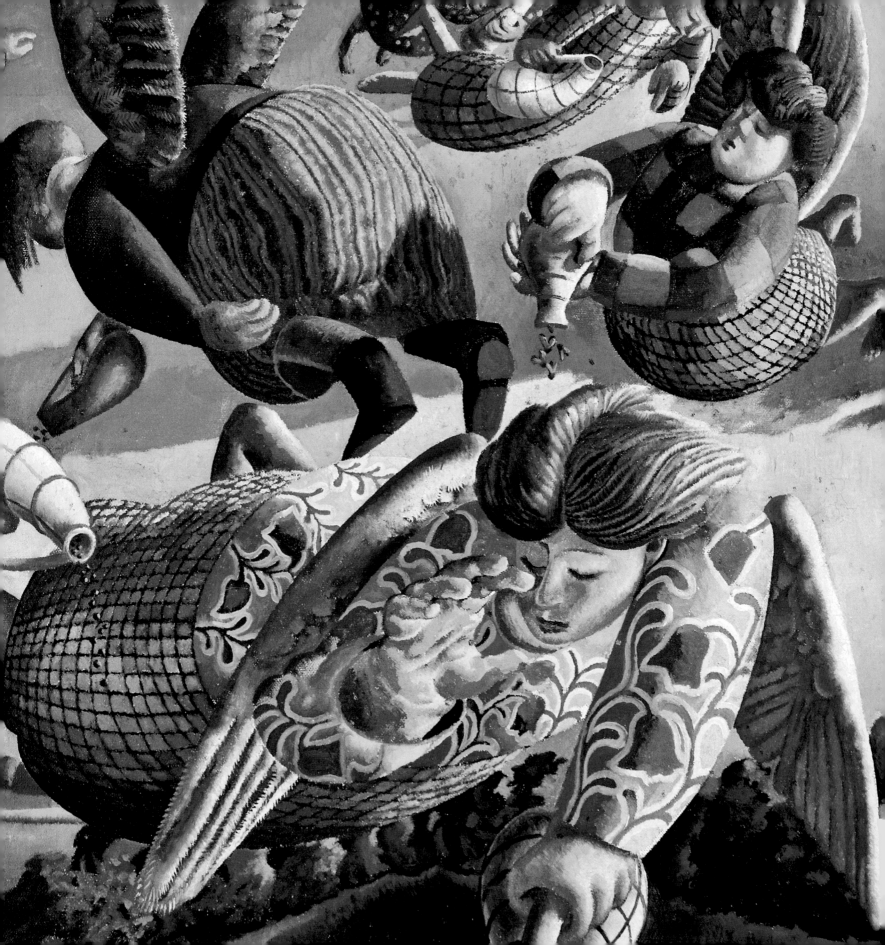

One of the most imaginative and important British artists of the twentieth century, Stanley Spencer communicated his intense awareness of the sacred in deeply personal drawings and paintings. While scholarship in the mid-twentieth century characterized Spencer as an eccentric, provincial, and rather odd English artist, recent scholarship, particularly two major exhibitions on Spencer, the first organized by The British Council and the Hirshhorn Museum and Sculpture Garden in 1997-1998, and the second organized by Tate Britain in 2001, have demonstrated the innovative and compelling quality of his diverse *oeuvre*.

Stanley Spencer grew up in the Berkshire village of Cookham. His family's connections to both the Anglican church and Methodist chapel there played a vital role throughout his life and work. His early works depict Cookham as a type of Eden, with Christian meaning and holiness to be found in all aspects of his everyday life. Spencer attended the Slade School of Fine Art at University College London from 1908 to 1912, traveling there each day by train from Cookham. At the Slade, one of the foremost schools of fine art in England, Spencer heard lectures by the eminent artist and art historian Roger Fry, who emphasized the importance to Modern art of the artwork of the Early Italian Renaissance, particularly that of Giotto and the Italian *Trecento* "Primitives." Fry also emphasized the importance of the Modernist art of France, particularly the art of Gauguin, Maurice Denis, and the Nabis. Because artistic instruction at the Slade was restricted to drawing, Spencer taught himself to paint in oils and completed his early paintings in Cookham in sheds, barns, and the crowded family home of Fernlea. At the Slade, Spencer identified with a group of students known as the Neo-Primitives, which included Mark Gertler, William Roberts, and C.R.W. Nevinson. Despite his fascination with contemporary French painting, Spencer stayed away from the avant-garde pre-war British art movement Vorticism. His early works instead maintain their focus on the specific location and landscape of Cookham and the Edenic atmosphere of his life there. Spencer collected postcards of paintings by Fra Angelico, Masaccio, Piero della Francesca, Uccello, and Mantegna, and his brother described their effect on Stanley as being as though he had received the stigmata.

During the First World War, Spencer served for nearly four years in Bristol as a hospital orderly and in the Macedonian campaign. During his service he carried with him pocket monographs of early Italian masters. When he returned to Cookham in 1918, he painted (as an official wartime commission) the monumental painting *Travoys* that served as a major witness to his wartime experiences, and particularly to the theme of resurrection that was to recur through his career. Unlike many other British artists in the interwar period of 1918 to 1939, Spencer did not focus on creating images of the rural picturesque in England, or on further official commemorative wartime commissions, instead focusing on biblical narratives set in modern England. Spencer described the effect that the First World War had had on him: "It has affected my work because it has naturally upset that confiding nature I had before the war towards people…that serenity of spirit which I then felt to be innate in everything around me as well as in myself."[28] He used his military service in Macedonia as inspiration for the grand murals he painted for the Sandham Memorial Chapel at Burghclere, Hampshire, between 1927 and 1932, which commemorated the life of Lt. Henry Willoughby Sandham who had died in Macedonia in 1919.

From 1920 to 1921, Spencer stayed with the trade union lawyer Henry Slesser in the village of Bourne End in Buckinghamshire and was introduced to Slesser's Christian Socialist circle that included the writer G.K. Chesterton. In London, he met regularly with other artists including Paul and John Nash, Mark Gertler, William Roberts, C.R.W. Nevinson, and Henry Lamb at the home of the Carline family, where he met

Stanley Spencer (1891-1959)
Angels of the Apocalypse, 1949 (detail)
Oil on canvas, 24 x 36 inches

his first wife, Hilda. Later, in 1924, Henry Lamb wrote of "the astounding novelty of such a personality stepping in at this time of day to restore narrative art to its primitive purity, lost in history since Fra Angelico and in every child after the age of 12 or 13."[29] In 1922 Spencer traveled with the Carlines to Vienna, Sarajevo, Munich, and Cologne, the only time in his life when he saw major collections of foreign masters outside of Britain. Particularly important to Spencer's artwork throughout the rest of his career was seeing the work of Northern masters, including Cranach and Breughel, and how they approached depicting a less idealized reality.

Washing, Study for Leeds Decoration, 1921

Spencer created *Washing, Study for Leeds Decoration* while living with Henry and Margaret Slesser from 1920 to 1921 and learning about their interest in Christian Socialism. He created the drawing as a result of a commission by the Chancellor of Leeds University, Michael Sadler, and the Leeds City Council authorities for a series of large-scale murals for Leeds Town Hall to celebrate the city of Leeds and its industry. In the 1920s in Great Britain, there was significant enthusiasm regarding commissioning art for public places due to the great achievements of artists in recording the First World War and creating war monuments. The artist Sir William Rothenstein chose the following artists to provide sketches for the projected Leeds mural series: Stanley Spencer (*Study for the Leeds Decoration*), Edward Wadsworth (*Leeds*), Albert Rutherston (*Building*), Percy Jowett (*Woolen Mills*), Jacob Kramer (*Mining*), and the brothers John Nash (*Rhubarb and Coal* and *Millworkers' Landscape*) and Paul Nash (*The Canal* and *The Quarry*). A panel of London museum directors, including Sir Charles Holmes of the National Gallery, D.S. MacColl of the Wallace Collection, and Charles Aitken of the Tate were to judge the designs and to submit them to the City Council. However, due to disagreements between Sadler, Rothenstein, and the City Council, the project fell through and the mural scheme never came to fruition.[30]

Throughout his career, Spencer demonstrated great interest in creating large-scale paintings for permanent settings.[31] However, while the other artists' sketches for the Leeds commission depicted industrial landscapes in accordance with the given theme of Industry, Spencer took a different approach. In his sketches he instead desired to show a (presumably somewhat idealized) view of the city slums in Leeds. Spencer was inspired by washing day in the slums and the city's narrow streets and alleys set against a background of the winding wheels of a coal mine.[32] He used a simple wash and pencil lines to compose the sketch, and yet imparts a sense of vibrancy and activity with laundry blowing in the breeze, a man straining to push a cart, perhaps with vegetables for sale, a woman stretching up to reach the washing, children playing, and a horse energetically trotting and pulling a man in a two-wheeled trap. A figure on the left walking up the street appears to be an angel with wings, lending a sacred atmosphere to the everyday activities of hanging up laundry and pushing a cart. The strong diagonal of the main street comes into the viewer's space and gives a sense of activity and dynamism. Stripes on the laundry show folds in the material and suggest Spencer's visual love of patterns. Even more laundry is penciled in at the foreground at right. Spencer described the blind alleys leading into the street as "chunk full of washing, all blowing upwards."[33] This sketch also shows Spencer's love of the shape of houses (also demonstrated in his painting *Christ Carrying the Cross* [1920], in which he modeled the shape of the house after the shape of a potato with many eyes). Spencer has penciled in all of the windows and doors of the row houses.

Spencer's various writings regarding his sketches of the slums in Leeds help to develop his vision for the finalized mural painting. Spencer wrote in a letter in 1920 after a week-long visit to Leeds,

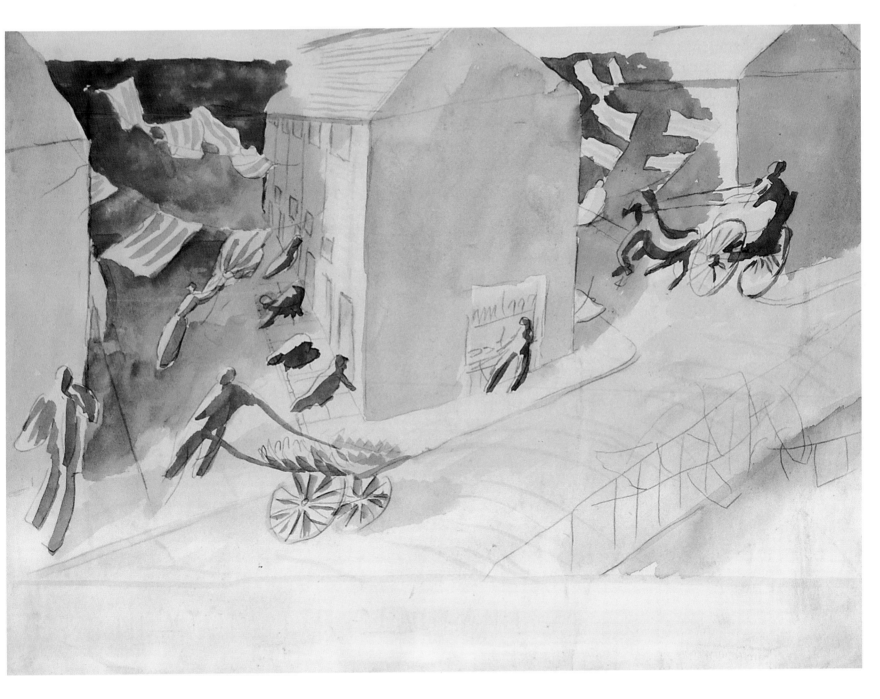

Stanley Spencer (1891-1959)
Washing, Study for Leeds Decoration, 1921
Pen, brush, and sepia wash on paper, 10 x 14 inches

I was in the worst slums most of the time. The smells were vile but it was very sad and wonderful. I am particularly keen on washing day in the slum. I have a magnificent idea for the Leeds picture. They hang the washing on a line which hangs from the window and swings forward onto some railings in front of the house. You know everything that *happens* in a slum happens on the *pavement* and not in the house; that is why I slumned [sic].[34]

He wrote in a notebook in 1936 regarding this work,
Washing hanging across street in blind alley. I like blind alleys I would like to live in one. The washing establishes a union between homes on opposite sides of the road. Very much like domestic atmosphere. The women wash the doorsteps and then the pavement as far as the gutter. The children walk about among the back of these steps and pavement washing women and they are like altars among the children.[35]

Spencer's direct identification of the washing women as being "like altars," along with the figure of an angel walking up the street show how in many of his works he transformed an image of daily life set in a well-known and perhaps overlooked location into a sacred space, enchanted and transformed. As in his *Christ's Entry into Jerusalem* (1921) and *Christ Carrying the Cross* (1920), which both take place in his native Cookham, a place where everything held a holy significance to the artist, in *Washing, Study for Leeds Decoration*, Spencer's determination to depict the city slums of Leeds demonstrates the artist's interpretation of overlooked places as extraordinarily compelling. This sketch exhibits visually the artist's statement: "I am always taking the stone that was rejected and making it the cornerstone in some painting of mine."[36] In this quote, Spencer directly engages Matthew 21:42, "Jesus said to them, 'Have you never read in the Scriptures: "The stone the builders rejected has become the cor-

nerstone; the Lord has done this, and it is marvelous in our eyes"?'" In his drawings and paintings, Spencer created sacred spaces out of places seemingly insignificant, illustrating his belief that every physical thing will eventually be redeemed, a belief at the core of his visual expression. By creating works such as *Washing, Study for Leeds Decoration*, Spencer makes himself a participant in this resurrection and transforms a humdrum scene into one of surprising beauty.

Self-Portrait, 1927

Throughout his career, Spencer included portraits of friends, family, lovers, and self-portraits in almost all of his imaginative figure paintings. Spencer also created a very fine distinct body of self-portraits, portraits of friends, and commissioned portraits, which are separate from his imaginative figure paintings. Spencer's landscapes and portrait paintings have in general received comparatively less scholarly attention. Indeed, Spencer viewed his creation of portraits as secondary to his imaginative figure subjects, and instead preferred to draw portraits of friends or people whom he found interesting rather than accepting commissions. Later in his life, Spencer wrote that he enjoyed creating portraits of people he found interesting because of his "exquisite appreciation of heads."[37]

Stanley Spencer created this penetrating self-portrait (signed and dated on the lower right) the same year that he began work on his monumental Sandham Memorial Chapel at Burghclere, Hampshire, and the intensity of this portrait drawing powerfully communicates Spencer's confidence and determination as he embarked on the Burghclere mural commission. Two years earlier, the artist had married Hilda Carline, who had also studied at the Slade School of Fine Art. Their first daughter, Shirin, was born in 1925, and their second daughter, Unity, was born in 1930. This self-portrait by Spencer is striking because of the incredible intensity of the artist's gaze. Spencer confronts and challenges the viewer

directly. All focus is on Spencer's face with only a hint of his shirt, necktie, and jacket created with just a few pencil lines. Spencer shows himself wearing the conventional jacket and tie that he wore in public, even when painting, rather than the open necked vest that he wore when working in a private studio.[38] The sensitive and subtle modeling of his face, a skill gained during the artist's training at the Slade School of Fine Art, captures all of the ripples and indentations of his skin through the contrast of light and dark, as if to create as honest a portrayal of his humanity as possible. The artist's skin bulges around his nose, his lips are tightly pressed together, and his hair falls across his forehead and reflects the light. One bold pencil line along his forehead creates the border of his hairline, while another bold line plunges downwards to outline his jacket lapel. Spencer's dramatically lifted right eyebrow, his rather abruptly cut off left eyebrow, and his slightly frowning countenance with his brows drawn together create an almost threatening self-portrait, with a sense of an eminent explosion. By leaving his left eye unfinished, Spencer suggests an image of the artist in the very process of creating this portrait. The artist tilts his chin slightly downwards, as if looking down at the viewer from a greater height. The artist's bowed head and directly penetrating stare, combined with the highlighted hair along his forehead, suggest the artist's brooding genius and creativity, and place this work within a long history of British artists depicting themselves as a melancholy genius. The vigorous nature of his self-portraits date back to an early 1914 self-portrait of which Spencer wrote in a letter, "I am doing a portrait of myself… I fight against it but I cannot avoid it."[39]

Washing Up, 1935

Spencer most likely began working on the painting *Washing Up* (signed with the artist's initials and dated 1935) while living in the village of Burghclere where he was working on the

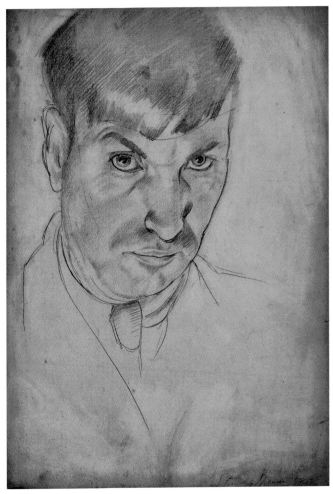

Stanley Spencer (1891-1959)
Self-Portrait, 1927
Graphite on paper, 13.75 x 9.75 inches

Sandham Memorial Chapel from 1927 to 1932. *Washing Up* is an important painting in this stage of Spencer's career because, as he wrote, it was "the only painting I did at Burghclere that was directly inspired by & was the outcome of the life at 'Chapel View,'" the Spencers' home in Burghclere.[40] *Washing*

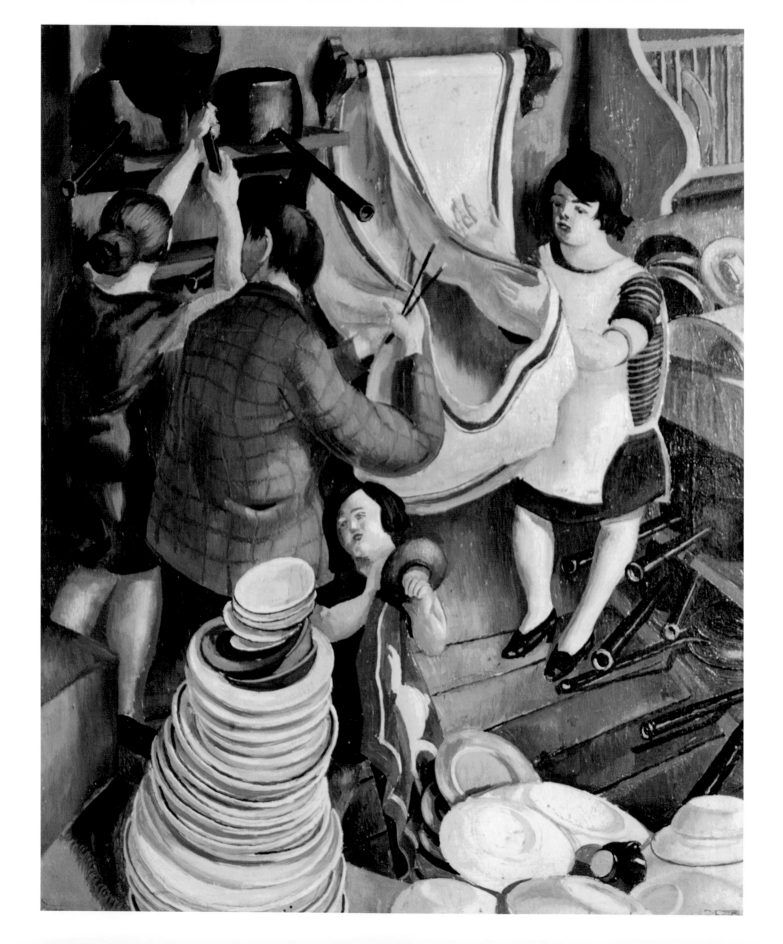

Up depicts the artist's wife, Hilda, at left, lifting a saucepan onto a shelf; the artist to the right of Hilda wiping two paintbrushes on a rolling dishtowel; their maid, Elsie, wearing a striped sweater and a bracelet (pushed up her arm to prevent it from getting wet), and wiping her hands on the dishtowel; and Hilda and Stanley's daughter Shirin in the foreground, who in 1935 would have been ten years old. Five years earlier, Spencer had given Hilda a study related to the final painting *Washing Up*, which depicted Hilda and some of the saucepans in the kitchen. *Washing Up* was one of several works exhibited in 1936 at a solo exhibition at the gallery of Spencer's art dealer, and in these paintings the artist avoided obvious sexual references and extreme distortion, two aspects which had led to his resignation from the Royal Academy in 1935.[41]

Completed in the interwar period, *Washing Up* presents the comforts, peace, and normalcy of family life as of vital importance to the artist. As in his post-First World War painting, *Travoys*, in which all of the faces of the soldiers, doctors, and hospital orderlies are turned away and hidden from the viewer, in *Washing Up*, the faces of both Stanley and Hilda are hidden, giving a sense of this private family moment and exchange between the parents, with Spencer turning to say something to Hilda while she puts a pot onto the highest shelf. The child-like maid Elsie displays a quiet serenity, not addressing the viewer, and peacefully absorbed in her task. Shirin also does not address the viewer, although, like Elsie, her face can be seen. Shirin stands merrily behind a stack of dishes nearly as tall as herself. All of the figures in this crowded family kitchen have a chunkiness to their doll-like shapes, and indeed, the whole painting is full of beautiful shapes. The painting is also full of patterns: the red, white, and blue stripes of the sweater worn by Elsie; the vertical lines of the dish rack hanging on the wall at the upper right; the pattern of lines on Spencer's jacket; and the handles of the pots at the middle right. The precariously balanced tower of dishes at the front threatens to topple into the viewer's space, and white and blue plates are piled at the right with a red cup serving as a vibrant highlight. Indeed, Spencer has included an incredible number of dishes and pots and pans in this kitchen scene!

Close examination of *Washing Up* is helpful in understanding Spencer's technique when painting in oils. Spencer used subtle gradations of color in the block of countertop at the left, and a varying finish of paint throughout the work, ranging from very smooth to showing the lift of his paintbrush. Spencer used simple brushstrokes to depict the facial features of the four figures, with a dab of white paint acting as a highlight on Shirin's nose. It is possible to see some of the artist's corrections made in the oil paint. For example, Spencer painted out some of Elsie's hair in order to make her head smaller. He also corrected the position of the paintbrushes that the figure of Spencer holds. In addition, it is possible to see some pencil outlines around the hands of the figures and around the dishtowels.

Spencer's writings regarding the figure of Elsie help to develop her role in this domestic scene and within the Spencer household. Stanley and Hilda hired Elsie as a maid after moving to Chapel View, and she stayed with their family for many years. Spencer depicted Elsie in many of his drawings of domestic life, such as hanging up laundry, ironing on the kitchen table, polishing door handles and fire irons, picking vegetables, and chopping firewood. In some of the drawings, Shirin accompanies Elsie. Spencer wrote regarding Elsie's role in *Washing Up*,

> It is a scene in the Kitchen & Elsie was the mainspring of its inspiration. She used to sit the children, when very small in the kitchen drawer so that they could watch her ironing, etc. I have memory drawings of her at her different occupations, chopping up wood, etc.... She was a real country child; she told me of the huge distances they had to walk to school

Stanley Spencer (1891-1959)
Washing Up, 1935
Oil and graphite on canvas, 24 x 20 inches

& that when one of her elder sisters took a situation 10 miles or more away from where she lived, she & her other little sisters - it was an enormous family - walked every Sunday to half-way to where her sister worked where her sister, walking also from where she was working, would meet them; they would then picnic somewhere & return.[42]

Spencer further described Elsie's life at Chapel View:

Cinamas [sic] motorbikes boys & local socials & callings on friends & goings off on jaunts & shopping & sending presents to innumerable baby nephews & nieces & quick & not prolonged chats to the tradesmen & then ironing & washing & picking beans & pulling off brussells [sic] sprouts & yet judicious & reflective in it all. The sound in the morning below my window of the wood being demolished to bits for the kitchen & dining room fires. Much singing of common love songs.[43]

The artist wrote regarding his relationship with Elsie:

Although [she] was "just" a servant we had & a very good one, she was something that has been a great part of my thought. If there was any affection it was never made known. So that I don't know what our feelings would have been had we been lovers....But I don't know of any similarity of aim & thought, only that we both knew what we liked & knew how not to interfere. She & I naturally thought in the same "rythum" [sic] had the same sence [sic] of joy. Both loved our work & life & could therefore sincerely sympathize & compare notes. If there was a family outing all would be well if left to her to arrange....But all my liking for her & hers for me (if there was any) is in the great unknown. It could never have been as she could not have accepted my views of love, but I would have been interested to know what her feeling was for me if she had any & what my love for her was.[44]

The painting *Washing Up* also needs to be considered within the context of a much larger mural series planned (but not completed) by Spencer. As mentioned previously with regards to Spencer's sketch for the Leeds mural painting project, Spencer enjoyed and was becoming more confident in creating large-scale works, and he wanted to find permanent settings for his paintings, as he had done at the critically acclaimed Sandham Memorial Chapel at Burghclere. In 1932 Spencer wrote, "I have done a small chapel now I wish to do a house."[45] Spencer wanted to create a building to accommodate an ambitious series of paintings based on a common theme, which found visual expression in his autobiographical *Church-House* project, which unfortunately never became a physical reality, and which combined the elements of both a church and a house. The *Church-House* project is an excellent example of how public and private mural painting projects played an important role in interwar Britain, and how artists, including Spencer, looked to early Italian fresco painting as a model for the public role of the arts. Over the course of thirty years, right up to Spencer's death in 1959, the *Church-House*, with an always developing design, was the planned destination for Spencer's non-commissioned figurative paintings, with the possible exception of the *Resurrection, Port Glasgow* series (see catalogue entry for *Angels of the Apocalypse*). The *Church-House*, like the Sandham Memorial Chapel, was intended to unite the artist's everyday domestic routine with his religious emotions. Spencer did not see a separation between the everyday and the spiritual. He wrote, "The secular pictures have religious associations and the religious ones secular associations, and just as I do not like the two separated in my work, so neither do I like them separated in what they are meant to epitomize collectively."[46] He specifically related this belief regarding the integration of the sacred and the

secular to the painting *Washing Up*. Although *Washing Up* is not explicitly of a religious scene or topic, it demonstrates the artist's conviction throughout his life that everyday events, surroundings, and people can be holy and a heaven on earth. Spencer wrote regarding this work that

> It is hardly correct to regard these simple notions that I have such as this washing up scene…as not religious. All that I paint or draw I would never do unless first I was able to conceive of the matter I was dealing with as occurring in some state of bliss in heaven, the fact that I see no need to take these matters out of their ordinary semblance of in nature, or give to them prescribed & known religious titles, should not allow one to assume that they are therefore earthly or worldly.[47]

For his *Church-House*, Spencer chose several sub-themes, based on biblical sources, including *The Pentecost*, *The Marriage at Cana*, and *The Baptism*. All of these sub-themes were included in the overall theme of the *Last Day* or *Last Judgment* and revealed his belief in secular and religious life being united. The artist writing to Hilda in 1947, "I want to show the relations of the religious life in the secular life, how that all is one religious life."[48] The painting *Washing Up* specifically belongs to the *Marriage at Cana Series* which focused on the marriage feast as a symbol of marriage, and also included the paintings *Bridesmaids at Cana* (1935), *A Servant in the Kitchen Announcing the Miracle* (1952-1953), and *Bride and Bridegroom* (1952-1953). The *Marriage at Cana Series* gives both domestic, behind-the-scenes impressions of the wedding as well as a personal interpretation of the married couple as represented by Spencer and Hilda.[49]

The painting *Washing Up* is also closely related to another sub-series of paintings which also belongs to the *Marriage Cana Series* and which Spencer painted from 1935 to 1936, the nine *Domestic Scenes*, which celebrate everyday activities within the Spencer family home at Chapel View and address generally the theme of married life.[50] The *Domestic Scenes* show Spencer, Hilda, Shirin, and Unity as part of the families at Cana, and depict them going to bed or getting dressed for the marriage feast. The *Domestic Scenes* served as a symbol of matrimony to Spencer when his relationship with Hilda still had some stability, and of the security and peace that mirrored his pre-war childhood at Fernlea. Creating these paintings enabled Spencer to present an idealized vision of his marriage, when his relationship with Hilda was beginning to crumble. Spencer wrote regarding his focus on marriage in 1937, the year Stanley and Hilda divorced, "Half the meaning of life, is in my case what the husband and wife situation can produce."[51]

Spencer continued adding images to his *Church-House* series throughout the 1930s, including during the year of his divorce from Hilda and his subsequent (brief) marriage to the artist Patricia Preece. Spencer added the more overtly sexual images of the *Beatitudes of Love* to the *Marriage at Cana Series* for the *Church-House* in 1937-38; however, these paintings contained no observable reference to the *Marriage at Cana* theme. In 1937-40, Spencer added five chapels to the *Church-House* and dedicated them to the five women in his life: Hilda, Elsie, Patricia Preece, Daphne Charlton, and Charlotte Murray.[52]

Sewing on a Button, c.1939-40

Sewing on a Button depicts Stanley Spencer with his friend Daphne Charlton and is part of Spencer's *Scrapbook Drawings*, a series of over 100 pencil drawings that served as independent compositions, sketches, and ideas for intended oil paintings for the chapels in his *Church-House*.[53] Spencer worked on the *Scrapbook Drawings* from 1939 to 1949 (*Volume One*: 1939-43; *Volume Two*: 1943-44; *Volume Three*: 1944-46; *Volume Four*: 1946-49) and concentrated on scenes of Hilda,

Elsie, and his friend Daphne Charlton.[54] Spencer had met Daphne and George Charlton in the late 1930s at a party given by their mutual friend, the artist C.R.W. Nevinson. Daphne and George Charlton were young artists who had both been educated at the Slade School of Fine Art. Spencer was greatly attracted to Daphne's beauty, sympathy, and friendship during a time when he was recovering from his recent divorces from Hilda Carline and Patricia Preece. Spencer stayed with the Charltons during the summer of 1939 at the White Hart Inn in the village of Leonard Stanley in Gloucestershire. Stanley and Daphne began a relationship, and he dedicated one of the chapels in his *Church-House* to her. Spencer's relationship with Daphne perhaps symbolized a hope that he would somehow recover his marriage with Hilda, the artist writing, "All things are redeemable in my opinion and I paint them in their redeemed state."[55]

While staying in Leonard Stanley with the Charltons, Spencer purchased four scrapbooks, or albums of "Derwent" paper, from the stationery shop, and used these scrapbooks for his numerous images which make up the *Scrapbook Drawings* series. *Volume One* focuses on his life at Leonard Stanley; *Volume Two* focuses on his domestic life at Chapel View in Burghclere; *Volume Three* includes resurrection compositions, including those associated with the *Resurrection, Port Glasgow* (1947-50); and *Volume Four* includes his experiences in Macedonia during the First World War.[56] Spencer wrote to Daphne regarding the vast number of subjects he undertook in the drawings, "I think my feeling of wanting to show appreciation through love to you & Hilda…is not the shallow thing it appears to be. It is exactly consistent with my work: in that I am always going a long way passionately in a variety of directions."[57] In general, the *Scrapbook Drawings* focus on couples and their shared domestic rituals, including undressing, having a bath, drying off with a towel, combing their hair, and having tea in bed.[58] Spencer wrote long inscriptions on the

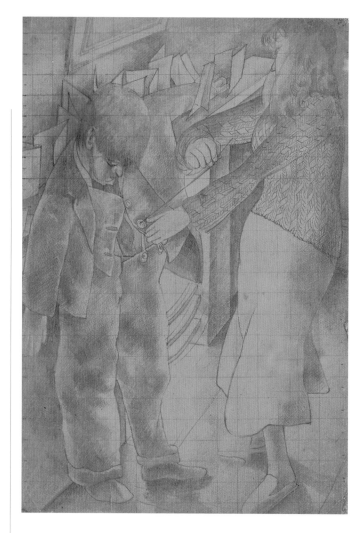

backs of many of the *Scrapbook Drawings*, making clear their autobiographical nature. In a letter to Hilda, he described how this set of drawings served as his autobiography: "As the possibility of a book being made of my work by me recedes, I wish as far as possible to thus make one myself….I have my own opinion of my work and of its changes and if I were making a book, it would be made as I am making this, namely in writing and drawing."[59] Spencer "squared-up" many of the drawings, including *Sewing on a Button*, so that he could transfer the drawings to canvas.[60] Overall, the importance of the *Scrapbook Drawings* cannot be overestimated in giving an invaluable glimpse into the artistic imagination of a major twentieth

Stanley Spencer (1891-1959)
Sewing on a Button, c.1939-40
Graphite on brown paper, 16 x 11 inches

century British artist. Despite opposition from art critics such as Roger Fry and the private, personal nature of many of Spencer's *Scrapbook Drawings*, the artist always envisioned the finalized *Church-House* as a public statement.[61]

Sewing on a Button is from the first volume of the *Scrapbook Drawings*. The artist wrote on the reverse,

> Sewing on a button. I like to celebrate all lovable acts. All ordinary acts such as this of Daphne sewing a button on my waistcoat are religious things & a part of perfection. While at Leonard Stanley I found what meaning I could as I always do wherever I am & here revealed several of the aspects of love & perfection of this simple order. On the mantelpiece are Christmas cards. The room is an imagined room I don't know where.

The drawing *Sewing on a Button* reveals Spencer's artistic training at the Slade School of Fine Art by his careful squaring up of this preparatory drawing, by his meticulous measuring shown in markings along the sides, and by his careful modeling of the figures through patches of light and shade. In *Sewing on a Button*, Spencer wears a lumpy coat, tie, suspenders, and trousers, and his tiny short body is dwarfed by that of Daphne, who wears a lumpy skirt and bedroom slippers and is sewing a button onto Stanley's waistcoat. Stanley stands in front of the fireplace and gazes down with his tousled hair almost in his eyes. Daphne's face is almost hidden behind her hair, while Spencer's face is only glimpsed in profile. Spencer appears like a little boy with his arms outstretched as if imitating the wingspan of an airplane, lending a childlike nature to the scene. The childlike and doll-like nature of the figure of Stanley in *Sewing on a Button* is also reflected in the nature of the medium, namely scrapbooks such as children might use. The thick hands and fingers of Stanley and Daphne give them rag-doll-like characteristics, and emphasizes the importance Spencer placed on the shape of objects, such as in

his earlier *Christ Carrying the Cross* (1920), in which the shape of the artist's house was inspired by the shape of a potato with many eyes. Spencer's love of patterning is revealed through the meticulous patterns of Daphne's sweater. An uncertain perspective is created in *Sewing on a Button* as the cards threaten to tumble from the mantelpiece down the strong diagonal created by Spencer's outstretched arms and Daphne's arms and hands pulling the thread. Spencer plunges his hand through the cards, one in the act of falling off the mantelpiece. The sharp angles of the open cards give the drawing a dreamlike atmosphere, as if the artist had combined the tumbling deck of playing cards from *Alice in Wonderland* with the mantelpiece from *Alice Through the Looking Glass*. Spencer deliberately emphasized the confusing depth and perspective of the drawing by having it very broad at left, with Spencer's right arm almost touching the edge of the drawing, and then narrowing the right side of the drawing dramatically. The artist's manipulation of perspective and depth demonstrates that he is presenting an imaginative re-creation of a domestic event, rather than a literal description.

As in much of his work, Spencer created *Sewing on a Button* to address the Christian theme of resurrection. The nature of the scrapbooks helped suggest the theme to Spencer, the artist writing,

> In the stationer's shop were sold scraps, such as I remembered from my childhood, and scrap-books for sticking them in. I bought several of these scraps and a scrap-book, the book to do these drawings in and the scraps for what they meant to me….A sheet of scraps was one of the earliest sort of heavens in which I found ordinary familiar objects, and this Last Day idea may be the "sheet of scraps" I myself wish to make.[62]

In his *Scrapbook Drawings*, Spencer "resurrects" the "sheet of scraps" into a "sort of heaven," the artist writing regarding an earlier related work, "Nothing I love is rubbish, and so I

resurrect the tea-pot and the empty jamtin and cabbage stalk, and, as there is a mystery in the Trinity, so there is in these three objects and in many others of no apparent consequence."[63] The artist also wrote further regarding the religious theme of the *Scrapbook Drawings* and specifically of *Sewing on a Button*:

> The series came about as a result of my wish to become clear in some notion I had long had concerning the Last Day. It is an idea which has influenced my thought and work through many years....
>
> I think the whole business of doing pictures is some sort of redemptive process, though not necessarily from what I dislike, but more in order to fulfill something I love. The Last Day theme is the home I am hoping to provide for all these items of thought that seem to belong to it. My art, whatever it is, is a home-finder, for me a nest-maker. It goes to prepare a place for me. In each of these drawings I approach heaven through what I find on earth. What is in my life and around me leads me to such hopefulness that I feel the surrounding happenings of the village are of heaven if not heaven itself. Ordinary happenings as I feel about them relate themselves in my mind to something embodying the hopeful significance I feel in contemplating the Last Day. Their import is related to some central all-redeeming fact. And it is my aim to express that in these drawings.
>
> When I see an ordinary circumstance I seem to see the whole of which it forms a part. All these isolated happenings touch on a conception of life which I call religious; they tell of it and there is truth in their revealing. I like to celebrate all lovable acts. All ordinary acts such as the sewing on of a button are religious things and a part of perfection....When I am composing these ordinary scenes I am seeing

them in this redeemed and after resurrection and Last Day state.[64]

In this quote, Spencer draws a parallel between his own art (which "goes to prepare a place for me") and the redemptive nature of Christ, rephrasing Jesus' words in John 14:2-3, "My Father's house has many rooms; if that were not so, would I have told you that I am going there to prepare a place for you? And if I go and prepare a place for you, I will come back and take you to be with me that you also may be where I am."

Buttercups in a Meadow, 1941-42

Stanley Spencer's beautiful painting, *Buttercups in a Meadow* (1941-42), evinces the artist's ability to create not only dramatic figurative works but also tranquil landscapes that evoke the beauty of the English countryside. Spencer began working on *Buttercups in a Meadow* while living in Leonard Stanley in 1941 and completed the painting in Cookham in August 1942.[65] *Buttercups in a Meadow* is an important painting in Spencer's *oeuvre* in underlining the importance the pastoral landscape played in British art during the Second World War, as well as the general importance that landscape painting played in Spencer's artistic career. In this painting, a meadow curves gently backwards, inviting the viewer into the landscape to a small house that is almost hidden by the trees. Delicate buttercups evoke the warmth of a still summer afternoon. The artist used a limited palette of greens, yellows, whites, tans, browns, and grays to suggest the lushness of the English landscape. A human element is introduced into the painting with the pathway forged through the plants beginning on the right-hand side of the canvas and continuing towards the center. The strong diagonals of the hedgerows point towards the centralized vanishing point. *Buttercups in a Meadow* reveals again Spencer's love of meticulous patterning through the innumerable buttercups and the patterns of groups of flowers. The artist gives the feathery tan plants a

soft texture and uses fine rhythmic patterns of vertical brush-strokes for the grasses in the middle ground.

Over the years, the importance that landscape painting played in Spencer's *oeuvre* has been generally ignored. While his landscape paintings were greatly successful with regards to sales and critique during the artist's lifetime, Spencer's forth-right opinion that his landscapes impeded his figurative work has in some respects discouraged scholarship regarding them.[66] Indeed, the artist wrote, comparing his landscapes to his figurative works,

I feel really that everything in one that is not vision is mainly vulgarity. It has always puzzled me the way people have always preferred my landscapes. I can sell them but not my Joachims. This fact of recent years has had a wearing effect on me...I don't under-stand and feel very muddled. If what an artist does comes from the stem of Jesse, it should be clearly apparent in everything that artist does.[67]

However, Spencer's interwar and wartime landscapes are critical to a comprehensive understanding of his work in its entirety to the formation and character of British Modernism. In his landscapes, the artist combined his interest in Post-

Stanley Spencer (1891-1959)
Buttercups in a Meadow, 1941-42
Oil on canvas, 16 x 20 inches

Impressionism with a traditional English artistic approach of directly observing nature. In a similar way to his British contemporaries in the Camden Town Group and the London Group, Spencer approached painting the English landscape by focusing on commonplace subjects. Spencer communicated his passionate captivation with familiar places, creating moving landscapes often concerning his personal feelings about specific and familiar places. The artist tended to compose his landscapes with an elevated viewpoint and a block of foreground detail with a dramatic sweep of receding landscape behind it towards the horizon. In the 1930s Spencer devoted increasing detail to the foreground area, with it achieving a sharply focused and nearly photographic quality.[68] Indeed, the artist wrote that "having photos of these landscapes is most important to me" and that "In all these landscapes I have, more or less, only been a camera; a camera that had some inkling of what I like & which arranged everything in about the point of view & angle I should want when I went to consider the next stage, namely a figure painting."[69] In later paintings, it becomes possible to identify the types of individual plants in the foreground, reflecting the artist's proficient knowledge of botany and interest in the meticulously detailed nineteenth-century Pre-Raphaelite paintings.[70] It is because of his precise rendering of familiar English landscapes that Spencer's landscape paintings were so highly sought after during his lifetime. It also explains why his landscapes have been given less attention in discussions of British Modernism in that his approach holds little in common with Surrealist landscapes of the 1920s and 1930s. However, more conservative English critics found this very disconnection of Spencer's landscapes from that of the French avant-garde as assurance that a "national" English art still existed.[71] The critic of the *Scotsman* wrote regarding Spencer's landscapes in a 1936 exhibition,

> Personally I think Spencer is in the tradition of British Pre-Raphaelitism...the poetic naturalistic kind of Hunt, Brown and the young Millais. Spencer paints landscape as they did, not so minutely of course, but with the same prodigious delight in all the facts of nature for their own sake. He loves to paint nettles and grasses leaf by leaf, blade by blade, as they did. He loves it all too much to leave anything out.[72]

As this quote implies, Spencer's landscapes placed him in a long and lauded tradition of English landscape artists, increasing his attraction to many potential patrons. The appreciation of viewers of Spencer's landscapes during the interwar and wartime years (with several of his landscapes acquired by serving officers, including *Buttercups in a Meadow*, which was purchased by Flight Lieutenant George Mitchell in 1942)[73] was based in an increasing widespread idealization of the English countryside. This idealization was expressed in multiple ways, from the interwar "back to the land" movement, to books such as the *English Heritage* series begun in 1929, to BBC programs on "national character," to *Country Life* magazine which lauded idealized and eternal rural English values. Spencer's ability to communicate a sense of the idyllic warmth of a field of buttercups on a warm summer day in *Buttercups in a Meadow* may have reminded his contemporaries of idyllic summer holidays in the countryside. His detailed images of a cultivated and picturesque English countryside appealed to this identification of rural Britain as the jewel of national culture. The artist himself wrote in looking back at a landscape he had painted of Cookham in 1914, "I know I was...feeling a new and personal value of the Englishness of England."[74]

Buttercups in a Meadow comes at the end of a spurt of activity in landscape painting by Spencer that began in the second half of the 1930s. In 1936 Spencer's art dealer advised him to create as many landscapes as possible in order to help relieve his debt accrued in his costly courtship of Patricia Preece. Accordingly, Spencer painted seventeen landscapes

that year. Spencer's creation of landscape paintings reached a climax in 1938 with nineteen still-life and landscape paintings. Towards the end of 1940, Spencer began to receive income from War Artists' Advisory Committee commissions and he was able to refocus on figurative painting. Subsequently he painted only three landscapes in 1941 (including *Buttercups in a Meadow*), three in 1942, and one in 1943. While landscape paintings helped to increase Spencer's prices and sales, the artist found that it interfered with his creation of imaginative figure paintings planned for the *Church-House*.[75] Spencer wrote in a letter in 1927, "It is strange that I feel so 'lonely' when I draw from nature, but it is because no sort of spiritual activity comes into the business at all."[76] In a later written composition by the artist in 1941, titled "Landscapes," he continued this bemoaning of his landscapes: "I am not pleased with myself over my landscape work, it never having been what I intended or wanted to do & having done them only to get money."[77] However, to some extent he reversed his earlier position that no "spiritual activity" was involved, instead writing that his landscapes that "[contain] some species of my own personal feeling & emotion" could actually "be regarded as studies or preludes to a picture or pictures I might hope to do."[78] He listed three aspects of his landscape paintings that particularly attracted him including, "the special religious atmosphere they suggested," "the domestic & homely atmosphere," and "My own sensitiveness to shapes & forms & composition."[79] Concerning these three aspects, he wrote that "All these feelings of mine might be found in some measure in each & any landscape of mine" although he realized that "this may be not a bit why my landscapes are liked."[80] Still, in this written composition, he continued to refer to his landscape paintings as "still only landscapes" and wrote that he selected the locations "from the point of view of being places I like to imagine people being in," thus maintaining an end goal of creating figurative compositions.[81] Also, the specific place of Cookham remained paramount to his landscape paintings, the artist writing in his "Landscapes" composition,

> To look at the [religious] landscapes…it seems too as if the emotion is inseparable from Cookham….as a child I used to peep through chinks & cracks in fences, etc & catch glimpses of these gardens of Eden of which there was a profusion at Cookham. From these glimpses I used to get, I assumed that some sort of saint or very wonderful person lived there & so on. If I was not so sure of that I invented & invited biblical characters to take over.[82]

A final aspect of his landscape paintings that attracted him, as recorded in this 1941 written composition, was a peace or rest, achieved through a synthesis of his religious and domestic emotions and his "being able to make some sort of home or nest in it":[83]

> In these landscapes the thing I seek chiefly is to express a crucial meaning I find in its status as a place & what makes it *there* and nowhere else. I do so, I think, because a place is somewhere one can find *rest* in, just as a person is. In this place sense I like sometimes to live, move & have my being.[84]

Angels of the Apocalypse, 1949

Angels of the Apocalypse is part of a fascinating series of paintings that Stanley Spencer created in Port Glasgow, Scotland, in the late 1940s. From 1940 to 1946 Spencer worked on a large commemorative series of paintings, *Shipbuilding on the Clyde*, commissioned by the War Artists' Advisory Committee and based in Port Glasgow. While in Port Glasgow, Spencer began work on another series, the *Port Glasgow Resurrection Series* (1945-50), in order to celebrate the joy and community of the shipyard workers he experienced during the Second World War. Spencer drew sketches for the series in his *Scrapbook Drawings*. The artist wrote to his art dealer that in the

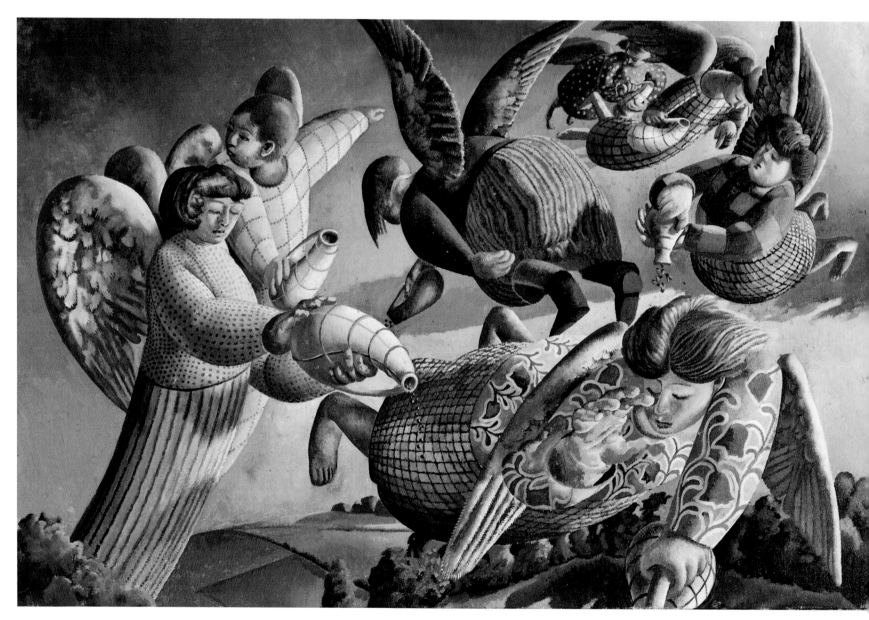

Stanley Spencer (1891-1959)
Angels of the Apocalypse, 1949
Oil on canvas, 24 x 36 inches

Port Glasgow Resurrection Series he wanted to "[express] the fulfillment and realization of this present lives [sic] hopes and wishes. This causes the joy expressed at the Resurrection to be something felt and shared between the resurrecting people and shown in their meeting again."[85] Port Glasgow achieved a related importance to Cookham in Spencer's artistic imagination. In the *Port Glasgow Resurrection Series*, the hilltop cemetery above Port Glasgow took the place of the Cookham churchyard in his 1926 *Resurrection, Cookham* as the location of the Second Coming of Christ.[86] Spencer wrote specifically regarding his discovery of the Port Glasgow cemetery,

> One evening in Port Glasgow, when unable to write due to a jazz band playing in the drawing-room just below me, I walked up along the road past the gas works to where I saw a cemetery on a gently rising slope…I seemed then to see that it rose in the midst of a great plain and that all in the plain were resurrecting and moving towards it…I knew then that the Resurrection would be directed from this hill.[87]

Spencer planned to paint a single canvas approximately fifty feet in length, similar in ambition to the Sandham Memorial Chapel and the *Church-House*. This canvas was to show a seated Christ at the top of a hill with angels around him and with those who were newly resurrected climbing up the hill. However, the artist decided against this rather ambitious arrangement. Spencer instead completed eighteen canvases for the *Port Glasgow Resurrection Series*, twelve of the canvases composed as four independent triptychs. *The Resurrection: The Hill of Zion* (1946, depicting Christ and his disciples seated on a hill), *The Angels of the Apocalypse* (1949, described below), and *The Resurrection, Port Glasgow* (1947-50, showing the resurrected climbing out of their graves in the cemetery and preparing to meet Christ in judgment) were intended to form a three-part vertical composition, with *The Resurrection: Port Glasgow* as the base and *The Resurrection:*

The Hill of Zion and *Angels of the Apocalypse* above it. However, because the scales of *The Resurrection: The Hill of Zion* and *Angels of the Apocalypse* vary significantly, Spencer may have abandoned his intention of keeping the three paintings together from the first.[88] Pressure to sell individual works may also have been a factor in his decision to split the composition into multiple canvases. The artist wrote regarding his decision to separate the scenes of the paintings,

> I do not know why I lost heart over it being at the top of the Hill of Zion. I think I thought…it cast a shadow over the sunlit hillside…and while the intent of both paintings is a kind of severity…in the angels flying it is the kind that goes with sadness, a something not of the same order of happiness that I expressed in the Hill of Zion.[89]

Originally, *The Angels of the Apocalypse* was intended to depict the avenging angels in the sky above Christ in judgment and was to be hung above *The Resurrection: The Hill of Zion*. In the Book of Revelation, the angels are described as the "seven angels with the seven last plagues—last, because with them God's wrath is completed" (Revelation 15:1) and who hold "seven golden bowls filled with the wrath of God" (Revelation 15:7). However, in a letter to his art dealer in 1949, Spencer wrote, "I wanted some measure of mercy and so hoped it could be thought that some less potent poison was being poured on the wrongdoers."[90] While keeping the seven angels, he instead decided to make the topic "one of the few compositions I have done of the Creation, this being angels assisting God in fertilizing the earth with distributory seeds." The artist further explained:

> I think the composing of these angels was done with the thought of them being Apocalyptic ones but not on such awful punishing errands….I cannot face the punishment as revealed in the book of Revelation… there is something inexplicable in angels carrying

out eternal punishments....A reminder of past wrongs and a call to repentance was as much as I could bear in the matter of the quality of punishment, if there was to be any at all.[91]

Thus, in the *Port Glasgow Resurrection Series*, Spencer brings the Creation and the Resurrection together into a united theme of redemption.[92] Spencer most likely chose Genesis 1:11-13 as his basis of inspiration for *Angels of the Apocalypse*:

> Then God said, "Let the land produce vegetation: seed-bearing plants and trees on the land that bear fruit with seed in it, according to their various kinds." And it was so. The land produced vegetation: plants bearing seed according to their kinds and trees bearing fruit with seed in it according to their kinds. And God saw that it was good. And there was evening, and there was morning—the third day.

Angels of the Apocalypse truly bears out the comment by one of Spencer's artistic contemporaries, Wyndham Lewis, in a review for the *Listener* in 1950 that "even [Spencer's] angels wear jumpers."[93] Indeed, according to Stanley Spencer's brother, Gilbert, the artist derived the clothing of the rather chubby angels from knitwear and fashion advertisements.[94] Spencer's angels wear sweaters (or jumpers) of vibrant colors and patterns as they hover over a beautiful English landscape with rolling hills similar to *Buttercups in a Meadow*. The vibrant polka dots, squares, checks, flowers, and stripes of the sweaters again evince the artist's delight in patterns. There are seven angels in total, six of them women with bobbed hair, and one of them a child, mostly likely a young boy with cropped hair, who appears to be trying to get his mother's attention as he points towards the right side of the canvas. He is wearing what looks like a long nightgown, while his mother wears a pleated skirt and sweater with small dots. Two of the angels on the upper right wear housedresses, and the angel just below them to the right wears a sweater with a vibrant quilt-like pattern. The angel closest to the viewer wears a sweater with a pattern of bell-like flowers that is reminiscent of the Arts and Crafts textiles designed by William Morris in the late nineteenth and early twentieth centuries, such as Morris's *Medway* design of 1885 with its bell-shaped flowers and sinuous vines.[95] The patterns of the sweaters and skirts of all of the angels give the composition the feeling of domestic "coziness" so important to Spencer. The feet of five of the angels are visible, and all of them are barefoot, with the exception of the angel wearing a red sweater who appears to have her gardening boots on! Indeed, Spencer remarked "I am on the side of angels and dirt."[96]

With the modern bobbed haircuts of the angels, if the artist had not stated the subject, the viewer might assume this composition depicts village women from Cookham who have sprouted wings and are planting a garden in the peaceful English landscape. All of the angels carry bottle-shaped vessels (covered with a pattern that matches the young boy-angel's nightgown) with seeds spilling out of them to fertilize the earth. There are two different kinds of seeds depicted: at the left, small, round, brown seeds are depicted, while at the right, the seeds have wings (similar to seeds from maple trees) with the wings of the seeds mirroring compositionally the wings of the angels. The angel at the upper right wearing a beige dress with brown stripes points downwards with her left hand, indicating where the seeds are falling. The angel closest to the viewer has her eyes closed or downcast and holds her hand up as if in greeting or warning to the viewer, or having just dropped a handful of seeds to the earth. She has a slight smudge on her nose, and she comes into the viewer's space with the neck of her seed jug being cut off by the picture plane. Not one of the angels looks at the viewer; all are intent on their task as shown in their focused, concentrated faces.

Spencer emphasizes the materiality of the angels' wings,

perhaps inspired by the swans on the River Thames by Cookham. The wings of the angels in *Angels of the Apocalypse* are similar to the angels and their wings in Spencer's earlier painting *Separating Fighting Swans* (1933), in which Spencer desired to express "a place in Cookham, and a religious atmosphere…In it the associations are my separating two fighting swans…and a drawing of angels I had done."[97] The chunkiness and physicality of the bodies and wings of the angels in *Angels of the Apocalypse* recollects the works of the Italian primitives Spencer so admired. The large, huggable shapes of the bodies of the angels and their doll-like plump hands and fingers show the kind of body shapes that Spencer enjoyed depicting. They are similar to the body of Saint Francis in Spencer's painting *Saint Francis and the Birds* (1935), which was rejected by the Royal Academy Hanging Committee, leading to Spencer's resignation. Throughout the composition of *Angels of the Apocalypse*, the artist's focus is on the bodies of the angels rather than in creating a finished-looking sky. Spencer blocked in beautiful liquid passages of color for the sky using visible brush strokes, creating an unfinished impression. The blue sky abruptly stops in its transition to the tan and brown passages, which suggest a cyclone sweeping through or the heavens sweeping down to earth. The possibility of the upper right section representing the heavens sweeping down to earth is suggested by the small boy-angel pointing towards the angels at the upper right corner who are the farthest away from the viewer and the closest to heaven.

During the creation of this series, Spencer wrote to his art dealer of his misgivings regarding the responses of potential patrons:

> I can give no guarantee and scarcely any hope that I could or would do a figure picture that would meet with the kind of approval…that was accorded to my early religious paintings. There is something in my figure pictures religious ones as well that I do nowa-days that seems to put people off.…The "trouble" in this last one is that as it is a more "personal" Resurrection subject, and naturally includes a lot of my varied feelings and wishes, I am so afraid that as there has been already shown such a dislike…for the figure pictures I have done since 1937 that herein also…in these pictures…[they] might see or find things of like nature that they disliked for some reason.[98]

Spencer's dealer responded bluntly:

> Whether [you paint] one large three feet high by forty feet long or five separate pictures, unless you eliminate the "elements which people object to" in your recent work, I can see little hope of the pictures helping to reduce your debts. May I see the compositions before you start to paint? If you would paint religious pictures without any element of sex creeping in, I would rather have them than landscapes. There was nothing to offend people in the "Christ in the Wilderness" series. However you must do what your inner feelings dictate.[99]

As a whole, the paintings in the *Port Glasgow Resurrection Series* follow the art dealer's advice and avoid any overt sexual references and awkward distortions. Even though Spencer called the series "a more 'personal' Resurrection subject," there are few direct references to his intimate friends in the paintings and it is unknown as to whether the angels in *Angels of the Apocalypse* represent Spencer's acquaintances.

Despite his misgivings, when Spencer exhibited the *Port Glasgow Resurrection Series* at the Royal Academy Summer Exhibition in 1950, the works were met with many positive reviews from art critics. The *Daily Telegraph* critic called *The Resurrection, Port Glasgow* the "Picture of the Year,"[100] while the *Sunday Times* critic called Spencer "the last of the medieval artists."[101] The critic from the *Yorkshire Post* commented, "the force and conviction of these works spring

from the wonderful simplicity of heart of the man who painted them. Stanley Spencer has the outlook of a genuine primitive."[102] The critic for the *Sunday Times* wrote an extended review, finding the series

> almost intolerably charged with visual detail and symbolic meaning. It is only when one realizes that this mass of detail is fused together by an intense emotional temperature that the pictures begin to be cumulatively impressive and one is forced to acknowledge that behind the naïveté and the quaintness is an imaginative pressure more sustained than any other British artist. That is why he can fill an enormous canvas without giving the impression that a sketch has been enlarged. It has to be big in order to do justice to its context.[103]

Some critics were less positive, such as the critic for the *Morning Advertiser* who found *The Resurrection, Port Glasgow* "crowded" and "so unorthodox and so wildly fantastic an interpretation of so serious a subject," that it "may be found repellant [sic] as well as bewildering" and found it "a relief" to view instead one of Spencer's landscape paintings.[104] However, even Spencer's contemporary Wyndham Lewis, who wrote a rather negative review for the *Listener*, concluded, "[Spencer] inhabits a different world from the potboiler. He has a visionary gift after all."[105]

Study for the Deposition, 1954-55

Towards the end of his life, at the same time that he was working on compositions for the *Church-House*, Spencer also completed a series of New Testament subjects that included three works: *Christ Rising from the Tomb* (1954), *The Deposition and the Rolling Away of the Stone* (1956), and *Saint Peter Escaping from Prison* (1958).[106] *Study for the Deposition* (signed by the artist at the bottom right), a preparatory drawing for *The Deposition and the Rolling Away of the Stone*, returned to the

Quattrocento-like visual and narrative directness and clarity of Spencer's religious series of the 1920s, such as *Christ Carrying the Cross* (1920).[107] In this preparatory study, the body of Christ on the Cross takes up the whole length and width of the page. Although Christ's eyes are open in the drawing, the Deposition took place after Christ gave up His spirit, and this sketch depicts the removal of Christ's body from the Cross. Spencer shows Jesus as a young man with no beard, and focuses attention on the nails in His hands and feet. A man at the bottom left uses pliers to cruelly pull nails from Jesus' feet, while another man at the bottom right holds a hammer and is pounding the nails up from the wooden pedestal that appears to support Christ's feet. Similarly, a man at the upper right uses a hammer to remove a nail from one of Christ's hands, which remain unfinished. The disciple John, who stands behind Mary, supports her limp body as she is overcome with grief. The hidden faces of the men standing behind Mary and the man at the upper right give a sense of mystery and foreboding to the scene. Spencer contrasts the contorted poses of the figures by Christ's feet with the classical bodies of Christ and the two men at the upper right. Careful, meticulous hatching and cross-hatching give the figures weight. Spencer squared up this drawing in preparation of transferring it to canvas, showing how he was still following his earlier artistic training at the Slade School of Fine Art, and revealing the importance of drawing to Spencer's work as an artist.

Study for the Deposition and the other works in this series reveal Spencer's interest in referring to multiple diverse visual sources. Spencer's depiction of the Virgin Mary in both *Study for the Deposition* and in the final painting, *The Deposition and Rolling Away of the Stone*, may particularly exhibit his interest in visual sources from Mexico. The Virgin Mary, depicted in a dress with stars on her gown, gazes sorrowfully at her Son as her body goes limp. In the final painting, Mary's gown is blue and is covered with white stars. Traditionally in Western art,

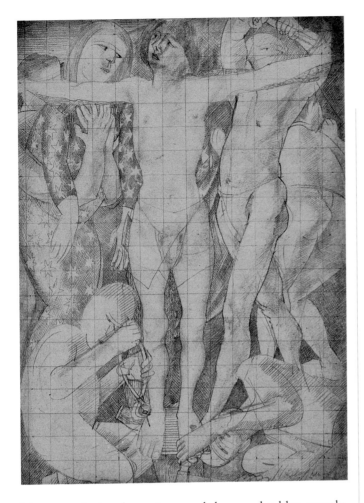

Mary was depicted wearing a red dress and a blue mantle. Spencer may have been specifically interested in depictions of Mary in artwork from Mexico, particularly images of Our Lady of Guadalupe, in which Mary wears a blue mantle covered with gold stars over a red dress.[108] Spencer has very effectively transformed this blue mantle with stars into Mary's dress. Contemporary interest in the arts of Mexico, both ancient and modern, by British artists is also reflected in the sculpture of Spencer's contemporaries Henry Moore and Barbara Hepworth, and in articles in contemporary art journals such as *Studio*.

This series of artworks reveals Spencer's interest in not only artwork from colonial Mexico, but also in artwork from the Early Italian Renaissance. The specific reference by Spencer to Early Italian Renaissance artwork is made clear in the posture of Christ in *Christ Rising from the Tomb*, which refers compositionally to Piero della Francesca's *Resurrection* (Palazzo Comunale, S. Sepolcro), where Christ correspondingly appears in a frontal pose. In addition, two of the works from this series, *Christ Rising from the Tomb* and *The Deposition and the Rolling Away of the Stone*, reflect compositionally the structure of an Early Italian Renaissance altarpiece. Each painting is divided into two sections by a horizontal strip of blank canvas. The upper main sections are devoted to the central narrative, and the lower, much smaller, sections act as a predella, or decorative base for an altarpiece, embellished with supportive narrative paintings. In *The Deposition and Rolling Away of the Stone*, the larger upper section depicts the Deposition of Christ. The lower section depicts a winged angel rolling away the stone from the tomb, while another enters the tomb where the body of Christ is still lying. Four guards are arranged sleeping around the outside of the tomb. Their bodies are curled in rather contorted fetal positions, similar to the figure at the lower right in the preparatory sketch, *Study for the Deposition*, who is pulling a nail out of Christ's feet. While the sketch, *Study for the Deposition*, and the painting, *The Deposition and Rolling Away of the Stone*, may draw compositionally from the art of the Early Italian Renaissance, as always Spencer also drew from a very specific and personal iconography. In 1955 the artist related that the scene of the tomb was inspired by his stays at a friend's house in the 1950s when a nanny would draw back the curtains in his room. The fetal shape of the sleeping soldiers may also be inspired by the tightly curled position in which Spencer tended to sleep. The shape of the tunnel-like tomb was inspired by the drainage pipes being installed along Cookham High Street.[109]

Stanley Spencer (1891-1959)
Study for the Deposition, 1954-55
Graphite on paper, 15 x 10.5 inches

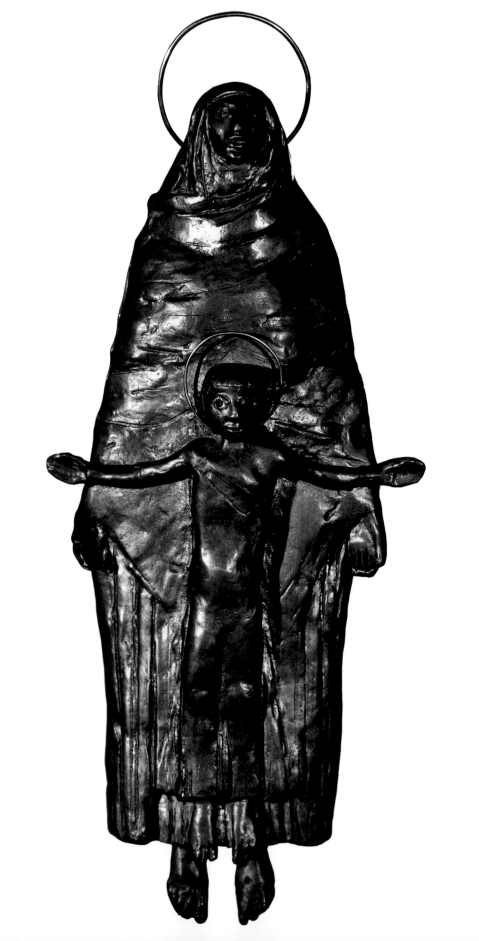

JACOB EPSTEIN

A leading sculptor of monuments and portraits in the history of Modern British art, Jacob Epstein was also a sensitive painter and illustrator. Epstein was born in New York of Polish-Jewish ancestry. He studied at the Art Students League in New York and then in Paris at the École des Beaux-Arts and at the Académie Julian. Epstein moved to London in 1905 and took British citizenship in 1907. He met Picasso, Brancusi, and Modigliani in Paris in 1912 and 1913. Epstein was a founding member of the London Group in 1913, an artistic group that included a diverse range of artists, including members from the Camden Town Group, the Bloomsbury Group, and the Vorticist Movement. The group was formed in protest to the perceived conservatism of the Royal Academy and the stagnation of the formerly radical New English Art Club. The Tate Gallery held a retrospective exhibition of Epstein's work in 1953, and the following year the artist received a knighthood.

Like his friend Eric Gill, Epstein advocated artistic tenets fundamental to twentieth century sculpture, including truth to materials, direct carving, and taking inspiration from ancient and non-western "primitive" sculpture that he studied at the British Museum. Throughout his career, the artist experienced much controversy over the reception of his works, which were often characterized by nudity and expressionistic deformity. Some of his sculptures that were viewed by his contemporaries as the most notorious were his sculptures for the façade of the British Medical Association in the Strand (1907–08) and his monumental sculpture for Oscar Wilde's tomb in Père-Lachaise Cemetery, Paris (1910). One of Epstein's best known works dates from his association with the short-lived yet avant-garde English art movement Vorticism, formed in 1913 by Wyndham Lewis. The Vorticists celebrated the dynamism and energy of the modern machine age, while acknowledging the more negative aspects of modern industry, and created angular, semi-abstract, machine-like forms to break with nearly everything associated with the Victorian era. Epstein's association with Vorticism resulted in his Modernist sculpture, *Rock Drill* (1913-16), a powerful and disturbing combination of man and machine that explored his anxieties about the devastation of World War I and the future of the human race in the machine age. The artist wrote regarding this sculpture,

> My ardor for machinery (short-lived) expended itself on the purchase of an actual drill, second-hand, and upon this I made and mounted a machine-like robot, visored, menacing, and carrying within itself its progeny protectively ensconced. Here is the armed sinister figure of today and tomorrow. No humanity, only the terrible Frankenstein's monster we have made ourselves into.[110]

Over the course of his career, Epstein's artwork maintained a focus on several themes including mortality, motherhood, virility, and a celebration of the human body. Epstein's modeled portrait busts were created in a fluid impressionistic style while his carvings exhibit his love for ancient and "primitive" sculpture. While Epstein's contemporaries mocked many of his monumental sculptural creations, they are now better understood and appreciated as powerful expressions of his sensual and often deeply religious vision.

Benaiah, c.1930-32

Epstein's beautiful watercolor painting *Benaiah* evinces the artist's superb mastery of a wide range of media. In 1932, Epstein exhibited fifty-four visionary *Illustrations to the Old Testament* at the Redfern Gallery in London. The series included images of well known Old Testament patriarchs such as Noah and Moses, as well as the lesser known warrior Benaiah. The subjects that Epstein selected for the exhibition at the Redfern Gallery included (not exclusively) the following works: *Abraham*; *Absalom the Pretender Seated on the Throne*;

Jacob Epstein (1880-1959)
Maquette for Madonna and Child, 1950
Lead and brass wire, 13.75 inches (height)

Absalom with David's Concubines; Absolom's Pillar; Adam and Eve; Babylon I; Babylon II (referring to the tower of Babel and the idol of the Golden Calf); *Benaiah; Billah; David and Abishag; David Dancing; David Playing his Harp to Saul; God Blessed the Seventh Day; Isaac; Jacob and the Angel; Jael and Sisera; Jezebel; Joash on the Throne; Judith and Holofernes* (a subject taken from the Book of Judith, a deuterocanonical book of the Old Testament, and not included in the Jewish scriptures); *Messenger for the Creation* (similar to *The Spirit Moving on the Waters*); *Moses Beside an Altar; Moses and the Ethiopian; Moses on Mount Sinai; Noah Family Group; Patriarchal Group* (perhaps Jacob and his sons); *Solomon's Court; The Spirit Moving on the Waters; Sun God* (a subject perhaps referring symbolically to Genesis 1:3, "And God said, 'Let there be light,' and there was light"); *Three Heads* (perhaps a generic family unit from the Old Testament, or perhaps a drawing of *Lot and his Daughters*); *To Divide the Light from the Darkness; Vision of Ezekiel; Vision of Jacob;* and *Women Laughing by the Nile* (an unclear narrative reference).[111]

Epstein's Jewish heritage may have sparked his fascination with these Old Testament narratives. The artist described in his *Autobiography* how, when working in his studio close to Epping Forest in 1931, "I made a series of drawings for the Old Testament. I became so absorbed in the text and in the countless images evoked by my readings, a whole new world passed in vision before me. I lost no time in putting this upon paper."[112] The artist also wrote in a letter to Kathleen Garman, who more than thirty years later was to become his second wife, "It is raining all the time. I have nothing to read except an old Bible. I keep reading Genesis and have made some drawings."[113]

Epstein took the subject for *Benaiah* from 2 Samuel 23:20-23, which discusses Benaiah as one of King David's mighty warriors:

Benaiah son of Jehoiada, a valiant fighter from Kabzeel, performed great exploits. He struck down Moab's two mightiest warriors. He also went down into a pit on a snowy day and killed a lion. And he struck down a huge Egyptian. Although the Egyptian had a spear in his hand, Benaiah went against him with a club. He snatched the spear from the Egyptian's hand and killed him with his own spear. Such were the exploits of Benaiah son of Jehoiada; he too was as famous as the three mighty warriors. He was held in greater honor than any of the Thirty, but he was not included among the Three. And David put him in charge of his bodyguard.

Epstein's watercolor *Benaiah* (signed by the artist at the lower right) depicts the dramatic moment when the great warrior is killing a lion with his club. Benaiah is depicted with a powerful body, strong arms, bulging calves, articulated pectoral muscles, and daunting stance. The strong, forceful figure of Benaiah takes up almost the whole length of the paper and appears to be in the act of punching the lion. The artist used incredibly active lines of the pencil to depict the fighting lion and to add detail to Benaiah's chest, thighs, and the garment around his waist composed of leaves or animal skin. While the eyes of the lion are hidden, making the animal an anonymous fury, Benaiah's large oval eyes with their empty pupils and calm concentrated gaze stare directly at the viewer. The fighting warrior's left leg comes towards the viewer, breaking the picture plane and entering the viewer's space. Throughout his career, Epstein preferred to depict figures from the front or in profile, irrespective of the medium (also seen in his *Maquette for Madonna and Child* of 1950). Benaiah's long hair and act of subduing a wild animal suggest a visual parallel with the figure of Samson and his triumph over a young lion in Judges 14:5-6. In *Benaiah*, the lion's body is partly cut off by a horizontal brushstroke, suggesting its fall into the pit mentioned in the passage in 2 Samuel. Burgundy blood spills in a stream

Jacob Epstein (1880-1959)
Benaiah, c.1930-32
Watercolor and graphite on paper, 23 x 18 inches

from the lion's mouth, the artist exploiting the liquidity of the medium of watercolor. The brilliant orange of the lion contrasts strongly with the darker outlines of Benaiah's body. The artist's use of graphite in the figure of the lion captures its curly coat, taut muscles, raised paw, extended claws, and sharp, jagged teeth, with the rest of its body simply blocked in. Epstein added these graphite lines after applying the watercolor to the paper, identifying the graphite lines as enhancements to the artwork, rather than as initial outlines of forms in the composition (which the artist includes as well). A simple flat background pushes all of the action to the foreground, with three trees (created with minimal broad brushstrokes) suggesting a forest setting. The simple background combined with a limited palette of colors places the focus on the tension between the figures and on the fury of the defeated lion.

Benaiah is a wonderful example of the astonishing visual expression that twentieth century British artists achieved in watercolor painting. While the medium of watercolor is perhaps best known for eighteenth and nineteenth-century works by famous masters such as J.M.W. Turner, *Benaiah* demonstrates watercolor's appeal to twentieth century artists. Epstein exhibited watercolor's ability to appear light and transparent as well as heavy and opaque through utilizing wet-on-wet as well as wet-on-dry techniques. The artist's quick application of watercolor can be seen in the drips and pools of pigment on the tree branches on the right. Epstein's bold lines and powerful forms break with past watercolor techniques, while affirming his position as one of the greatest modern exponents of the medium.

While Epstein's contemporaries may have been taken aback by much of his sculpture, the artist was able to claim from an early stage that "I could always sell my drawings,"[114] and indeed his series *Illustrations to the Old Testament* helped to supplement his income as an artist.[115] The Redfern Gallery sold the watercolors for twenty guineas each, and the catalogue stated that all copyrights were reserved to the artist, pos-sibly indicating that the artist was planning on publishing them. Unfortunately, Lady Epstein (Kathleen Garman), later wrote that all of the works "sold immediately and became so dispersed that when later on someone wanted to publish them with the text it was thought to be too great a task to trace all the owners and collect them again for reproduction, so the idea fell through."[116]

However, although Epstein's *Illustrations to the Old Testament* "sold immediately" during their exhibition at the Redfern Gallery in London in 1932, it is vital to recognize the anti-Semitism that Epstein, as a Jewish artist in interwar England, experienced in creating and exhibiting these works. In his *Autobiography*, originally published in 1940 (only three years after the *Degenerate Art* exhibition organized by the Nazi Party in Munich in 1937), Epstein wrote an extended reflection upon the reception of the *Illustrations to the Old Testament* eight years earlier by viewers and critics:

> When I exhibited them it seemed that I had again committed some kind of blasphemy, and countless jibes were forthcoming. There is an element in all countries which would suppress the free artist, kill original thoughts, and bind the minds of men in chains. In England, happily, this retrograde element does not make much headway. Our totalitarians are still in the minority. Daumier was imprisoned for his political cartoons, Courbet fined heavily for his partisanship in the Commune; and in many countries artists and writers who are suspect are banned or exiled. Today, no artist must imagine that he's back in the happy-go-lucky days, when he was looked upon as a rather irresponsible fellow, and allowed to go his way. Oh, no! The artist today is part of the culture-Kultur it is rather, part of the consciousness of the nation, with a responsible mission towards the race. Whatever he paints or sculpts cannot be separated

from the body-politic. He is to be called to account. A bureau, a commissar, or gauleiter must look after his activities, and after a day's work he had best review what he has done and see that it is in line (*gleichschaltung*) with the right political and social ideology. Sculpture in the future may well be made under the supervision of guards with rifles and machine guns.

Postscript

I remember that soon after I first wrote the above I came across an article in a Spanish paper, *A.B.C.*, November 22nd, 1939, praising the Franco system of compelling political prisoners to work for the state as part of the national industry—in reality, a system of organized slavery. This is the sentence which most impressed me: "A great number of shops have been established in the jails and as a model can be pointed out that of Alcala de Henares, with carpentry and printing shops, and the sculpturing of religious images which are really beautiful."[117]

While an extended examination of contemporary responses to Epstein as a Jewish artist is beyond the scope of this exhibition catalogue, it is imperative to place his artwork within its artistic and social context of interwar England and to recognize the anti-Semitism that he experienced. Many critics wrote about a perceived controversial "racial aspect" of Epstein's artwork. The art critic for *The Times* on February 23, 1932, wrote that where Epstein's "work differs from that of other Bible illustrators is in its strongly racial flavor." While William Gaunt, writing a review in *The Studio*, recognized that Epstein was being made "the scapegoat of the whole modern movement" (using an Old Testament term, "scapegoat") and that it was dangerous to relate Epstein's sculpture and drawings "to a multiform prejudice, racial, religious and even political," Gaunt identified Epstein's purpose in creating his *Illustrations to the Old Testament* series to depict "the racial epic

of the Jews as it emerges from the historical and legendary books of the Old Testament."[118] A year later, Eric Underwood rejected Epstein's work for his *Short History of English Sculpture*, because he claimed it was "wholly exotic" and not British, writing "Epstein's ancestry and early environment go far to explain his art. This is essentially oriental…Epstein is with us but not of us."[119] Epstein had first experienced these references to his "racial art" in 1920, in response to his life-size *Risen Christ* (1917-19), a subject foundational to the history of Western art, and that, whether consciously or not, drew attention to the artist's Jewish identity. Art critics claimed that the work expressed Epstein's outsider status and challenged moral and aesthetic values, using terms such as "archaic," "barbaric," "Oriental," "Egyptian," "aesthetic," and "revolutionary."[120] However, a defender of Epstein's work, John Middleton Murray, instead asked whether there was "any chance of insulting a nation if we say that it is, after all, a Jewish Christ and not the Christ of the Western World."[121] The artist himself replied,

> You have only to read the Gospels to see that the sweet lovable Christ is but one of many aspects of that wondrous Personality. There was intellect as well as sentiment; power and a rare sense of justice as well as compassion and forgiveness. The passivity and weakness have been too much emphasized. The sterner elements are repressed or lost sight of…He inspired fear as well as devotion. He drove the moneychangers out of the Temple. He could blaze out in righteous wrath, and voice justifiable indignation. [It] is this complex Christ that I have endeavored to body forth.[122]

Both Epstein's *Illustrations to the Old Testament* as well as his *Risen Christ* reveal the artist's desire to create powerful and personal images and to thoughtfully challenge past artistic models for biblical themes.

Maquette for Madonna and Child, 1950

Maquette for Madonna and Child is a small model for one of Jacob Epstein's significant large-scale public religious sculptures, *Madonna and Child* (1950-52, Cavendish Square, London), his first religious commission. Epstein created the *Madonna and Child* for the Convent of the Holy Child Jesus. During the Second World War, bombing damaged the Convent, which was located in three Palladian houses in the middle of the north side of Cavendish Square (now owned by the King's Fund, and located just behind the John Lewis department store in Oxford Street). The houses had been built c.1770 and were separated by a lane (Dean's Mews). The Convent commissioned the architect Louis Osman to rebuild the house that was destroyed in the war, and to create a bridge across the mews to join the houses. The bridge would also complete the view that runs north from St. George's, Hanover Square, across Oxford Street, to Dean's Mews on the north side of Cavendish Square. Osman designed a windowless bridge set back from the square to curve between the two buildings. The bridge is framed by Corinthian pilasters, and topped by a balustrade.

Osman wanted to have a large-scale sculpture attached to the plain supporting wall of the bridge so that it would become the focal point of the surrounding architecture, writing,

> The whole of the recession between the two buildings would really form a niche. The sculpture should not recede again but must project away from the wall over the arch. This immediately gave me an interesting plastic form and also suggested a religious subject in which it was appropriate that the sculpture should not rest on anything but should have levitation of its own, not being concerned with gravity...to my mind the idea of this not wanting to rest on anything had a devotional significance. It was made of the heaviest thing one could find, lead, but it did not require to rest on anything. It had no regard for gravity. To my mind that was a religious conception in itself.[123]

Osman's idea was a novel one; instead of relying on a work in low relief, he commissioned a fully modeled piece, the architect pronouncing in a lecture to the Royal Society of Arts in 1957, "If the sculpture is important it must be given its head, like the role of a soloist in a concerto; the orchestra being like the architecture, with the solo instrument speaking its poetry; related but clear and independent."[124] The architect described the opportunity to commission an artist to create a major religious sculpture for this site as "rather as though it were ordained."[125] Osman commissioned Jacob Epstein to create a sculpture (without stating the subject matter) for this unconventional site using lead from the bombed roof of No. 12. With Epstein's controversial reputation as a British sculptor, Osman's commission was a daring one. However, the architect wrote of Epstein,

> I was convinced that the only person who could possibly achieve the work with all the many qualities required was Epstein. I was convinced that the work should be modeled and not carved. His wonderful gift of modeled form had not been made use of by any architect before. He was a man of seventy, but previously had only been employed to do carved work in relation to a building...Epstein had not in my opinion been used properly...Therefore I was quite determined that I was going to get Epstein to do this work. There was no money or commission or authority whatever.[126]

The architect compared Epstein's skill in creating modeled sculpture with that of Donatello, writing that Epstein's sculpture was "linked with that of Donatello, right in the main stream of Palladian art and Palladian theory. I also knew him to be an artist deeply concerned with religious themes."[127]

Like the modern Palladian architecture Osman created for the convent, the architect wrote that "I was determined too that the sculpture should have equal affinity with the past while not being in any way a mere copy."[128]

Osman commissioned Epstein without telling the order of nuns of his choice of artist, although the nuns had already discussed with Osman their intention of commissioning a Catholic sculptor to create a figure of the Madonna and Child, when their funding would allow. Epstein was eager to accept this commission, his first commission in twenty years to ornament a building, even though the project funding was not guaranteed. According to Osman, Epstein was delighted with the prospect of this commission: "The idea of producing a work of religious art linking and forming an integral part of a work of architecture thrilled him."[129] Epstein wrote in his *Autobiography*, "I gladly seized this opportunity to design and execute a work of this nature with such a great subject and fitting site."[130] The only conditions associated with the commission were that the sculpture be modeled and cast in lead.[131] Epstein created his *Maquette* in only a week, apparently independently choosing the subject of the Madonna and Child, and resulting in, according to the Catholic periodical *Studies*, "the first time since the Reformation that a monument representing Our Lady and the Christ Child has ever appeared in London in so public a space."[132]

The *Maquette* allowed Epstein to state his intentions for the final 13-foot-high magnificent and emotionally moving sculpture. The artist created a sculptural group with a vertical lozenge-shaped composition that would soar wonderfully on the empty wall. In the *Maquette*, Epstein based the Madonna's head on Kathleen Garman, his long-term mistress who later became his wife in 1955; his wife Margaret (Peggy Dunlop), whom he had married in 1906, had died three years earlier in 1947.[133] In the *Maquette*, the artist used the modeled approach in sculpture to emphasize the flatness of the figures, giving all

focus to the front of the sculpture because of its final position within the architecture. Mary's body provides a flat background to highlight Christ's head. Her face is alive with an eager expression and her mouth is open as if in the middle of uttering an expression of joy. The robes wrapped around Mary's body suggest the clothes later wrapped around Christ's body in the grave. Epstein depicted the Christ Child as a young boy, rather than as an infant. His arms are extended in a gesture of embrace that also mirrors the position of the Cross, visually foretelling His Crucifixion, while His expression is full of quiet joy and serenity. Long verticals dominate the *Maquette*, with Christ's arms providing the only horizontal focus, giving all attention to the shape of the Cross. The artist depicted a modern image of Christ with His slender body wearing trousers, and revealed a love of patterning with the pairs of feet and folds of the garments. The golden color of the halo and the dark lead of the bodies and garments provide a beautiful contrast of materials in this deliberately un-classical composition. The softness of the lead material gives the viewer a sense of contact with the artist, enabling one to almost see the artist's fingerprints.

The architect wrote regarding Epstein's *Maquette*,
In a week Epstein produced a beautiful strong sketch which interpreted all that I required of the sculpture in relation to my design. I also found that it surpassed beyond measure what I had imagined as sculpture, and I was quite convinced that here was a masterpiece. I felt that it just had to be got through, being something that had not really existed in England since the Reformation, but how to put this over to a community of nuns, very intelligent and very learned — they could not but be prejudiced — I did not quite know. I showed them the sketch which Epstein had produced. I would not tell them who had done it. I said that it interpreted all that I

required architecturally and was a greater work than ever I could have hoped for, but they were the judges "devotionally."[134]

Although stunned by the swift arrival of a study for a sculpture they had not commissioned, the nuns were impressed with Epstein's *Maquette for Madonna and Child* and approved the commission without knowing the name of the sculptor and committed £500 towards the commission. The Arts Council sent a check for £500 accompanied by a letter to the Convent, congratulating them on their choice of artist. On learning the name of the sculptor, the nuns were alarmed at the choice and withdrew approval of the sculpture. The drama of the situation was intensified with the architect consequently threatening to resign from the project. The architect recollected,

I was convinced that if the nuns met Epstein and discussed the matter with him they might agree. I was also sure that, if they met Epstein and discussed it, they themselves would have an influence on him, and would make their own contribution. I felt that his original sketch had a certain slight feeling of antagonism. I thought this had probably resulted from the fact that every time he started any monumental work he could not but help seeing in the daily papers lurid stories of what he might produce. I did not see how, after reading such stories, any artist could go into his studio and work properly, and I was determined that if he was going to do this work he should be sheltered from all that kind of thing…

I explained to the nuns that, if they did not try to tell Epstein what shape he should make something or how the hands or faces should look but instead spoke of their beliefs and their ideas, they would influence him. I think they did. They too noticed the antagonism of the sketch which was alien to their conception. A paper has said that it cannot under-stand how Epstein could have produced a work which so exactly interpreted Catholic devotional thought. I feel that the nuns in Cavendish Square had very considerably influenced what was produced, in just the right way.[135]

The Mother Superior and one of the nuns from the Convent subsequently visited Epstein's studio and studied the plaster cast Epstein had prepared for the final sculpture. After spending time alone studying the plaster cast, the Convent requested that Epstein give the Madonna a more contemplative face rather than the more outward-looking face of Kathleen in the *Maquette*. Earlier in 1950, Epstein had met an Italian pianist, Marcella Barzetti, and the artist was enraptured with her introspective face, immediately creating a modeled sculpture of her head. In accordance with the nuns' request, Epstein adapted his head of Marcella for the dignified Madonna, with her head covered with a mantle. The nuns called Epstein before the Convent community and "catechized" him on his approach to the subject of the Madonna and Child before giving their final approval.[136]

In the final monumental sculptural group, cast in lead by A. Gaskin of the Fine Art Bronze Foundry, Mary looks down solemnly and gently with a meditative and introspective expression in the direction of Jesus. She opens both of her hands beside the Christ Child as if in readiness to protect Him. This emotionally powerful and complex work emphasizes the parental relationship between the Mother and Child. Despite the rather unsettling beginning to his work, Epstein recorded that "most [of the nuns] were thrilled by [the sculpture]. They feel that Epstein has given his work a perfectly right expression and that it is a very great work of Catholic art."[137] A letter from the Convent in January 1952 (the same year Epstein was given a Tate retrospective exhibition) to the Reverend Mother Provincial communicates the sculptor's overwhelming success regarding the final sculpture:

The group presents Our Lady not standing, but poised between heaven and earth…[Her] outward gazing is inexpressibly compelling because the sculptor has succeeded in conveying that it is essentially an inward look, unfathomable in its utter serenity… Our Lady's arms are stretched downwards in a gesture of giving and support, directed Godwards and manwards…The support is delicately yet powerfully indicated by the fact that her hands appear just beneath the outstretched hands of the Holy Child who is poised immediately in front of her, looking straight out over the world facing His Vocation: 'Behold I come'. The Child is more difficult to describe because the artist has subtly conveyed inherence of the divine in the immaturity of a child's body. The Mother stands completed as human person. The Child poignantly reveals that as a man He has still to grow, to experience, to suffer. The foreknowledge of the face pertains to the divine, as does the strength in the poise of the head, the courage of the arms outstretched, the directness of the gaze, the vitality of the hair. Yet the whole visage asks the very human question…What will it avail? And because it is the face of a child, it looks uncertain of the answer. Yet the hands of the sculptor have made this very poignancy into a challenge, and the outcome of the challenge for past, present and future is expressed in the feet of both Mother and Child; they proclaim the reality of the world of the spirit transcending the world of sense, the peace that comes when desire is at rest, the "Consummatum Est" of the task accomplished. One might justly call them the artist's signature.[138]

Before Epstein's sculpture was unveiled to the public, the art critic of *The Times* wrote of it as "an important work of religious art"[139] and Sir Kenneth Clark described it as a work of "arresting beauty and dignity, entirely appropriate to its setting, and…one of the finest pieces of sculpture permanently exhibited in London."[140] T.S. Eliot had visited the foundry when the large sculpture was being cast, and Epstein recorded that Eliot "seemed profoundly impressed" with the sculpture.[141] The sculptural group was unveiled on May 14, 1953, Ascension Thursday, the artist writing that the opening ceremony "seemed to reach back to the days of the Renaissance when the appearance of a new religious work was the occasion for public rejoicing."[142] The sculpture was met with praise by the public, art critics, and the religious community. The artist wrote in his *Autobiography*,

> No work of mine has brought so many tributes from so many diverse quarters. One which particularly pleased me by reasons of its spontaneity was from a bus driver. Halting his bus as he passed the statue he suddenly saw me standing by and called out across the road, "Hi Governor, you've made a good job of it." A less aesthetic but equally spontaneous comment was overheard when the cockney owner of a bedraggled pony and cart halted beneath the statue and observed wistfully to his mate, "Think of that now. A solid lump of lead." Fortunately the statue is suspended about twenty feet from the ground.[143]

The architect was particularly pleased with the sculpture, relating,

> The original sketch did not resemble the work now finished. It had been produced by Epstein to help himself, it was not a miniature replica which was then to be blown up, as with a bicycle pump, to twenty times its size. I had advised the nuns that many people could produce work to small scale but that very few people could transmute that to twice life size without decreasing the feeling and intensity

of the work. I had told them that there were various sculptors who could work to varying sizes but that there were very few who could work to this monumental scale.[144]

In a review in *The Manchester Guardian*, the art critic described the work as "one of the most serious and deeply felt" works by the artist.[145] The English architect and architectural critic Robert Furneaux Jordan praised the sculpture as "beautifully conceived for its position" and "with perhaps Le Sueur's Charles I [in Trafalgar Square] — London's finest post Reformation figure."[146] A critic writing in *The Times* in 1958 called Epstein's sculpture "a masterpiece in which the sculptor's personal power is happily subdued in its purpose and is a most fitting reminder of the existence of a religious building there."[147] The English art critic John Berger wrote a lengthy praise of the sculpture:

> Epstein's Madonna and Child… is one of the most successful pieces of modern public sculpture now to be seen in London…The elongated distortion of their limbs is considered in relation to the perspective from which one views the group. The spread-eagled poise of the figures, a little like that of a bird momentarily held against the wind, aptly expresses the transience of childhood security. Their placing on the wall is so careful that even the sculpturally unsatisfying corrugated-iron treatment of the Madonna's dress seems architecturally justified. In fact…Epstein has *accepted* the sculptural "expectations" of the site and then rightly fulfilled them in an unexpected way.[148]

Many responses from the religious community to Epstein's *Madonna and Child* have been generally overlooked until recently.[149] These responses elaborate how, as a religious work of art, the *Madonna and Child* goes beyond simply being of a religious subject and placed on a religious building, by nurturing a spirit of worship and reverence inside the viewer. The sculptor John Bunting wrote in 1955 in *Liturgical Arts*,

> When the Cardinal-Archbishop of London blessed a sculpture by Epstein, he dedicated it to the service of God. The Church has traditionally exercised this divine blessing, and through this God-given power the Church transforms our actions so that they are "born not of blood or of nature or of man but of God." It is the Church's mission, and such was the Cardinal's mission when he blessed the new statue of the *Madonna and Child* for the Convent of the Holy Child Jesus in Cavendish Square. The blessing was a kind of baptism.

However, Bunting revealed some underlying concerns about Epstein's suitability as a sculptor for a religious commission:

> I do not propose [sic] about the artistic or aesthetic qualities of a work which I admire. There is a problem that made the nuns apprehensive for similar reasons that I wish to consider. It is a problem the Church must face when she cooperates with modern artists. How can a man who is not Christian, let us suppose, produce a Christian work of art?[150]

Nonetheless, another author, writing in the religious journal *Common Ground* four years later, concluded that Epstein was successful in creating deeply felt Christian art specifically because of his religious heritage and artistic vision:

> Somehow this man got at us, and if that is not the function of a prophet, what is?
>
> One of the strangest things about the art of Jacob Epstein was that, as a Jew, he could give us such a magnificent statement of Christian faith….[Go] to Cavendish Square and look around until you see his bronze Virgin and Child, and look in that Child's eyes. This Jewish prophet indeed had things to tell us Christians.[151]

Yet another author concluded that Epstein's *Madonna and Child* was successful as a religious sculpture because it demonstrated "highly acceptable progressions within the realm of traditional sacred art."[152] As these quotes demonstrate, viewers' responses differed widely with regards to how they related Epstein's Jewish heritage to his "suitability" of being an artist of a Christian subject. Indeed, it may be that because of Epstein's adoption of aspects of more "traditional sacred art," the negative and anti-Semitic criticism that had been leveled at his earlier sculptures of biblical subjects, because of their perceived associations with "primitive" and Jewish qualities, were (overall) not directed at his *Madonna and Child*.[153] Epstein's success with the *Madonna and Child* opened up another opportunity for him to create a monumental public religious sculpture. When considering Epstein for a sculptural commission for Coventry Cathedral, the Bishop examined the *Madonna and Child* and proclaimed, "Epstein is the man for us."[154]

MISEREBITVR
SECVNDVM·MVLTI-
TVDINEM·MISERA-
TIONVM·SVARVM

ERIC GILL
1882–1940

A foremost English artist of the first half of the twentieth century, Eric Gill worked as a sculptor, lettercutter, typographic designer, calligrapher, engraver, writer, and teacher. Gill's typeface designs (for example, his Gill Sans, created in 1927 and still in common usage today) had an enduring influence on twentieth century printing. He received his initial artistic training at Chichester Technical and Art School where he developed an interest in lettering. In Chichester, he also was captivated by the Anglo-Saxon and Norman stone-carvings in the Cathedral. Gill moved to London in 1900 and took classes in practical masonry at Westminster Institute and in writing and illumination at the Central School of Art and Design. In 1906 he began teaching writing, illumination, monumental masonry, and lettering. Trips to Rome, Bruges, and Chartres Cathedral in the early 1900s increased his interest in stone-carving and served as important and lasting sources of inspiration. Gill's work was informed by a multitude of sources, including French and English Medieval ecclesiastical sculpture, Egyptian, Greek, African, and Indian sculpture, Byzantine, Assyrian, and Archaic styles, and the Post-Impressionism of Cézanne, van Gogh, and Gauguin. Gill's inclusion in the Second Post-Impressionist Exhibition (organized by Roger Fry and held from 1912 to 1913), combined with his conversion to Catholicism in 1913, led to his commission to create fourteen Stations of the Cross for Westminster Cathedral from 1914 to 1918. The Catholic Church subsequently became his most significant patron. Gill's Catholic faith inspired his creation of numerous religious works throughout his career, including a war memorial for the University of Leeds and a sculpture for the League of Nations building in Geneva. Gill's skill in stone-carving was in great demand after the First World War when he received commissions for headstones and private and public memorials.

Gill and his family moved to Sussex in 1907, where he established and led the Guild of St. Joseph and St. Dominic, a Catholic artistic community dedicated to the community role of the artist. In addition, Gill became a member of the Third Order of St. Dominic in 1918, a lay order affiliated with the Dominican Order, which tied his life and work closely to a religious structure. In establishing the community of the Guild of St. Joseph and St. Dominic, Gill was influenced by William Morris, the founder of the Arts and Crafts Movement. Members of the Guild desired to bring their lives and work away from the materialism and commercialism of Modernism and nearer to God. The Guild included artists and printers, and promoted skills in engraving, woodcutting, calligraphy, weaving, silverwork, stone-carving, carpentry, building, and printing. The St. Dominic's Press was established as part of the community in 1916, and printed some of the earliest writings and engravings created by Gill. In creating this community of artists, Gill expressed his longing for a return to the role that the artist enjoyed in Medieval Europe, writing,

> The artist…is the skilled workman…The idea of work, the idea of art, the idea of service and the idea of beauty were and are, in spite of our peculiar century, naturally inseparable; and our century is only peculiar in that we have achieved their unnatural separation.[155]

Gill wrote further regarding the role of the artist, commerce, and religious art:

> All the best art is religious. Religious means according to the rule of God. All art that is godly, that is, made without concern for worldly advantage, is religious. The great religions of the world have always resulted in great artistic creations because they have helped to set man free from himself — have provided a discipline under which men can work and in which commerce is subordinated.[156]

From 1924 to 1928 Gill and his wife endeavored to recreate the Sussex community at Capel y Ffin, a deserted

Eric Gill (1882-1940)
Christ the Sacred Heart, 1935-36
Bath stone with painted highlights, 84 (height) x 19 (width) x 10 (depth) inches

monastic building located in the Black Mountains of Wales. However, the impracticality and remoteness of Capel y Ffin convinced the Gills to establish an additional residence nearer to London.

Gill was friends with many significant early-twentieth century British artists, such as Roger Fry, Augustus John, William Rothenstein, and, most importantly, Jacob Epstein. Gill taught Epstein the technique of direct carving, a technique that prevailed in the Medieval era. In direct carving, the artist carves directly in the stone, rather than employing a craftsman to copy from a plaster model. Subsequently the sculptor Henri Gaudier-Brzeska learned the same methods through Epstein's work. Gill wrote regarding his direct carving:

> Without knowing it I was making a little revolution. I was reuniting what should never have been separated: the artist as man of imagination and the artist as workman… Of course the art critics didn't believe it. How could they? They thought I was putting up a stunt — being archaic on purpose. Whereas the real and complete truth was that I was completely ignorant of all their art stuff and was childishly doing my utmost to copy accurately in stone what I saw in my head.[157]

Gill and Epstein worked together on several projects. Gill worked on the lettering for Epstein's tomb of Oscar Wilde, and they planned on collaborating on a large outdoor Temple of the Sun (never executed) which Gill described as "a sort of twentieth century Stonehenge" of huge standing stones of nude figures.[158]

Design for Christ the Sacred Heart, Ratcliffe College, 1935
Christ the Sacred Heart, 1935-36

Christ the Sacred Heart (1935-36) is a beautiful religious sculpture that Eric Gill created during the later stages of his career for Ratcliffe College, an independent Catholic school in Leicester, England. Gill created *Christ the Sacred Heart* with a

companion sculpture, *Our Lady Immaculate* (to whom Ratcliffe College is dedicated). According to noted Gill scholar Judith Collins, Father O'Malley of Ratcliffe College commissioned the two sculptures in February 1935. C.R. Leetham, the author of the College's history (written in 1950) and past President of the College, stated, however, that the statues were commissioned through "the piety of the School and the enthusiasm of Fr. Horgan…to be placed in the Lady Cloister."[159] Gill visited Ratcliffe College on March 14, 1935 to discuss the statues and their future location. On August 15 and 16 of that year he made several preparatory drawings for the two sculptures.[160] Gill reviewed the drawings for *Our Lady Immaculate* on October 29 and 30, 1935. He carved the two statues in only a few days in January of 1936: *Christ the Sacred Heart* from January 13 to 20, and *Our Lady Immaculate* from January 20 to 23. He carved the inscriptions on January 24, and sent the two sculptures to the college on January 27. Gill attended the blessing of the two sculptures by the Bishop of Nottingham on February 13 at the College.[161] The statue of *Christ the Sacred Heart* was originally located in the south half of the east passage of the Cloisters at Ratcliffe College, while *Our Lady Immaculate* was located in a niche along the cloister between the main entrance and reception. Both sculptures are made of Bath stone (a type of limestone) with red pigment added. They are both nearly exactly the same height, width, and depth, with *Our Lady Immaculate* measuring eighty-three (height) by nineteen (width) by nine (depth) inches, including the plinth.

Both of the sculptures have inscriptions on their bases that correlate to their religious subjects. *Christ the Sacred Heart* has an inscription on the base that reads "MISEREBITVR/ SECVNDVM•MVLTI-/TVDINEM•MISERA-/TIONVM •SVARVM" ("He will have mercy according to the multitude of his mercies.")[162] This inscription is taken from Psalm 50:3 (Vulgate) "Miserere mei Deus, secundum magnam misericor-

diam tuam" ("Have mercy on me, O God, according to thy great mercy") which correlates to Psalm 51:1 (NIV) "Have mercy on me, O God, according to your unfailing love." The inscription on the sketch for this sculpture, *Design for Christ the Sacred Heart, Ratcliffe College*, is only slightly different and reads: "MISEREBITUR • SECUND/MULTITUDINEM • MISE/RATIONEM • SUARUM." The inscription on the base of *Our Lady Immaculate* reads "MARIA/ SINE LABE ORI-/ GINALI CONCEPTA/ O.P.N. ['ora pro nobis']" ("Mary, conceived without original sin, pray for us"). The sculpture depicts the Virgin Mary standing on a defeated dragon that represents Satan. Red pigment colors the letters of the Latin inscription as well as Mary's crucifix brooch, which fastens her mantle.[163]

On the sketch, *Design for Christ the Sacred Heart, Ratcliffe College*, Gill wrote "The Sacred Heart. (For Ratcliffe Coll.)," indicated its scale as "1/8 full size," and signed it "EG 16.8.'35." The sketch of the sculpture has a beautiful organic quality. Gill has greatly simplified the folds and curves of the drapery and gives the figure a flexible, tall stature, which imparts a more Gothic feel than the Romanesque qualities of the finished sculpture. In both the sketch and the finished sculpture, the standing figure of Christ points to His heart with His right hand, and with His left embraces a leafing branch that symbolizes Christ's sacrifice on the Cross as the tree of life. Gill gives the leaves on the branch a beautiful abstraction and includes the branch as more than merely a source of physical support for the sculpture.

In the finished sculpture, *Christ the Sacred Heart*, Gill imparts greater Romanesque qualities by making the face of Christ blockier (in accordance with the artist's belief in being true to the materials of the stone) and by using thicker lines and fewer folds in the garments to give a feeling of stability. Christ wears simple garments with a rope tied as a belt around His waist. His robes go down past His ankles, as opposed to

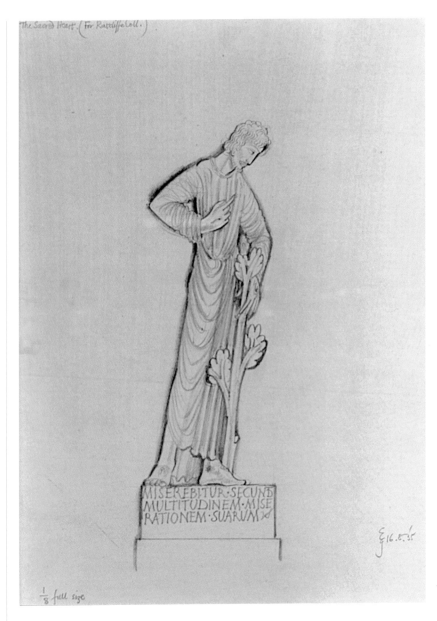

Eric Gill (1882-1940)
Design for Christ the Sacred Heart, Ratcliffe College, 1935
Graphite on paper, 9.75 x 7.25 inches

in the preparatory sketch. The long clear lines of Christ's fingers and robes focus all attention on Christ's action of pointing to His Sacred Heart and give a feeling of rest, peace, and stability. Christ's oval eyes and slender nose are reminiscent of early Greek statuary, while the beautiful wavy lines of His hair and beard reveal Gill's love of patterning. In certain places on the stone, such as the plinth beneath Christ's feet, it is possible to see the diagonal pattern created by Gill's chisel. Red pigment highlights the stigmata on Christ's hands and feet, and draws a visual connection to the words on the plinth which are also highlighted with red pigment. Because the sculpture was intended to be placed in a niche facing the cloister at Ratcliffe College, all detail is focused on the front rather than the back of the sculpture.

Christ the Sacred Heart and *Our Lady Immaculate* were commissioned as companion sculptures to celebrate the historical, theological, and spiritual links in Catholic devotions to the Sacred Heart of Jesus and the Immaculate Heart of Mary, both key elements of Catholic teachings. The Sacred Heart is one of the most famous religious devotions to Jesus' physical heart as the representation of His divine love for Humanity. It emphasizes the love, compassion, and long-suffering of the heart of Christ towards humanity and the Church in the Eucharist; His love for God the Father; and His love for Mary the Mother of Christ.[164] The Immaculate Heart of Mary is a devotion that refers to Mary's interior life and the beauties of her soul. It focuses on her joys, sorrows, virtues, love for God, and submission to His will; her maternal love for her Son; and her compassionate love for all people.[165] Throughout his career, Gill made many sculptures of the Virgin Mary, both with and without the Christ Child. In his sculptures of the Virgin Mary and the Christ Child, Gill emphasized the tender bond between Mother and Son and often presents Mary symbolically as the Church, thus representing the bond of Christ and the Church.

Although Gill's sculptures of *Christ the Sacred Heart* and *Our Lady Immaculate* both beautifully exemplify the artist's skill in direct carving as well as his tenderness and personal devotion towards the subjects, the past president of Ratcliffe College, President Leetham, recalled, "There was a great outcry for and against, and many of the unsophisticated continue to regret the homely statue of Our Lady that now adorns the Study."[166] Ironically, later in 1936, the year in which Gill delivered these works to Ratcliffe College, the two sculptures actually helped to calm fears regarding the artist's other sculptures that were considered much more risky in subject and technique. The private secretary of the Archbishop of Westminster Cathedral asked Gill to send him a photograph of *Christ the Sacred Heart* to show to the Archbishop in order to demonstrate that "your 'pagan' work is so only for lack of opportunity of expressing yourself in more Christian subjects and atmospheres. Clerical circles are, I'm afraid, grossly inartistic very often."[167] While Gill's artistic approach to the religious subjects of *Christ the Sacred Heart* and *Our Lady Immaculate* may appear to viewers today as respectful, devout, and almost entirely uncontroversial, Leetham's recollection is a helpful indicator of Gill's novelty in using direct carving for religious sculptures intended for religious settings and the perceived shocking simplification of the sacred figures.

Design for the Church of St. Peter the Apostle, Gorleston-on-Sea, 1938

Gill's design in 1938 for the brick church of St. Peter the Apostle at Gorleston-on-Sea, Norfolk (near Yarmouth), evinces the artist's architectural expertise. The Church of St. Peter the Apostle was Gill's only ecclesiastical architectural commission, and is one of his most important works from his later years and one of the gems of twentieth century English church architecture. The small drawing *Design for the Church of St. Peter the Apostle, Gorleston-on-Sea* is a beautiful depic-

Eric Gill (1882-1940)
Design for the Church of St. Peter the Apostle, Gorleston-on-Sea, 1938
Graphite on paper, 7.5 x 6.5 inches

proposed church of S. Peter Ap. Gorleston on sea.

EG 11.6.38

tion of this church that is planned around a central altar.[168] Gill created this drawing only two years before his death in 1940. The small dimensions of this drawing give the work an intimacy that allows the viewer to focus on the few simple lines that compose the church. Along the bottom of the drawing, Gill wrote, "proposed church of S. Peter ap. Gorleston-on-sea" and signed it "EG 11.6-38." *Design for the Church of St. Peter the Apostle, Gorleston-on-Sea* is an invaluable tool in considering how Gill approached creating a sacred space. Fiona MacCarthy, in her biography of Eric Gill, summed up Gill's intentions: "He seized on the project as a long-awaited opportunity to put into practice a multitude of related ideas about building, preaching, singing, church history, world politics, all burgeoning out from the elementary question: What is a church?"[169]

The commission to design the Church of St. Peter the Apostle, Gorleston-on-Sea, by Father Thomas Walker, the Parish Priest and a friend of Eric Gill, gave Gill, then at the height of his fame, the opportunity to put his architectural ideals into practice, with the assistance of a local architect. Gill was commissioned to design a 300-seat church, including the altar and sculpture, the whole costing £6,775. The first Catholic Church since the Reformation had previously been established in Gorleston in 1888 in a converted malthouse, and the new church building provided needed room for the growing congregation. The site for the new church had been purchased twenty-five years earlier. The church building was funded with income from a trust established by a benefactor in 1908. The contractors for the work were the Yarmouth firm of H. R. Middleton & Co., and Gill visited the site to check progress during construction, wearing his distinctive standard working clothes of a monk-like tunic. Gill's drawings of the exterior of the church, including *Design for the Church of St. Peter the Apostle, Gorleston-on-Sea*, depict a plain building with a traditional cruciform plan, a steeply angled roof, and

plain pointed windows. Pointed arches are used throughout the church, with no lintels spanning doors or windows, and the arches spring directly from the floor, instead of being supported on piers. The intersecting and crossing of the arches creates a high drama and soaring vistas. The solidity of the church design suggests Gill's early fascination with Anglo-Saxon and Norman stone-carvings. Gill designed the fresco in the tower and it was painted by his son-in-law.[170] Gill designed the low-relief sculpture of St. Peter over the porch and lettered the foundation stone. The holy water stoups, piscina, font, altars, and crucifix over the altar were made in Gill's workshops. Fourteen black squares set in the plain red-tiled floor of the arcades mark the original positions of the Stations of the Cross, which were brought from the old Catholic church in Gorleston. The current Stations of the Cross were designed by Gill and painted by his son-in-law.

Gill wrote extensively regarding his design for the church, giving insight into his design process and his hopes and fears for the finished building. Gill described the church in a letter of 1938:

> It is an interesting plan with crossed arches to make an octagonal central space…The Church will be very plain and small — no ornaments except perhaps a figure of St. Peter on the outside and a large Crucifix hanging over the altar. One good thing about this job is that being built in a country place, there is no need to have recourse to mechanical town methods. It will be just a plain building done by bricklayers and carpenters, though I suppose the Rector will insist on central heating and electric light. I don't mind if he does — if you build a good house for a man and he insists on putting in the telephone, that is his affair.[171]

This letter expresses Gill's determination that the Church of St. Peter the Apostle be a plain building built by

local workmen and carpenters, avoiding industrial products, while compromising on secondary issues such as electric light and heating. Gill continued his description and confessed to some self-doubt in a subsequent letter written in 1939:

> God alone knows if it will be a "success". Anyway it's free, I think, from architectooralooralism [sic] and it's free, apart from electric lighting (which I can't refuse to install) & heating (which, again, I can't resist — tho. I think it's a shocking waste of money), apart from these it's free from industrial products. Just bricklayers', tilers' & carpenters' work....Because although I *know* it will be good in some ways (& those not the least important) I think it quite likely that it will be gawky & amateurish. (If we ever get another church to do, we shall have learnt a lot from this one...) and it is certain to be judged by all sorts of false canons.[172]

This letter reveals Gill's choice of a quiet red brick for the church, as opposed to modern concrete, in order to give preference to local craft over what he described as "mechanical town methods." Another letter from 1939 also expresses Gill's self-doubt at accomplishing all of his architectural and spiritual goals in the church's design:

> there are many things we would do differently next time — for instance, the east, south and north windows are too big and too low and the panes of glass too big; the red-tiled steps of the Altars are not satisfactory; the little Crucifix over the main Altar is not really a Christian work though it says the right word, I think; the Crucifix (Anthony F's) over the Lady Chapel Altar is a failure and will be replaced by another. I hope you like Denis' paintings and the big Crucifix, also Anthony Foster's carving on the porch, and I hope you will like the big crossed arches.[173]

One particularly important aspect of the Church of St. Peter the Apostle is the centrally positioned altar in the middle of the congregation under the tower, a radical design concept which Gill described in 1939 as the "central feature & whole raison d'être of the building."[174] Gill also wrote regarding the importance of the altar,

> It is of course actually impossible to exaggerate the mysteriousness, but it is easily possible to under-do the evangelical; and one of the ways in which the loss of contact is most apparent is the tradition which has grown up and placed the altar away from the people at the East end of the church.[175]

Gill had earlier stated his strong views regarding the critical nature of the centrality of the altar in a paper titled *Mass for the Masses* (before receiving the Gorleston-on-Sea commission), writing that a central organization was necessary to move away from "the mystery mongering of obscure sanctuaries separated from the people."[176] In *Mass for the Masses*, he advocated at length for the altar's centrality, both ideological and physically:

> The altar is a place of sacrifice, on which something is offered and made holy: this is the Christian idea of a church; where there is an altar there is a church....
>
> Now there is nothing whatever in the nature of an altar that implies that it should be anywhere but in the middle. It began as a table around which people sat and partook of the consecrated bread and wine. It remains that thing. But we may go further and say that not only is the altar a table, but it is a representation of Calvary — the place upon which Christ, *the* Bread and Wine, offered Himself. Hence the congruity of the crucifix on or above this table, heraldically to designate the altar as a Christian one. And as Calvary itself was surrounded by the people who witnessed the Crucifixion, so we must suppose the altar should be surrounded by the people when

at the Elevation the priest symbolically repeats the act of Christ. "If I be lifted up I shall draw all men to me." And not only does Christ offer Himself in the Holy Sacrifice, but the people also offer themselves. It is a corporate offering....

Bearing this in mind, it is clear that there is one thing which must be done, and it must be done immediately; for the time is short. But it is a very big thing as well as a very simple one. It is a very revolutionary thing, as revolutionary as Pope Pius X's reform in the matter of frequent communion. And it is in line with that reform, part of the same thing. *The altar must be brought back into the middle of our churches*, in the middle of the congregation, surrounded by the people — and the word, surrounded, must be taken literally. It is essential that the people should be on all sides, in front and in back. The Holy Sacrifice must be offered thus, and in relation to this reform nothing else matters.

The choir and the organ, the vestments and the stained glass windows, the carvings, the paintings and the statues, all are so much frippery compared with the altar and the service of the altar....The only important thing and the only thing that matters is to bring the altar to the people. It is like the cry "back to the land," which means back to the people, back to humanity, and in this connection we must add, back to Christianity, back to the Incarnation....

As God came among men, so must the altar be. It will, of course, be said that this suggestion will violate all the architectural arrangements as well as affront our ancient customs. But architecture and our more or less quaint customs are of no importance compared with the vital necessity of our time. Some will say that the altar will not look nice where

we suggest putting it; that is not the question. The only question is where it would be right. Look after goodness and truth and beauty will look after itself. What, indeed, is beauty but the radiance of what is right, so that what is seen is pleasing?

And another extremely important thing effected by this placing of the altar is the emphasis placed on the act of receiving Communion. This act will remain all it is at present but it will become more. It will become corporate, a public act. It may be imagined to become even a clamorous act. It will become the act of the people clamoring for Bread — demanding recognition as the Mystical Body of Christ.[177]

Gill thus designed the Church of St. Peter the Apostle from the altar outwards, expressing his belief that a church exists "first and chiefly as a canopy over an altar."[178] He wrote of his design for the church in a subsequent letter in 1939:

The only thing about it to write home about is the fact that it will have a central altar. Everything springs from that — the plan grows from that & the outside is simply the result of the inside. I bet you anything you like it will be jolly decent & a holy house, but whether it will "go down" with the people, the clergy & the architects remains to be seen... No one will believe that we designed the job from the altar outwards & trusted to luck after that.[179]

The church was opened on June 14, 1939 (before the outbreak of the Second World War later that year) by the Bishop of Northampton and to great praise by architects, clergy, and the local people of Gorleston. Gill communicated his pleasure in a letter in 1939: "Any one will tell you where the new Catholic Church is — it is pretty conspicuous and as it was opened last Wednesday with a great flourish, the whole town is aware of its existence."[180] His letter particularly discusses the specific approval of the clergy regarding how the central

plan of the church around the altar provided an invaluable theological focus:

> At the opening...Canon Squirrell of Norwich preached a wholly admirable sermon on the subject of the Altar — Calvary — and the importance and indeed the sine qua nonness of a return to this realization, especially today when the Church *"has lost the masses"*, and apart from being a really quite hardheaded discourse, it was full of piety and sweetness. And then at the luncheon party afterwards...the Bishop made a speech in which he said he endorsed every word of Canon Squirrell's sermon and proceeded to rub it in a bit more, so that without any doubt this candle has been very well and truly lit. Much gratified also by obviously sincere approval and congratulations from many of the clergy... But, of course, it is one thing to supply the bones — it is another to make them live — so we must not crow too soon. Anyway, it is undoubtedly a great triumph to have established — at least in this Diocese — the notion that it is the right thing to do and apostolical to place the Altar in the middle of the Church and that it represents Calvary in the middle of the world.[181]

Since the opening of the Church of St. Peter the Apostle in 1939, few architectural changes have taken place in the church. One of the main changes is the replacement of the plain glass, installed by Gill, with stained glass. Indeed, the Church of St. Peter the Apostle exemplifies how Gill appears to have anticipated the liturgical reforms of the Second Vatican Council (held from 1962 to 1965), after which many churches installed a new altar away from the east end of the church and closer to the congregation.[182]

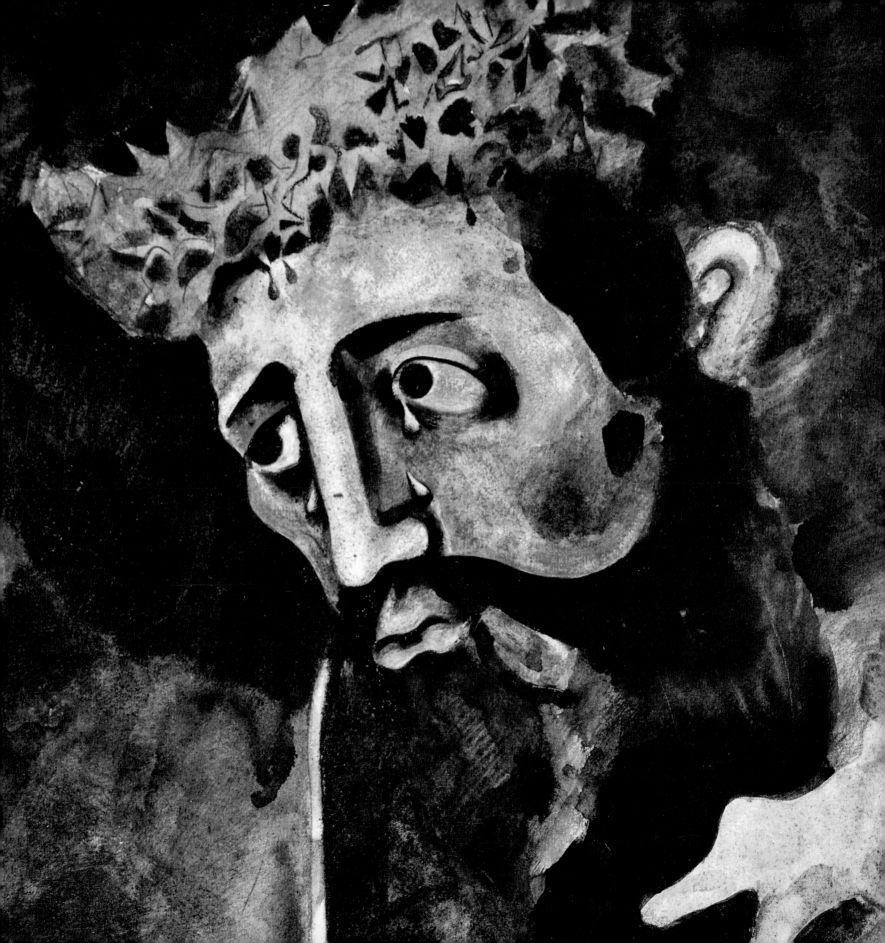

EDWARD BURRA
1905–1976

Edward Burra played a pivotal role in the development of Modernist painting in twentieth century British art. Because he suffered from rheumatoid arthritis from a young age, Burra is a rare example of a Modernist artist who chose to paint exclusively in watercolors, rather than oils, as he found the medium easier to control. Throughout his life, Burra created daring watercolors that abandon a traditional focus on atmospheric effects in favor of tightly defined outlines, claustrophobic spaces, and vivid color, marking his forceful position in the national heritage of British watercolor artists. Burra used the variety of effects possible in watercolor painting to capture his visionary imagery, as seen in both *The Agony in the Garden* and *The Coronation of the Virgin*.[183] Burra had little formal education because of his illness. He studied art at the Chelsea Polytechnic and the Royal College of Art and became a talented figure draughtsman. In addition to painting, Burra also created book illustrations and set and costume designs for ballet and theater performances. He lived a bohemian life, and was attracted to depicting louche and dangerous society and urban scenes. Burra was inspired by artistic movements such as Cubism, Dada, and Surrealism, and the English satirical tradition of William Hogarth as well as the modern life scenes of his contemporaries Stanley Spencer and William Roberts. Burra was included in the avant-garde Unit One exhibition in London in 1934, solidifying his place in English Modernism. Unit One was a group of British painters, sculptors, and architects formed in 1933 that included Henry Moore, Barbara Hepworth, Ben Nicholson, and Paul Nash, among others, and that encouraged the modernization of British art according to the example of Continental Modernism. Nash chose the name of the group to express both unity (Unit) and individuality (One). Edward Burra was also a member of the English Surrealist group and exhibited at the 1936 International Surrealist Exhibition in London. As Burra's artwork demonstrates, Surrealism provided a radical alternative to the rational and formal qualities of Cubism, instead emphasizing the subconscious and the imaginative and creative powers of the mind. However, when evaluating Burra's *oeuvre*, like many of his British artistic contemporaries, Burra preferred to stand independently as an artist, rather than be identified with a specific artistic group or movement.

Burra traveled widely throughout his life, enabling him to use ideas from diverse cultural sources. Burra visited the United States from 1933 to 1934 where he was fascinated with the street life of Harlem. He spent much time in Spain between 1933 and 1936 where he witnessed the outbreak of violence in the wave of anti-clericalism that preceded the Spanish Civil War. As a result, violence and destruction became frequent themes in Burra's art, the artist reacting in general against cruelty and repression. Burra collected photographs of the desecration of churches in Spain.[184] He related to John Rothenstein (director of the Tate Gallery from 1938 to 1964) an experience he had had in Madrid just before the Spanish Civil War:

> One day when I was lunching with some Spanish friends, smoke kept blowing by the restaurant window. I asked where it came from. "Oh, it's nothing," someone answered with a gesture of impatience, "it's only a church being burnt." That made me feel sick. It was terrifying: constant strikes, churches on fire, and pent-up hatred everywhere. Everybody knew that something appalling was about to happen.[185]

Burra's fascination with the exoticism of Catholicism, his sympathy with Catholic piety, and his concern with suffering can be observed in his paintings of religious subjects, and may ultimately stem from Burra's personal reaction to the art and the events of the Civil War in Spain in 1935 and 1936. Although he remained independent of any specific confession of faith and did not follow any specific religious observances, Burra shared with Catholicism a sense of evil as something real and

Edward Burra (1905-1976)
The Agony in the Garden, 1938-39 (detail)
Watercolor, gouache, and graphite on paper, 30 x 48 inches

concrete, as communicated through his paintings.[186] In 1937 Burra visited Mexico. Attributes of Mexican art and cultural traditions became an important theme in his macabre and powerful allegorical works. Burra's religious works of the late 1930s also recall the somber imagery of the mannerism of El Greco.[187] Burra traveled to northern Italy in 1938, when he visited Venice, and also visited Italy in 1965 and 1966. Burra admired the emotional extremes, bulky forms, rich chiaroscuro, dramatic shadows, and interest in the common man and social outcasts found in the religious art of the Italian Baroque, and sought to communicate a similar intensity of vision in his watercolors.[188] Throughout his artistic career, as in many religious paintings of the Italian Baroque, Burra identified with individuals who had experienced social rejection and exile, including gypsies, tramps, and those displaced by war, as a means of expressing his own sense of isolation.[189] Burra was unable to travel during the Second World War and his work during these years focused on melancholy and remote English landscapes. Burra traveled less as he grew older, although he did return to America in the 1950s.

The Agony in the Garden, 1938-39

Burra completed two series of biblical works during his life, the first series in the late 1930s (including *The Agony in the Garden*) and the second between 1950 and 1952 (including *The Coronation of the Virgin*). Other works in the series from the late 1930s include *Mexican Church* (c.1938), *Saint and Candles* (c.1938), *Santa Maria in Aracoeli* (1938-39), *The Vision of St. Theresa* (1938-39), *The Agony in the Garden* (second version, 1939, Birmingham Museum and Art Gallery), and *Holy Week, Seville* (1939). *The Agony in the Garden* (1938-39, signed "Burra" at the lower right) is an excellent example of how Burra began to create very large watercolors in the late 1930s by joining together several sheets of paper. In this work, the artist used two sheets of paper to create an impressive

work of very dramatic scale. Burra used multiple techniques of watercolor painting that exemplify his skillful handling of the medium. The "wet-in-wet" technique of applying a wet wash on wet paper can be observed in the blurriness of the paint of Jesus' Crown of Thorns; the "dry-brush" technique of applying less-diluted paint to dry paper can be observed on several of the stones of the wall; and Burra used "scratching-out" to form the veins on the plant leaves at the lower left by scraping through the painted surface to reveal the whiteness of the paper beneath. The multiple curving lines in this work created by both Burra's pencil and watercolor brush exhibit the artist's love of an animated, active line in nearly all of his works. The artist did not sell the painting, and it remained in the collection of his sister, Lady Ritchie of Dundee, until 2002. The title appears on a contemporary label on the back of the work.

In *The Agony in the Garden*, Burra created an image of intense drama that strongly communicates Christ's isolation and rejection the night before His Crucifixion, and perhaps echoes Burra's own sense of isolation and social rejection. In this exhibition-size watercolor, the tall figure of Christ takes up nearly half of the composition and fills the height of the picture plane. Jesus wears the Crown of Thorns, foreshadowing his imminent Crucifixion. The ghastly yellow pallor of Christ's face emphasizes his agony, while three tears on his face mirror three drops of blood on his brow, alluding to the text of Luke 22:44, "And being in anguish, He prayed more earnestly, and His sweat was like drops of blood falling to the ground." The figure of Jesus has a large black beard, also suggesting Burra's fascination at this time with Mexican art and culture. Jesus wears a brightly colored red robe with sashes crossed around his chest, reminiscent of the priests in the much earlier watercolor *The Rending of the Veil* by William Bell Scott. Christ points to the candles at the left, identifying himself as the "Light of the World." The brilliant white of the

Edward Burra (1905-1976)
The Agony in the Garden, 1938-39
Watercolor, gouache, and graphite on paper, 30 x 48 inches

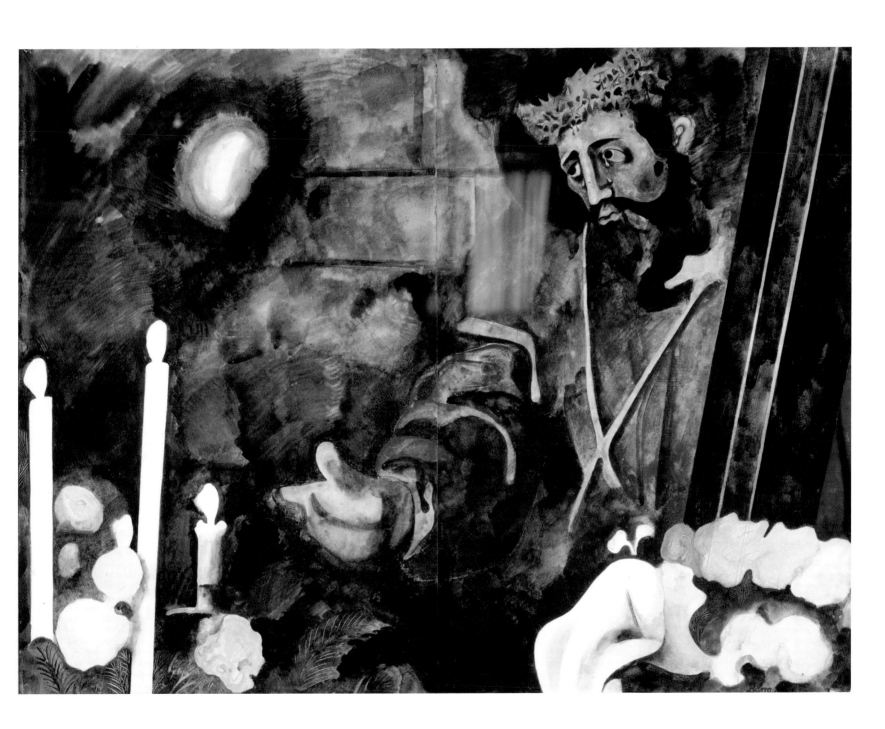

candles is achieved not only by the white color of the paper, but by the application of gouache (also known as bodycolor), a type of watercolor made opaque by the addition of white pigment, which enables it to contrast with the translucency of the surrounding colors. Dramatic chiaroscuro lighting creates a poignant drama by contrasting the light of the candles and of the moon with the shadowy darkness of the interior space. The scene takes place in an undefined space, although the title of the work specifies the Garden of Gethsemane. The moon at the left dissolves a stone wall of (perhaps) a Mexican church, which is also suggested by the presence of the candles and the beautiful Calla lily flowers on an unseen church altar. The artist thus creates a composite time and space that emphasizes an overall focus on devotion.

Burra likely chose the Christian theme of *The Agony in the Garden* and presented it in an overtly Roman Catholic style as a reflection on the passionate religious expression that he had witnessed in Spain and Mexico in the 1930s. Burra admired the long heritage of Mexican art, from its early civilizations, to the Catholic Baroque, to the modern muralists. In Mexico City, Burra focused on the Baroque churches, which he found fascinating due to their immense size and ornate, sculpture-encrusted surfaces.[190] The church setting and the dramatic Baroque figure of Christ in Burra's *The Agony in the Garden* reveal British artists' fascination in the 1930s with the visual culture and historic heritage of Mexico, when British artists endeavored to find and depict a "primitive" culture away from civilization and the horrors of the First World War.[191] Burra was fascinated by the "exotic" Latin cultures of Spain and Mexico and wrote of "[wanting], for as long as I can remember, to go to Mexico."[192] He created a scrapbook filled with items related to both his trips to Spain and to Mexico, indicating his perceived continuity of these two cultures, and in 1933 wrote of his love for Spain, "I don't want to leave ... till I must."[193] Burra collected religious postcards in Spain and

Mexico that he used in composing his large-scale biblical watercolors. In *The Agony in the Garden*, Christ's pose against the vertical beam of the Cross may have been inspired by one of these postcards that depicts Jesus wearing the Crown of Thorns and leaning on the upright beam of the Cross. This postcard has the title "Sevilla — Nuestro Padre Jesús del Gran Poder" (Seville — Our Father Jesus of Great Power).[194]

One painting by Burra can be concretely linked to the artist's trip to Mexico: *Mexican Church* (c.1938). *The Agony in the Garden* and *Mexican Church* share strong formal similarities and suggest that the artist created them at approximately the same time and from the same types of sources. For *Mexican Church*, Burra used postcards from two different sites he had visited in Mexico as sources: the reredos from the cathedral in Taxco and the recumbent crucifix of *El Señor de la Preciosa Sangre* from Santa Caterina in Mexico City.[195] Burra related in a letter, "the churches are wonderful & such simple piety I've never seen - people go on to such a pitch of devotion they even kneel a good quarter of a mile round the cathedral reciting the rosary."[196] In both paintings, Burra emphasizes Christ's suffering and draws from the focus on realistic suffering in Mexican devotional art, in *Mexican Church* through the shrouded worshippers and their closeness to the crucified body of Christ, and in *The Agony in the Garden* by pushing the figure of Christ close to the picture plane. Burra used similar colors to depict the blurry stone walls and claustrophobic spaces of the two paintings, with details outlined in graphite. The back wall in *The Agony in the Garden* dissolving in the moonlight also suggests Burra's concern with decay, especially the Baroque cathedrals in Mexico and their crumbling magnificence, both from neglect and from damage in earlier, anti-Catholic stages of the Mexican revolution.[197]

The figures of Christ in *The Agony in the Garden* and *Mexican Church* also demonstrate Burra's general interest in sculpture within painting. The sculpture of the crucifix in *Mexican*

Church demonstrates this directly, and the postcard source of a Spanish Baroque sculpture of Christ for *The Agony in the Garden* demonstrates this indirectly. By including sculptural figures of Christ, Burra references the history of Catholic Baroque sculpture and its emphasis on suffering and communication with the viewer.[198] At this time in his career, Burra was particularly interested in exploring the overlap between the temporal and eternal worlds in his painting, often through the use of sculptures and masked figures to convey a sense of longing for the eternal.

Thus, in *The Agony in the Garden*, Burra rejected completely the traditional representation of this subject in the Italian Renaissance paintings that he could have seen in the National Gallery in London. Two particularly important works on this subject in the National Gallery's collections from which he differentiated his own work include the paintings by Mantegna (c.1458-60) and Giovanni Bellini (c.1465), both of which depict a calm atmosphere, with Christ turned away from the viewer to pray, the disciples sleeping, and a hint of the approaching soldiers. Instead, he produced an image more in keeping with the later approaches to the subject in the National Gallery in London, including works by Ludovico Carracci (c.1590), a copy after Correggio (c.1640-1750), and the studio of El Greco (c.1590).

Overall, *The Agony in the Garden* presents a nearly overpowering image of anguish and suffering, and suggests the artist's self-identification with Christ as the Man of Sorrows. Like Burra, Paul Gauguin in his earlier *Christ in the Garden of Olives* (1889) had identified with the figure of Christ as one who had been rejected and deserted, with Gauguin even making the face of Christ a self-portrait. Burra's second watercolor of *The Agony in the Garden* (1939) takes the expression of passion and suffering further, with a machine-like red angel holding out the cup towards Christ, while soldiers rush violently towards Christ in the background. Like Gauguin's *Christ in the Garden of Olives*, this second watercolor by Burra includes the figures of the sleeping disciples in a rocky landscape and Christ facing the viewer with his hands clasped in anguish.[199] In this second watercolor by Burra, the drops of blood and sweat even fall from Christ's fingers and cascade down his face in red rivulets, and Burra again emphasizes the chiaroscuro effect of strong contrasts of light and dark, alluding to the Italian Baroque.

The Coronation of the Virgin, 1950-52

At eighty by fifty-two inches, a staggering size for a watercolor created by joining together four pieces of paper, *The Coronation of the Virgin* is Burra's largest work (in total surface area). *The Coronation of the Virgin* was the main piece of Burra's first exhibition at the Lefevre Gallery, which was held in 1952 and focused on his recent biblical subjects. The watercolor is one of a series of paintings by Burra from the late 1940s and early 1950s that depict Christian themes of violence and celebration, the other works including *Limbo* (1948-50), *Resting Angel* (1948-50), *Resurrection* (1948-50), *Salome* (1948-50), *Judith and Holofernes* (1950-51),[200] *Christ Mocked* (1950-52), *The Entry into Jerusalem* (1950-52), *The Expulsion of the Moneychangers* (1950-52), *Joseph of Arimathea* (1950-52), *Peter and the High Priest's Servant* (1950-52), *The Pool of Bethesda* (1950-52), *The Rest in the Wilderness* (1950-52), and *Simon of Cyrene* (1950-52). These works are remarkable in Burra's *oeuvre* for their emotional intensity, passion, and drama. As compositions on religious themes, they are linked with Burra's paintings from the late 1930s, including *The Agony in the Garden*. The intensity of the artist's vision in these works encourages a personal response from the viewer.[201]

In *The Coronation of the Virgin*, Mary appears at the upper left and wears a deep blue mantle, a traditional iconographic identification for her. Mary's traditional symbols of a sun behind her, a crescent moon beneath her, and a crown of

twelve stars above her allude to her as a figure of the Church, and the Church's suffering, fortitude, and victory, and in Catholic tradition are linked to Revelation 12:1, "Now a great sign appeared in heaven: a woman, clothed in the sun, standing on the moon, and with the twelve stars on her head for a crown."[202] The artist used touches of white gouache to highlight the accents in Mary's crown.

Burra heightens the intensity of the scene through his depiction of Christ, His immense presence above the crowd possessing an authority and power. Burra used pointillism around Christ's face, the multiple dots composed of various colors of paint. Christ's hair and beard appear windswept, alluding to the motion of the S-shaped rejoicing crowd around Him.

Peter appears at the lower right holding the keys to heaven, while the trio of men wearing red and gold in the lower third of the watercolor hold ropes and nets and most likely allude to the apostles being "fishers of men." Monks at the center right carry palm branches, and martyrs appear in the crowd along the right, one figure holding a spiked wheel alluding specifically to Saint Catherine of Alexandria. Of the three women in the foreground, who may represent the three Marys of the New Testament, the posture of the central woman with her hands clasped beneath her chin creates a visual parallel to that of the Virgin Mary who is being crowned. One scholar has suggested that the coronation scene and parade of angels may, in a similar manner to Paul Gauguin's *Vision After the Sermon* (1888), be an imaginative visualization of the faith of the women in the foreground.[203]

Burra created beautifully saturated colors that lead the viewer's eyes throughout the composition. Spiraling clouds suggest his love of the Venetian works of Tiepolo. Extreme contrasts of scale create a huge recession and a tremendous amount of space, from the large faces of the women at the bottom, to the tiny processing figures at the top. Burra masterfully depicted the lively crowd with gesturing figures and vibrant colors. The curving, flowing line of figures who are receding back in space and playing various instruments recalls the large-scale nineteenth-century work by the British artist Edward Burne-Jones, *The Golden Stairs* (1880). However, the contorted expressions and exaggerated movements of the rather raucous trumpet players in Burra's composition, especially the one with puffed out cheeks positioned in the center, create a less subdued atmosphere. Indeed, the trumpet and lute players, especially the swooping trumpet player at the upper right who displays his lower calves and bare feet, are a rather rowdy bunch for a coronation! Burra places the viewer directly in the pathway of the line of forward moving figures and in the very midst of the celebration.

Burra drew on a number of cultural sources for this painting. The woman on the right with dark skin who is wearing a red dress and is playing the trumpet leads the viewer's eyes back, and suggests Burra's love for Harlem nightclubs and the exhilarating jazz music of New York. In addition, Burra visited Ireland in 1947 and 1948, and was particularly interested in the people he observed in the streets in Dublin and their faith and quiet stoicism towards the difficulties of life after the war. Brian Desmond Hurst, who commissioned this work, was born in Belfast, and the first owner was Michael Benthall, author of the play *The Passing of the Third Floor Back*, which was adapted as the 1944 ballet *Miracle of the Gorbals* (for which Burra designed sets and costumes), a Christian allegory set in the slums of twentieth century Glasgow. In *The Coronation of the Virgin*, Burra links the contemporary figures of the women in the foreground with the heavenly background in a similar manner to the work of his contemporary Stanley Spencer who set miraculous, visionary events in his native Cookham and in Port Glasgow, both artists visually connecting the local and the heavenly.

In *The Coronation of the Virgin*, Burra created an over-

Edward Burra (1905-1976)
The Coronation of the Virgin, 1950-52
Watercolor, gouache, and graphite on paper, 80 x 52 inches

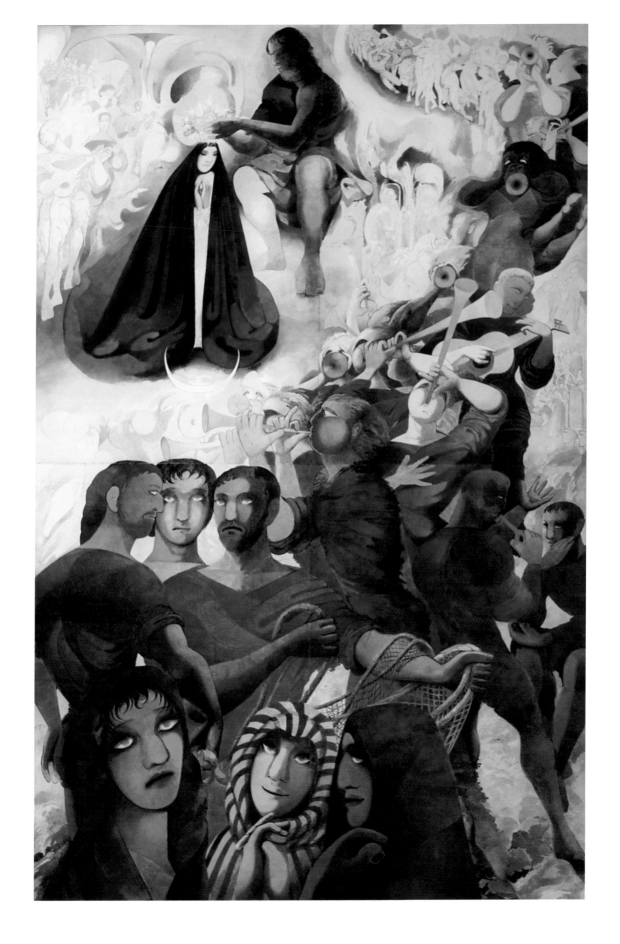

whelmingly joyous depiction of this event, which has been the subject of innumerable works of art throughout the history of Western art. An inscription in the apse mosaic of this subject by Jacopo Torriti in Santa Maria Maggiore in Rome (c.1291-96) helps to explain the theme of Mary's coronation: "The Virgin Mary has been assumed into the celestial bridal chamber at whose starry threshold sits the King of kings; the holy Mother of God has been lifted above the angelic choirs to Heaven's realm."[204] Burra's work, with its exuberant action, drama, upward movement, and bands of figures is deliberately in line with Italian Baroque depictions of this theme, such as the painting by Guido Reni (c.1607) which Burra could have viewed at the National Gallery in London. For his other biblical paintings in this series from the late 1940s and early 1950s, Burra was also looking to Spanish Baroque depictions of the subjects, such as Bartolomé Esteban Murillo's *Christ Healing the Paralytic at the Pool of Bethesda* and El Greco's *Christ Driving the Traders from the Temple* (c.1600), both found in London's National Gallery.

The art critic of the *Glasgow Herald* wrote a very positive review of the Lefevre Gallery exhibition:

> A new one-man show by Edward Burra is a considerable event, and a fairly rare one; after an interval of nearly four years the new collection of recent paintings at the Lefevre Gallery has, not unexpectedly, a most powerful effect. It would be startling in any case, for the highly individual imaginings of Mr. Burra have lately been given fresh stimulus by an interest, not wholly new but more explicit than before, in religious subjects: the preoccupation with violence and evil has moved in a new direction, and into an illuminating relationship with good. Of the 11 large works in the show eight are direct illustrations of the Gospels; they are among the most remarkable of their nature that any modern artist has produced, and two

or three of them are certainly better than anything Mr. Burra has done in the past. In manner there is no great alteration: there are the same bulbous, misshapen figures, the same tortured, blind, and hideous countenances familiar in earlier Burras; but they appear, literally, in a new light. The harsh and lurid colors Burra has used before still have their place… but they are set off by others of a different sort. The distant sunlit landscape in the "Entry into Jerusalem," the arches of the Temple in the "Expulsion of the Money-changers" shine with an astonishing serene radiance, there is a sense of release from bondage expressed almost entirely in chromatic terms. The "Coronation of the Virgin" is a notable composition, a skillful disposition of figures according to classic requirements; as an arrangement of pure color, wonderful rich blues, golds, reds, it may stand as an original masterpiece.[205]

KEITH VAUGHAN
1912–1977

An English painter and writer, Keith Vaughan was greatly influenced by his contemporaries Graham Sutherland and Henry Moore in his endeavors to reconcile figurative and abstract elements in his work. The 1945 Victoria and Albert Museum exhibition of works by Picasso and Matisse influenced Vaughan's decision to focus on figural rather than purely landscape subjects, and to begin painting in oils, although works in ink and gouache remained foundational to his *oeuvre*. Vaughan admired the way that Picasso distorted human anatomy and the way Braque and Matisse had flattened and emphasized rhythm and color for their own sakes. However, Vaughan's work never embraced total abstraction, the artist writing,

> Painting has always been a representational art and if you remove the representational element from it, as a great many painters do, then you simply impoverish it. Even if you can't see the representational element in the finished product it must be there to begin with; for to me painting which has not got a representational element in it hardly goes beyond the point of design.[206]

Vaughan humorously reacted to Wassily Kandinsky's famous statement regarding the tension between the abstract and the figurative in the visual arts, "The impact of an acute triangle on a sphere generates as much emotional impact as the meeting of the [fingers] of God and Adam in Michelangelo's Creation," by commenting in his journal in 1961, "Not to me, boy."[207]

After the Second World War, Vaughan traveled widely to the Mediterranean, North Africa, Mexico, and the United States. He taught in London at Camberwell School of Art (teaching illustration) from 1946 to 1948, at the Central School of Arts and Crafts (teaching painting and illustration) from 1948 to 1957, and at the Slade School of Fine Art from 1959 to 1977. His remarkable journal that he kept from 1939

until his suicide in 1977 reveals the tension in his life and work as he became increasingly melancholic and reclusive.[208]

Vaughan was part of the Neo-Romantic Movement in England that flourished from c.1935 to c.1955 in painting, illustration, literature, film, and theater. Neo-Romantic artists, including (not exclusively) Paul Nash, John Piper, Henry Moore, and Graham Sutherland, created imaginative, abstract, and somber English landscape paintings that often included vulnerable figures. Their brooding and sinister works reflected the somberness and tensions of the years around the Second World War, and yet were also of a poetic and visionary intensity. Keith Vaughan and his Neo-Romantic contemporaries were inspired by the visionary nineteenth-century pastoral English landscapes of Samuel Palmer and William Blake, and based their work on an emotional response to the British landscape and its history and symbolism.

Vaughan's drawing *Triptych* beautifully communicates the concerns of Neo-Romanticism with the drawing's shadows, brittle and linear qualities, and creation of a mysterious atmosphere. Vaughan signed the drawing "KV. 14iii49." In this drawing, Vaughan used sketchy lines, gouache accents, and austere washes to give the subject its intense, poetic emotion. Vaughan depicts (from the left) the Lamentation with Christ and Mary; the Crucifixion with Christ being nailed to the Cross; and the Deposition, with Christ's body being taken down from the Cross. Vaughan's approach to the human figure in *Triptych* illustrates how the Neo-Romantics combined the figural Modernism of Picasso with the earlier landscape work of Blake and Palmer. By the end of 1948, the year before Vaughan created *Triptych*, the fusion of figures with their landscape developed as a major theme in Vaughan's work.

Despite the beauty of this work, two months before completing *Triptych* Vaughan wrote in his journal of his misgivings regarding his artistic abilities, communicating his overwhelming and painful self-doubt:

Keith Vaughan (1912-1977)
Triptych, 1949 (detail)
Pen, ink, gray washes, and gouache on paper, 5 x 12 inches

5 January 1949 Demoralizing bouts of self-doubt and helplessness. Conviction that my whole position is a fraud and far from being the result of any innate gifts is simply the result of perfecting a technique of dissimulation, acting out the person I would like to be. However, there is no choice now but to go on until I'm found out. The exhaustion of doing nothing. Fears of being unable to work again, that I'm living on some sort of false credit which will run out. Feelings of guilt at watching all the people who go off to work in the morning past my studio window, and envy at seeing them come back in the evening to their simple pleasures earned — Ils sont dans le vrai — but it doesn't make it any less painful.[209]

However, two days before he completed his drawing *Triptych*, an interview was published in which Vaughan discussed his goal of ultimately finding a sense of reconciliation, order, and harmony in visual images of conflict:

I find myself constantly drawn towards objects of the natural world in which conflict is apparent. By conflict I do not mean active violence, but simply a state of tension which results when two different things of different natures are brought together. A figure in a landscape, the natural world and the human world, a man lighting his cigarette from the butt of another's — the essential separateness of individuals momentarily united in a single gesture — these to me are situations of conflict. In painting I seek for reconciliation. I seek a common unit of construction with which, while each individual object retains its essential identity both can be built anew together in order and harmony.[210]

Multiple British artists approached the subject of the Crucifixion in the 1940s. Five years before creating *Triptych* (which includes a central image of the Crucifixion), Vaughan

Keith Vaughan (1912-1977)
Triptych, 1949
Pen, ink, gray washes, and gouache on paper, 5 x 12 inches

recorded in his journal a conversation he had with Graham Sutherland regarding the subject of the Crucifixion:

> I asked [Sutherland] if he thought it was still possible to paint the great myths; Prometheus, for instance, or a Crucifixion or an Agony in the Garden. I said I didn't see they had become any less valid for certain individuals merely because they had ceased to be generally accepted. He said there was no real reason why they should not be painted if one could feel strongly enough about them. The question of understanding the subject and not simply illustrating it was so important. It is essential that one can believe in the reality of the subject. For example, it is possible to paint a picture of a man being attacked by a dog because such a situation, though not necessarily experienced, is sufficiently near to experience for the imagination to be able to handle it truthfully. Whereas a man being attacked by a lion is incomprehensible to anyone who has not been so attacked, and so is not a legitimate subject for most painters. As for a Crucifixion he did not know whether there was anyone who could handle it. "It is an embarrassing situation," he said, "to say the least of it, to contemplate a man nailed to a piece of wood in the presence of his friends."[211]

Vaughan developed an atheistic worldview over his lifetime (although having been confirmed into the Church of England at school in 1927, but never expressing a personal belief in Christianity after his school days).[212] He wrote in a letter to a friend in 1943, "For myself religion is indistinguishably merged in Art. Maybe it is not religion at all. But I do not feel the need for anything outside the spiritual domain of art."[213] However, Vaughan created emotional, moving works in multiple types of media that depict religious subjects, such as his *The Agony in the Garden (After Bellini)* (1944) created

the same year he had been invited to exhibit with other Neo-Romantic artists at the National Gallery in London, whose collections included both Andrea Mantegna's *The Agony in the Garden* (c.1458-60) and Giovanni Bellini's *The Agony in the Garden* (c.1465). Vaughan wrote in his journal regarding his reflections on these two paintings and Sutherland's comments on them:

> I want to set down all I can remember of what Graham Sutherland said last Sunday about painting. We were discussing the question of perfection in art…The Mantegna is obviously the more perfect. The articulation of the whole picture space is flawless; the transition from body to limb from limb to hand and hand to fingers is effortless and consummate. Bellini's is altogether different. There is a tremendous sense of strain in bringing the objects into relationship. A feeling of anxiety that it may at any moment not quite succeed, and the whole picture fail. This feeling permeates the whole picture, it gives a vibrant tension to every relationship. The Bellini is the greater picture. The Mantegna is the more perfect.[214]

Notably, Vaughan is careful to specify in the title of his own work that it is "After Bellini," which he had noted in his journal as "the greater picture." In his depiction of *The Agony in the Garden*, as in *Triptych*, Vaughan brings a similar focus to the "tremendous sense of strain," "feeling of anxiety," and "vibrant tension" that he had admired in Bellini's foundational painting.

In his later paintings, Vaughan continued to retain a human dimension in his figural works, and yet took away more and more specific meaning, writing in 1958,

> No longer incorporated in the church or any codified system of belief the *Assemblies* are deprived of literary significance or illustrative meaning. The participants have not assembled for any particular pur-

pose such as a virgin birth, martyrdom, or inauguration of a new power station. In so far as their activity is aimless and their assembly pointless they might be said to symbolize an age of doubt against an age of faith. But that is not the point. Although the elements are recognizably human their meaning is plastic. They attempt a summary and condensed statement of the relationship between things, expressed through a morphology common to all organic and inorganic matter.[215]

In 1961, the artist wrote in his journal of his continuing struggles to find purpose behind creating his artworks: "The futility of the search for the Absolute — symptom of an age without religion which cannot tolerate the anxieties and insecurities of relative and purely human values."[216] Vaughan was responding to the recent work of the American Abstract Expressionists, and concluded that although they were engaged in a serious quest for absolutes, they ultimately failed to fill a deep void:

> [Abstract Expressionism's] main sources were anarchy and a sense of decoration. Its achievement was to show how much could be done with so little. Its failure was that it brought no disciplines, no restrictions which would enable growth. It offered the artist perfect freedom, the kiss of death. It tried to express directly the prime values of painting which, like happiness, are the by-product of a search for something else. Since it had no aesthetic it had to substitute historical or dramatic values — the painting as record of an event, the artist as hero unarmed before his canvas. Such fantasies can appeal only to a society deeply frustrated by having had its spiritual problems transposed into economic ones.[217]

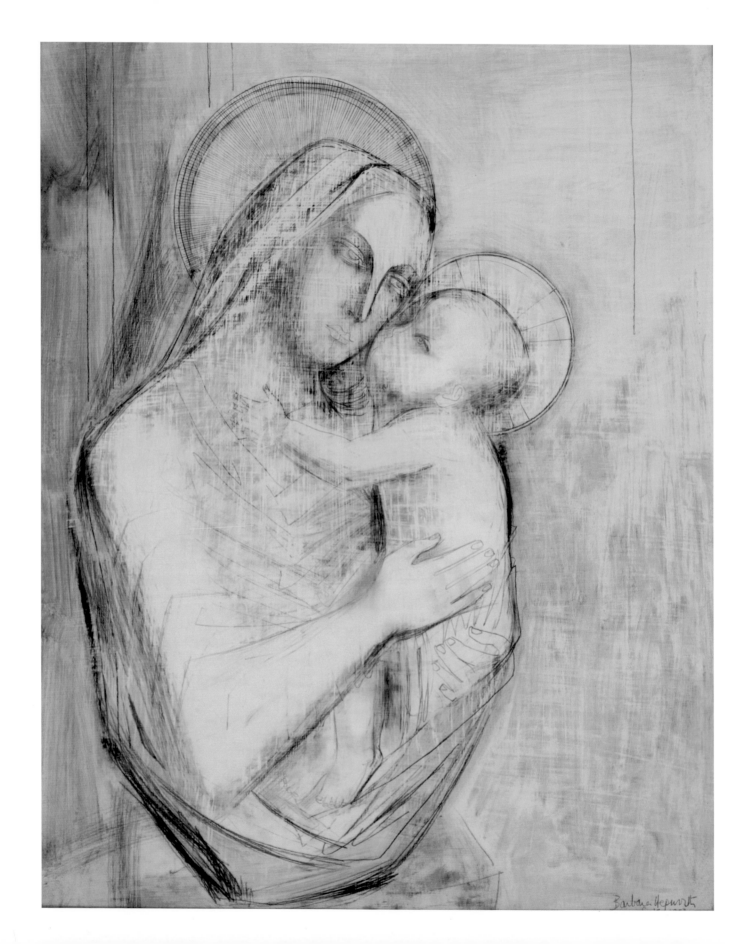

Barbara Hepworth

BARBARA HEPWORTH
1903–1975

A preeminent British sculptor of the twentieth century and one of the few British women artists to achieve international prominence, Barbara Hepworth created figurative and abstract sculptures and preparatory drawings that express the human body and spirit in the landscape. Her powerful monolithic sculptures are often biomorphic in appearance and of female subjects. Hepworth worked predominantly in carving stone and wood, and also began working in metal in the 1950s. Hepworth believed that sculpture was the fundamental art form, and advocated for direct carving (sculptors carving their own work as opposed to modeling maquettes for craftsmen to translate into stone) and truth to materials (forming the sculpture through the artist's immediate response to the material). Hepworth's figurative carvings through the mid-1930s exhibit less interest in "primitive" non-Western carving than those of her contemporary, Henry Moore. From the late 1930s she created works with tautly stretched strings and wire, focusing on their effect on the opened-up sculpture. Through the 1940s she developed a method of piercing the stone and progressively opening the form to light and space with fewer references to the human body. In the 1950s, her work returned to a focus on the human figure. The artist described the source of her inspiration and the overall purpose of her artwork in 1966:

> Whenever I am embraced by land and seascape I draw ideas for new sculptures: new forms to touch and walk round, new people to embrace, with an exactitude of form that those without sight can hold and realize. For me it is the same as the touch of a child in health, not in sickness. The feel of a loved person who is strong and fierce and not tired and bowed down. This is not an aesthetic doctrine, nor is it a mystical idea. It is essentially practical and passionate, and it is my whole life, as expressed in stone, marble, wood and bronze.[218]

Barbara Hepworth trained in sculpture at Leeds School of Art and at the Royal College of Art in the 1920s. She was runner-up to John Skeaping for the 1924 Rome Prize to the British School at Rome, but earned a West Riding Travel Scholarship that enabled her to travel to Florence. Hepworth and Skeaping were married in Florence in 1925. They moved to Rome, where both began work in carving stone. Hepworth later described her time in Italy: "I explored the whole of Tuscany's Romanesque architecture in landscape and sunlight; Masaccio; Michelangelo; Cimabue; Giotto; Assissi; Siena, and Perugia."[219] In 1926, Hepworth and Skeaping returned to London and became leading figures in the new sculptural movement associated with direct carving. Hepworth and Skeaping joined the London Group and the 7 & 5 Society, originally formed in London in 1919 as a return to order following the First World War, but renamed the Seven and Five Abstract Group in the 1930s. Hepworth and Skeaping had a son, Paul Skeaping, in 1929. The couple divorced in 1933.

In 1934 Hepworth and the painter Ben Nicholson had triplets, and they married in 1938. Both Hepworth and Nicholson moved towards abstraction during the 1930s. They visited the studios of avant-garde artists in Paris, including Pablo Picasso, Georges Braque, Hans Arp, Piet Mondrian, and Constantin Brancusi. They joined Abstraction-Création, an association of abstract artists organized in Paris in 1931. They also joined Unit One in Britain. Together with a group of eminent European exiles who arrived in London in the mid-1930s, including Mondrian, Gabo, and László Moholy-Nagy, Hepworth and other English artists became the center of a group of artists based in the Hampstead area of London and committed to avant-garde ideas. During the Second World War, Hepworth and Nicholson evacuated to St. Ives, Cornwall. In 1948, Hepworth and Nicholson founded the Penwith Society of Arts in St. Ives, which played a major role in the development of Modern and abstract art in the St. Ives

Barbara Hepworth (1903-1975)
Madonna and Child, 1953
Oil and graphite on panel, 19.5 x 15.5 inches

artists' colony. Hepworth bought Trewyn Studio in St. Ives in 1949, where she lived after her divorce from Nicholson in 1951. Hepworth was especially active within the artistic community in St. Ives during its post-war international prominence. She participated in the Venice Biennale of 1950 and won the Grand Prix of the 1959 São Paulo Biennale, which confirmed her international standing. She was named a Commander of the Order of the British Empire in 1958 and a Dame Commander of the Order of the British Empire in 1965. In 1964, her work *Single Form* was installed outside the United Nations building in New York as a memorial to the Secretary-General, Dag Hammarskjöld. Hepworth served as a Tate trustee from 1965 to 1972. After a long battle with cancer, she died in St. Ives in 1975 in a horrific fire in her studio. Her studio was turned into the Barbara Hepworth Museum in 1976, and is now part of Tate St. Ives | Barbara Hepworth Museum and Sculpture Garden.

Barbara Hepworth created the tender and sensitive drawing *Madonna and Child* as a preparatory drawing for her stone carving *Madonna and Child* (1954) for the Lady Chapel in St. Ives Parish Church. Her emotional sculpture *Madonna and Child*, together with her painting *Two Figures (Heroes)* (1954), served as a memorial to her son Paul Skeaping, who was killed on active service with the Royal Air Force over Thailand in 1953, along with his navigator. This piece is a rare demonstration of a direct correlation between an event in Hepworth's life and her work. Paul had lived with his father, John Skeaping, since the age of nine, but spent extended time with Hepworth in Cornwall. A close friend of Hepworth recorded that Paul's death was "a lasting grief" to the artist.[220] Hepworth later related that her sculpture often resulted from a period of crisis and adversity which created "the moral climate in which my sculpture is produced."[221] Hepworth visited Greece in 1954 in an effort to recover from the sudden death of her son.

Hepworth's drawing *Madonna and Child* is a particularly important work to include in an exhibition of twentieth century British art, as drawings by sculptors are rarely exhibited and the subject is largely unstudied. A sculptor's drawings help the viewer to understand how the sculptor initially approached the three-dimensional representation of the figure.[222] In *Madonna and Child* (signed and dated by the artist at the lower right), Hepworth beautifully evoked the incredible delicacy and tenderness of the Mother and Child. Multiple lines radiate around Mary's head creating a halo. A few pencil lines precisely outline the hands of both figures, the Child's feet, and the profile of the Child's face as He embraces His Mother, creating a vulnerable and tender image. Additional pencil strokes create a suggestion of Mary's curly hair, the gentle and controlled folds of her drapery, and the delicate curl of Christ's ear. Hepworth preserved all focus on the Mother and Child by avoiding any hint of a background. The pure whiteness of the Mother and Child gently contrast with the soft golden background, preserving the quietness of the image. By using a wooden panel as the support for this image, Hepworth was able to achieve an incredibly smooth surface. She softened and muted the color and texture of the oil paint on the panel by rubbing it over, and indeed rubbing it off in places. The graphite of the artist's pencil reflects off of the smooth surface of the oil paint on the wood, creating a subtle sheen and radiance. The artist wrote of this approach to drawing, "the surface takes one's mood in color and texture; then a line or curve which, made with a pencil on the hard surface of many coats of oil or gouache, has a particular kind of 'bite' rather like incising on slate."[223]

Hepworth made a deliberate return to the figurative in this work. From the late 1940s, Hepworth had been returning to a figurative motif, including her 1947 series of drawings in a hospital theater.[224] Hepworth reflected on the connection of the physical and the spiritual in these figurative hospital drawings:

We forget, or we have not time in which to remember, that grace of living can only come out of some kind of training or dedication, and that to produce a culture we have to understand all the attributes of a proper co-ordination between hand and spirit in our daily life. A particularly beautiful example of the difference between physical and spiritual animation can be observed in a delicate operation on the human hand by a great surgeon. The anatomy of the unconscious hand exposed and manipulated by the conscious hand with the scalpel, expresses vividly the creative inspiration of superb co-ordination in contrast to the unconscious mechanism. The basic tenderness of the large and small form, or mother and child, proclaims a rhythm of composition which is in contrast to the slapping and pushing of tired mother and frustrated child through faults in our way of living and unresolved social conditions.

For two years I drew, not only in the operating theatres of hospitals, but from groups in my studio and groups observed around me. I studied all the changes and defects which occurred in the composition of human figures when there were faulty surroundings or muddled purpose. This led me to renewed study of anatomy and structure as well as the structure of integrated groups of two or more figures. I began to consider a group of separate figures as a single sculptural entity, and I started working on the idea of two or more figures as a unity, blended into one carved and rhythmic form. Many subsequent carvings were on this theme.[225]

In her drawing *Madonna and Child*, Hepworth was most likely responding visually to the long Byzantine history of religious icons. The serenity of the countenances of the Mother and Child, the stylized abstraction of their small hands and feet, small facial features, long straight narrow noses, and small curved lips, and the soft golden background all suggest a Byzantine influence. The embracing actions of the Mother and Child's arms and the unbroken contour that encloses the two figures suggests strongly that Hepworth was looking specifically to the figures of Mary and Jesus in the renowned *Virgin (Theotokos) and Child (Vladimir Virgin)* icon (late 11th to early 12th century). In both Hepworth's *Madonna and Child* and in the *Vladimir Virgin*, the artists created tender images of Mary as the Virgin of Compassion, who presses her cheek against her Son's. Both images communicate a deep pathos as Mary contemplates her Son's future sacrifice. This is made even more explicit on the back of the *Vladimir Virgin*, which depicts images of the instruments of Christ's Passion. In turn, Hepworth created an image that would have personally evoked her sorrow at her son's death earlier that year. Hepworth's creation of *Madonna and Child* suggests that she personally identified with Mary's tragic sorrow, as both mothers experienced the death of their first-born sons.

More generally, *Madonna and Child* reveals Hepworth's focus throughout her artistic career on the theme of maternity. The titles of Hepworth's sculptures often suggest words associated with the theme of maternity, the artist writing of one work, "The feeling is Genesis…very peaceful. I had thought of 'Arkhe' [beginning] but don't feel satisfied — though 'the beginning' would be the right idea …'Origin'? 'Source'? 'Eiréne' [peace]?"[226] Hepworth found the relationship between her art and her responsibility for her children to be mutually enriching. She emphasized the inspiration she received from her children, writing "the forms flew quickly into their right places in the first carvings I did after SRS [Simon, Rachel, and Sarah, her triplets] were born" in 1934, associating them with a major shift in her work and a new clarity of vision.[227] She wrote extensively of her own experience as a woman artist:

The feminine point of view is a complementary one to the masculine. Perhaps in the visual arts many women have been intimidated by the false idea of competing with the masculine. There is no question of competition. The woman's approach presents a different emphasis.

I think that women will contribute a great deal to this understanding through the visual arts, and perhaps especially in sculpture, for there is a whole range of formal perception belonging to feminine experience. So many ideas spring from an inside response to form; for example, if I see a woman carrying a child in her arms it is not so much what I see that affects me, but what I feel within my own body. There is an immediate transference of sensation, a response within to the rhythm of weight, balance and tension of large and small forms making an interior organic whole. The transmutation of experience is, therefore, organically controlled and contains new emphasis of forms. It may be that the *sensation* of being a woman presents yet another facet of the sculptural idea. In some respects it is a form of "being" rather than observing, which in sculpture should provide its own emotional and logical development of form.[228]

While the theme of maternity was a foundational aspect of the Modernist carvings of Jacob Epstein and Henry Moore, who depict the figures of pregnant women as symbols of creation and nurturing, Hepworth's overall approach to the theme is more complex, depicting mother and child as unified within one sculpture, and yet as distinct figures. Her poignant works communicate the artist's direct experience of carrying a child in herself, and of the separation of birth. This unity and separation is embodied in *Madonna and Child*, as Mary contemplates the future death of her Son.

Madonna and Child also represents Hepworth's return in the 1950s to the Christian faith as an "Anglican Catholic." While in 1944 she had clearly stated her atheism, in the 1950s she gave a number of works religious titles, and in 1966 she elaborated on her purpose behind her artwork:

> At an early stage I became troubled about the "graven image", but I decided that it was sin only when the image sought to elevate the pretensions of man instead of man praising God and his universe. Every work in sculpture is, and must be, an act of praise and an awareness of man in his landscape. It is either a figure I see, or a sensation I have, whether in Yorkshire, Cornwall or Greece, or the Mediterranean.[229]

Five years after creating *Madonna and Child*, Hepworth created other explicitly religious works that reveal the artist's personal reflections concerning Christianity in the 1950s. These works continued the renewed spirituality in her work following the tragic death of her son in 1953 and the emotional distress of her earlier divorce from Nicholson in 1951 and his remarriage in 1957. In 1969-70, Hepworth wrote in a letter:

> My sculpture has often seemed to me like offering a prayer at moments of great unhappiness. When there has been a threat to life — like the atomic bomb dropped on Hiroshima, or now the menace of pollution — my reaction has been to swallow despair, to make something that rises up, something that will win. In another age...I would simply have carved cathedrals.[230]

One of these religious works from the 1950s is *Figure (Requiem)* (1957), and may also directly commemorate the death of Paul. In addition, on the acquisition by Tate of Hepworth's sculpture *Cantate Domino* (1958, "Sing to the Lord," the opening phrase of Psalm 98), Hepworth wrote to

the director, "It was intended to be reserved as a Headstone for my grave in St. Ives...I only mention this because I have always considered this a religious work."[231] Hepworth's religious devotion was especially strong after she was diagnosed with cancer in 1965. She specifically connected her creation of her sculpture *Construction (Crucifixion)* (1966) to her illness. In the 1960s and 1970s she was a regular communicant at St. Ives Parish Church, and was friends with Father Donald Harris of St. Paul's Knightsbridge in London, and Moelwyn Merchant, former Dean of Salisbury Cathedral. Her reflections on the relationship between the artist and Christianity were also shaped by her reading of writers including Teilhard de Chardin, Søren Kierkegaard, and Thomas Traherne.[232]

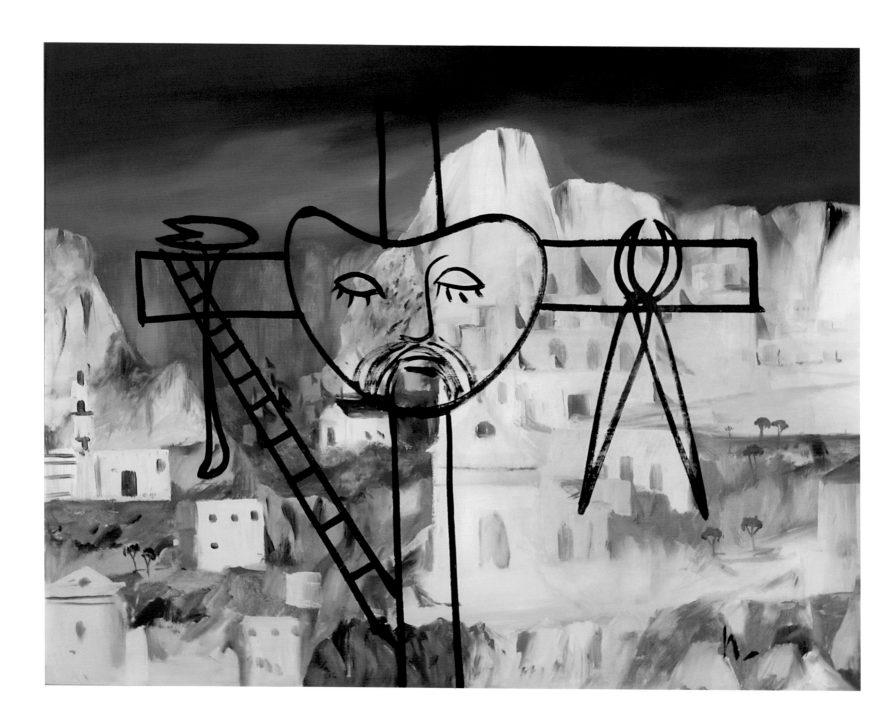

SIDNEY NOLAN
1917–1992

Created only three years after Barbara Hepworth's drawing *Madonna and Child*, Sidney Nolan's *Crucifixion* of 1956 is an excellent example of this artist's stimulating and unique artistic vision. An internationally acclaimed Modern painter who created works on themes closely related to his own life, Nolan worked prolifically in a vast variety of media including painting, drawing, printmaking, and stage and costume designing for operas and ballets. Born in Australia, Nolan enrolled twice at the National Gallery of Victoria School of Art (in 1934 and 1936). However, he preferred to educate himself, looking to reproductions of works by Picasso, Paul Klee, Henri Matisse, and the Surrealists for inspiration in his own semi-abstract works. In 1942, Nolan was conscripted into the army. He began to paint his immediate surroundings of the Australian landscape, developing a new tradition of evocative desert-scapes of arid central Australia that barely acknowledged the world at war. His postwar paintings continued to evoke his happy childhood in Australia. The year the war ended, Nolan began his first famous paintings on the theme of Ned Kelly, an Irish-Australian outlaw who was hanged for theft and murder in 1880. Beginning in 1953, Nolan established his new home in London and began traveling extensively, living in Greece from 1955 to 1956 and in the United States from 1958 to 1959 and in 1966. From the 1970s Nolan visited Australia nearly every year. He also traveled to China. When he traveled, Nolan made tiny sketches in small notebooks, took photographs, and began paintings, later completing his paintings in his studio. Although many aspects of his artwork throughout his career had deep connotations to his years in Australia, Nolan expressed how his travels had shaped his sense of national identity, stating in 1992, "I didn't feel Australian, I don't feel English, etc. I like to feel wherever I land is the planet Earth. I'm an earthling."[233]

Crucifixion is a painting from Nolan's *Crucifixion Series* that stems from an extensive artistic pilgrimage that he and his wife made in 1954 to see Early Renaissance painting in Northern Italy and to see Calabria and Puglia in Southern Italy. Four years earlier, Nolan had traveled for almost thirteen weeks to Spain, Portugal, Italy, and France, during his first trip overseas. During this earlier trip, Nolan had been captivated by viewing the art of the Old Masters in person, particularly the work of Giotto, Van Eyck, Mantegna, Bosch, and El Greco, writing in a letter, "After seeing the El Greco's [sic] in Spain for instance it is difficult to feel the same again about painting. Even for an Australian. He is an incomparable artist."[234] In another letter he wrote, "El Greco…had the courage to look miracle in the face and paint it."[235] Viewing the works of the Old Masters enabled Nolan to gain a deeper understanding of the faith of the artists and the cultures that had produced them, the artist reflecting,

> The painters who moved me most (El Greco & Giotto) seemed men primarily of faith. Presumably religious faith. The painting is wonderful in the sense that it is a painting of wonder. Differently from Michelangelo for instance, in the Sistine Chapel, which is certainly wonderful painting, but by no means painting of wonderment. What implications can be drawn I do not know, but I know that I did feel it in Spain with El Greco first & felt it verified later in Italy.[236]

However, although captivated by the paintings of the Old Masters after this first trip to Europe, Nolan concluded,

> I knew one day I would want to be back in Australia, with or without art, with or without religion. In short, in a crisis it is a good idea to start from scratch. Which is not to say I do not admire almost hungrily and passionately, the beautiful things that are in Europe.[237]

On returning to Australia in 1951 after this first trip to Europe, Nolan learned about the inaugural Blake Prize for

Sidney Nolan (1917-1992)
Crucifixion, 1956 (detail)
Ripolin enamel on board, 35.5 x 47.25 inches

Religious Art, one of the most prestigious art prizes in Australia, which had been held earlier in the year with the aim of encouraging the Church to become a patron of the arts and to encourage prominent artists to create religious images, an area of iconography greatly dismissed by Australian artists. Nolan found the Blake Prize an inspiration. He began to work on a large religious altarpiece consisting of 18 panels that would set biblical figures against a background of black burnt bush, evocative of contemporary brush fires in the Sydney suburbs. However, he turned instead to creating seven individual paintings of religious events and figures, painted over a few weeks of Christmas 1951 and New Year 1952, including *St. Francis Receiving the Stigmata* (1951), *Flight into Egypt* (1951, received third prize in the 1952 Blake Prize), *St. John in the Desert* (1951), *Dream of Jacob* (1951), *Annunciation* (1951), *Temptation of St. Anthony* (1952), and *Centaur and Angel* (1952). For these works, Nolan referred to catalogues, brochures, and postcards accumulated during his travels abroad, with specific references to the iconography of Giotto and El Greco, combining his direct knowledge and experiences of Australia and Europe. In a letter, the artist wrote,

> The problem in this country is one of relating the magnificent formal discoveries of Europe with the impact that the Australian landscape makes on a painter here.
>
> I have attempted, during the last few months, to treat the traditional religious themes, Agony in the Garden, Flight into Egypt, St. John in the Desert etc placed in the landscape here, as I understand it...
>
> [I] feel I am a bit closer to the old urge of making the content indivisible with the form.[238]

In 1954, Nolan was made Australian Commissioner for the Venice Biennale, and he returned to Italy. From April of that year, he and his wife spent six months in Italy, and he found his inspiration for the *Crucifixion Series* during this trip. The paintings in the *Crucifixion Series* continue his earlier direct engagement of Christian imagery in the 1950s and include some of Nolan's most powerful paintings resulting from his travels abroad. The paintings in the *Crucifixion Series* explore a Cubist and sometimes Surrealist approach to the landscape of the dry Puglia coastline. The paintings in the *Crucifixion Series* include *Crucifixion* (1956, Collection of Howard and Roberta Ahmanson); *Italian Crucifix* (1955, Art Gallery of New South Wales, Sydney); *Italian Crucifix* (1955, Private Collection); *Crucifixion* (c.1955, Christie's Melbourne, May 2-3, 2002, Australian and International Paintings); and *Crucifix, Southern Italy* (1955, National Gallery of Victoria, Melbourne). The theme of the Crucifixion remained central to Nolan's work of the 1950s, with the artist also creating two more traditional Crucifixion images: *Crucifixion* (1959, Private Collection) and *Yellow Cross* (c.1959, Private Collection, Sydney). Nolan's 1968 series of three illustrations (Bonhams & Goodman, Melbourne, "Australian, International and Aboriginal Art," November 19, 2007) based on Benjamin Britten's *The Holy Sonnets* of John Donne also focus on the Crucifixion.

Sidney Nolan's *Crucifixion* of 1956 in this exhibition is set against a hillside Italian village dotted with small olive trees. In *Crucifixion*, the artist evokes the breathtaking beauty of the southern Italian landscape with its steep mountains, plunging valleys, and dry earth tones of the hillsides. A road zigzags up the steep hillside at right. The bold yellow circle at the right makes it seem as if the viewer is looking at the landscape through two different colored lenses, a teal green lens on the left and a yellow lens on the right. The striking crucifix, painted with heavy black and brown brushstrokes with red accents, dominates the scene. The sheer faces of the gray cliffs dwarf the village below and provide an appropriately stark setting for the sorrow and drama of the Crucifixion. By making the crucifix so large when compared to the

landscape, the artist suggests the long history of Catholicism in Italy as well as the global impact of the Crucifixion. The crucifix acts as a symbol of redemption in an area of Europe that only nine years before had experienced the trauma of the Second World War.

Crucifixion exhibits Nolan's characteristic use of overlaid thin washes of color, and the influence of the Australian desert in his use of pastel colors. The magnificent color of the azure sky is emphasized through the lushness and fluidity of the paint and Nolan's bold turbulent brushstrokes. The smoothness of the ripolin enamel paint is emphasized through its placement on wooden board. Throughout his career, Nolan worked almost exclusively with ripolin, a fast-drying, high-grade commercial enamel. Nolan wrote in a letter in 1943 regarding his fascination for this medium, "Ripolin is like quick-silver…I can see us cooking it over a fire or leaving it out under the rosemary all night to see what secrets can be found in it."[239] He also stated in 1962, "Picasso said Ripolin was a healthy paint. I was after a transparent thing on the smooth surface."[240] Nolan had a wonderful ability to describe the paint with great sensory appeal: "I like the immediate feeling of Ripolin (and the aroma!). When you can see every brush stroke if you like. Some people want all surfaces to be crumbly like Stilton cheese."[241] By using an enamel-based paint, Nolan, consciously or unconsciously, evoked the history of this medium, which was used frequently in Medieval reliquaries (containers that store and display sacred relics). In Medieval Europe and Byzantium, worshippers enshrined relics in reliquaries that were made of gold, silver, ivory, gems, and enamel because of the high value and sacred nature of the relics themselves. The enamel paint used in *Crucifixion* thus suggests the sacred nature of this subject and the high value placed upon it by the artist. Nolan signed the painting three times, as if determined that he should be identified with this work: a large "N." at the lower right; a signature "Nolan/1956" at the lower right; and again a signature "Nolan/1956" at the lower left center.

In *Crucifixion*, the boldly outlined crucifix is derived from a roadside shrine that Nolan saw and recorded in a black-and-white photograph during his travels in Southern Italy in 1954. The crucifix that Nolan saw was a tall wooden Cross with a ladder attached to the base and left arm of the Cross; a hammer attached to the left arm of the Cross; a pair of pliers attached to the right arm of the Cross; a dove and a sign reading "INRI" attached to the top of the Cross; and the head and body of Jesus attached to the center of the Cross, with His body covered in a robe, and the image of His head depicted on the Veil of Veronica. The Veil of Veronica is an account that states that Saint Veronica encountered Jesus carrying the Cross on the way to Calvary, and that when she wiped the sweat off His face with her veil, the image of His face was imprinted on the cloth. This event is celebrated by the Sixth Station of the Stations of the Cross. In his painting, Nolan stays close to the original photograph, and depicts the ladder on the left going up the Cross, the hammer on the left arm of the Cross, and the pliers on the right arm of the Cross, illustrating the instruments of Christ's passion. The painted red accents on the crucifix suggest Christ's blood being spilled out. Nolan gives the face of Christ a moustache, as in the image on the roadside shrine, but no beard. Nolan also preserved the iconography in the original roadside shrine of Christ's face being presented on Veronica's Veil. The reference by Nolan in *Crucifixion* to Veronica's Veil and the Stations of the Cross is also supported by a statement the artist made in 1978, "I like what an historian [Steven Runciman] said of the Kelly series: 'They are really stations of the Cross.'"[242] Nolan was working on his second Kelly series in 1955, at the same time as his *Crucifixion Series*.[243] In *Crucifixion*, the artist transposed the shape of Veronica's Veil to be the abstract shape of Christ's face. The shape of Christ's face also perhaps alludes to the shape of an artist's palette.

Immediately behind the face of Christ and the lower section of the Cross, Nolan painted an image of a church, which is representative of the bombed Eremitani Church in Padua (which he had visited), with its roof and walls seemingly dissolved, and which also gives the setting where worshippers could participate in the Eucharist by taking Christ's body and blood, so startlingly depicted on the Cross.

Nolan's *Crucifixion Series* exhibits his lifelong focus on themes of violence, isolation, and the need for a hero. He was perhaps drawn to creating his *Crucifixion Series* as a continuation of these themes in his Kelly paintings (and even references to Christ, as in *Kelly* [1956], in which the outlaw's mask is topped by clusters of burnt sticks resembling the Crown of Thorns).[244] However, Nolan expressed his doubts about the role of a hero in contemporary life, writing in his diary in 1952:

> The reception that the Kelly paintings had in Paris seems to suggest that the times are ready again for hero portrayal but I do not know that I am ready to provide what the times desire. When I painted the Kellys I did, but they were paintings of violence, conceived in violence and executed in violence. The times are jaded, naturally they turn to violence but all told it seems an adolescent sphere. Eminently paintable of course and perhaps my responsibility stops there. Leaving that point for the moment, what search is at the back of my present series of religious paintings? Does one conceive of Jesus as the ultimate hero? This is an attractive proposition for painting but seems a travesty as far as faith is concerned.
>
> We are not animals, neither are we angels. But we are (if you like) refracted versions of both. But not one and then the other, but each at the same time, fused in time and place. Certainly we cannot escape, but we can accept.[245]

Nolan expressed a sense of personal identification with the figure of the hero Ned Kelly in his isolation, separated from his family, community, and civilization, which could also be seen in the isolated figure of Christ on the Cross, carrying the sins of the world. In 1988, the artist reflected,

> The Kelly pictures weren't really only history pictures. They were about a psychological situation I was in…I wanted to embody the violence I had encountered in the army…I was a loner. It was this sense that everybody, without exception, in the community was against you. Even your mother and father were against you: total isolation from the community you were born into. It's that which allows you to look at a civilization without any tremors…Something of that threads its way through my work…I guess I'm a man without a civilization…Like Milton, I would like to inhabit Paradise. But that's not the same thing as wanting to belong to a civilization. I've never lost my belief that I wanted to inhabit Paradise. But I've very guarded about civilizations!…This Paradise thing: what matters is that your nerve does not break. Nietzsche's did. So did Ruskin's. You've got to belong to a civilization that's doomed, and express Paradise. It's a dangerous mental position to occupy; but then I wouldn't like to occupy any other… Children inhabit a kind of limbo — between Paradise and intense disappointment or despair. Radiant happiness and desperation: all that can happen to a child in one day. Children are defenseless against the world. I want to see if I can become defenseless and none-the-less maintain growth and survival. No one can will themselves to do a bad painting, or a good painting: to that extent, you're like a child.[246]

Throughout his career, in interviews, letters, and his personal diary, Nolan reflected on the role of religion in his life and in his artwork, stating in 1965,

I would say I would like to be a religious person. Perhaps I am. But I feel we 20th-century ones are midway between two religions. The first is Christianity which has been tried and found wanting. The second is yet to come. God only knows what it might be… As of now, however, I agree with Archbishop Gough's [the Anglican Archbishop of Sydney] reported reluctant admission that the so-called "post-Christian era" is a fact. I also believe that the post-civilization era is a fact. We are living in it now.[247]

Later, in an interview in 1980, Nolan continued to express his doubts about the existence of a greater power, or, as he termed it, "an umpire," his thoughts perhaps shaped by the horrors of the Second World War:

I believe that the game has to be fought out on its merit and there isn't an umpire. Well, most people — and society in general — assume that there is an umpire and they act accordingly and everybody toes the line. But, of course, this cracks up from time to time and there are wars and they can see that there isn't any umpire.[248]

However, in 1975, Nolan had begun to reflect upon human mortality and his desire to express the spiritual in his artwork and to create something lasting, describing the artistic body of contemporary artists as a "holy community":

I now realize that there is a time limit for what I want to do. There are areas, spiritual as well as technical, which I haven't explored. What an artist really wants is to say something which, one day, out of contemporary contexts, will mean something important, will be sure of survival. This is quite different from momentary success or fulfilling current demands. It is a deeper need, more like the maternal feeling for children. And because you don't know when that might occur, you have to chase it incessantly. It is this quest which links all artists together. We are forced to compete with each other, but we are really pledged together, like some kind of holy community. We know that the competition has nothing to do with what drives us on…To artists, the winning is subsidiary.[249]

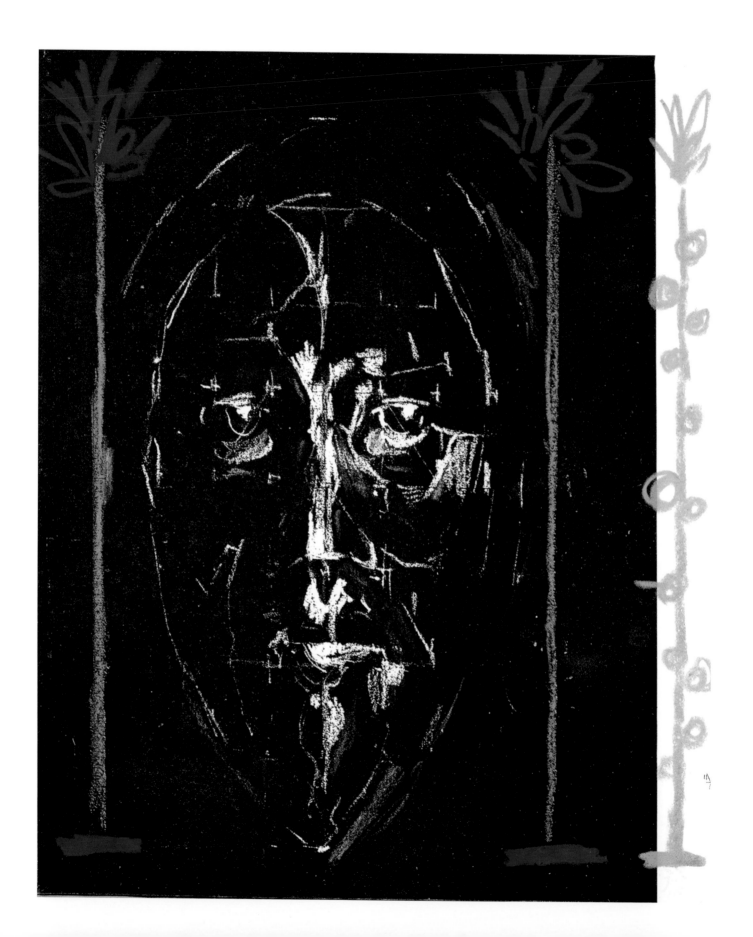

One of the greatest British artists of the mid-twentieth century, Graham Sutherland studied at Goldsmith's College of Art in London in the 1920s and began his career as a printmaker. His early poetic etchings of rural England from the 1920s reveal his affiliation with the Neo-Romantic Movement and his love of the visionary nineteenth-century English etchings of Samuel Palmer. Sutherland began painting after the collapse of the print market in 1930. He was especially inspired by the bareness of the landscape of Wales and the objects he found in the landscape, depicting them as abstract and anthropomorphic forms in dramatically mysterious and threatening paintings. In 1936 Sutherland exhibited at the International Surrealist Exhibition in London, and during the Second World War he worked as an Official War Artist, creating vivid and memorable images of the Blitz in London. Beginning in 1947, Sutherland and his wife Katherine lived for part of each year in the south of France where he depicted Mediterranean scenes using vivid colors to emulate the intensity of the southern light. Sutherland's fascination with nature continued throughout his career. He was also an immensely successful portrait painter, his unconventional portraits created from drawings and oil sketches made directly from the sitters. Two of his most famous (and infamous) portraits include *Somerset Maugham* (1949) and *Sir Winston Churchill* (1954; strongly disliked by the sitter and destroyed by Lady Churchill). Sutherland also designed posters, ceramics, book illustrations, ballet costumes, and set designs. During the artist's lifetime, multiple significant retrospective exhibitions were held, including at the Venice Biennale; the Musée National d'Art Moderne, Paris; the Tate Gallery; and the São Paulo Biennale, Brazil. Sutherland was awarded the Order of Merit in 1960.

Many of Sutherland's most moving works of art concern Christian themes, particularly the Crucifixion. Sutherland converted to Roman Catholicism early in his life in 1926. He wrote in a letter in 1980, "Although I am by no means *devout*, as many people write of me, it is almost certainly an infinitely valuable support to all my actions and thoughts."[250] Sutherland reflected on the contemporary role of the religious artist and religious art:

As I see him in the strict sense (though I wonder if this is the most truthful one?) he is someone who brings his skill and understanding to bear on the problem of giving expression to the tenets of an organized belief. Those who have done this best in the past have gained no doubt from their belief. But they seem to have excelled especially because, in addition to this, they were naturally good artists. But is it not a fact that the possession of such a gift may be held outside any organized faith?...It seems clear to me that there are various kinds of artists who, whether believers or not, have produced or could produce what could be called religious art both today and in the past...These artists come to mind because deeply rooted in them there is a genius for expression, a largeness of spirit, great perspicacity and curiosity, to say nothing of technical invention and a passion close to the sentiment which could be called, properly I think, religious.

On the other hand, what can one say of those "religious" works in the period of the decline of understanding of the visual arts in the Church — for they are not religious at all.[251]

Sutherland's first religious commission was in 1946 when he painted a large *Crucifixion* for the church of St. Matthew, Northampton. Sutherland wrote regarding this commission, "I should welcome the opportunity to see what I can do. To do a religious painting of significant size has always been a wish at the back of my mind."[252] Before creating the Northampton *Crucifixion*, Sutherland created a

Graham Sutherland (1903-1980)
Head of Christ, 1964
Lithograph and pastel on paper, 9 x 8 inches

number of works inspired by the Crown of Thorns, the artist writing,

> My thorn pictures came into being in a curious way. I had been asked by the Vicar of St. Matthew's, Northampton, to paint a Crucifixion...So far I had made no drawings — and I went into the country. For the first time I started to notice thorn bushes, and the structure of thorns as they pierced the air. I made some drawings, and as I made them a curious change developed. As the thorns rearranged themselves, they became, whilst still retaining their own pricking, space-encompassing life, something else — a kind of "stand-in" for a Crucifixion and a crucified head...The thorns sprang from the idea of potential cruelty - to me they *were* the cruelty; and I attempted to give the idea a double twist, as it were, by setting them in benign circumstances: blue skies, green grass, Crucifixions under warmth.[253]

For the *Crucifixion*, the artist stated that he wanted to produce an image which was within the tradition of the Anglican church, and that would focus on Christ's suffering and isolation and encourage a personal response from the viewer.[254] Sutherland elaborated on his approach to the subject of the *Crucifixion*, writing, "It is the most tragic of themes yet inherent in it is the promise of salvation. It is the symbol of the precarious balanced moment...and on that point of balance one may fall into great gloom or rise to great happiness."[255] *Crucifixion* was Sutherland's first life-size representation of the human figure and was inspired by the *Crucifixion* of the *Isenheim Altarpiece* by the Northern Renaissance artist Matthias Grünewald. Both Sutherland and Grünewald depict Christ's body as blistered, and commemorate the Crucifixion with overpowering emotion. Sutherland also looked to the depiction of human cruelty and suffering in Picasso's *Guernica* (1937), and to a recently published book of photographs of the victims of the Nazi death camps,[256] writing in 1970 regarding this book,

> I remember receiving a black-covered...book dealing with the camps. It was a kind of funeral book. In it were the most terrible photographs of Belsen, Auschwitz and Buchenwald...in them many of the tortured bodies looked like figures deposed from crosses. The whole idea of the depiction of Christ crucified became much more real to me after seeing this book, and it seemed to be possible to do this subject again. In my case, the continuing beastliness and cruelty of mankind, amounting at times to madness, seems eternal and classic.[257]

Sutherland's painting, *Crucifixion*, was appreciatively received by viewers, the rector of the church describing the work as "the combination of timeless symbolism and contemporary immediacy" and as "disturbing and purging. For generations the subject of the Crucifixion has been wrapped in cotton-wool...Sutherland has deliberately unwrapped a great deal of that cotton-wool covering to bring home with tremendous power the effect of human sin and the cost of man's redemption."[258] One contemporary remarked, "Only one other professing Christian artist of this century, [Georges] Rouault, has handled this great theme with as much skill and real feeling."[259] Indeed, the names of Sutherland and Rouault were coupled together multiple times as artists of powerful religious works, and a major Rouault exhibition was held at the Tate Gallery while Sutherland was working on his *Crucifixion*.[260] In his subsequent religious paintings Sutherland continued to emphasize the suffering of Christ and the motifs of the Cross and the Crown of Thorns, explaining that he saw the suffering of war in the suffering of Christ, which offered the hope of redemption through Christ's personal sacrifice.

The work by Sutherland in this exhibition, *Head of Christ* (1964), stems from Sutherland's most famous work, the *Christ*

in *Glory in the Tetramorph* tapestry (1962, 74 feet 8 inches x 38 feet) created for the wall behind the altar of the new Coventry Cathedral designed by the architect Basil Spence. The old cathedral in Coventry had been destroyed in 1940 by bombing by the Luftwaffe, and Spence was commissioned to design a new cathedral next to the bombed-out remains of the old Cathedral as a sign of faith, trust, and hope. Spence had admired Sutherland's 1946 *Crucifixion* for the church of St. Matthew, Northampton. Sutherland worked on the designs for the tapestry for ten years. The final tapestry depicts the seated figure of Christ surrounded by the emblems of the four Evangelists. The French weaving firm of Pinton Frères of Felletin, near Aubusson in France, wove the tapestry from Sutherland's design.

The tapestry, *Christ in Glory in the Tetramorph*, was installed in time for the cathedral's consecration in 1962. Sutherland's tapestry reflects the wishes of Spence and the Cathedral authorities for the artist to create a design to which the ordinary viewer could relate, the architect writing to Sutherland, "This is a modern cathedral, and I have tried to contain in it understandable beauty to help the ordinary man to worship with sincerity, and I feel that the tapestry too should have a direct communication."[261] The tapestry reflects the four themes requested by the Cathedral authorities, including the Glory of the Father, observed in the light coming down from heaven above Christ's head; Christ in the Glory of the Father; the Holy Spirit and the Church, represented by the dove above Christ's head and by the four symbols of the Evangelists; and the Heavenly Sphere, represented by an image of St. Michael casting Satan out of heaven. The four symbols of the Evangelists (Matthew symbolized by a winged man, Mark symbolized by a winged lion, Luke symbolized by a winged ox, and John the Evangelist symbolized by an eagle) compose the Tetramorph, an aspect of Christian iconography with a long tradition. Images of the four Evangelists in the

form of the Tetramorph can be found in the Book of Kells (c.800), and images of the four Evangelists in the form of the Tetramorph surrounding a seated figure of Christ can be seen in the Bamberg Apocalypse (c.1000) and on the tympanum of the Romanesque church of St. Trophime in Arles, France.

Sutherland undertook a great deal of research for his approach to the images in the tapestry. He had been deeply impressed by the magnificent Byzantine mosaics of the cathedral of Santa Maria Assunta on the island of Torcello when traveling in Venice in 1952. The Byzantine aspects of the tapestry (and the subsequent lithograph, *Head of Christ*) can be observed in Christ's frontal pose, the strong symmetry, and the linear rigidity. In the tapestry's imagery, Sutherland also wanted to communicate the solemnity of the Pantocrator imagery present in Greek and Sicilian churches, the beauty of a Medieval enamel reliquary, and the magisterial sculpture of the great Romanesque and early Gothic French cathedrals.[262] Sutherland also elaborated,

> I made studies from nature for the figure only [not Christ's head]. I studied the proportions of my own head, and I looked at myself in a glass with regard to lighting and so on. The final head really derived from a hundred different things — photographs of cyclists, close-ups of people, photographs of eyes, Egyptian art, Rembrandt and many others. [But] Not El Greco at all.[263]

Sutherland connected the Crucifixion at the base of the figure of Christ in the tapestry with the sufferings of those in the Nazi death camps, and intended the congregation in the Cathedral to be mourners at the Crucifixion. Overall, the figure of the risen and ascended Christ in the tapestry shows Christ in glory, triumphing over death, protecting His people, and as King and Prince of Peace.

Sutherland created approximately twelve lithographs (including *Head of Christ*, and multiple other works based on

the tapestry) two years after the completion of the tapestry. The creation of this lithograph by Sutherland reveals the artist's lifelong love of printmaking. He applied various details in pastel by hand to each lithograph. A lithograph very similar to *Head of Christ* was used for the cover of the book *Christ in Glory in the Tetramorph — The Genesis of the Great Tapestry in Coventry Cathedral* (1964, published by the Pallas Gallery for the Redfern Gallery). Although the lithograph *Head of Christ* (initialed and dated at the lower right, "GS/1964") is relatively small in size, like the Coventry tapestry it creates a monumental depiction of the face of Christ, its abstraction capturing Christ's mystery and majesty. As in the tapestry, Sutherland depicted Christ's face as a long oval with a line down its center and a faint line across Christ's forehead, thus forming a Cross. The dark black ink of the lithograph with its dramatic white accents suggest the weight and majesty of the presence of God, while the hand-touched accents in brilliant purple, blue, and tan pastels of plant forms to either side of the head of Christ (which have no correlation to the imagery in the tapestry) give it a joyful sensation and act as symbols of regeneration. By isolating the head of Christ in the lithograph, Sutherland may have drawn on the history of images of the Veil of Veronica, as also earlier explored in the *Crucifixion* by Sidney Nolan. As mentioned with regards to the Nolan painting, the account of the Veil of Veronica states that Saint Veronica encountered Jesus carrying the Cross on the way to Calvary, and that when she wiped the sweat off of His face with her veil, the image of Christ's face was imprinted on the cloth (this event celebrated by the Sixth Station of the Cross, and meaningful to Sutherland as a Catholic).

Sutherland exhibited *Head of Christ* in 1964 in an exhibition of studies for the Coventry Tapestry at the Redfern Gallery, in conjunction with the publication of the book regarding the tapestry's creation, *Christ in Glory in the Tetramorph — The Genesis of the Great Tapestry in Coventry Cathedral*.[264] Along with works associated with the Coventry tapestry, Sutherland also exhibited a silver crucifix he had originally designed for the high altar of Ely Cathedral. Many of Sutherland's preparatory drawings can be found at the Herbert Art Gallery and Museum, located close to the Cathedral in Coventry. These drawings offer intriguing glimpses into Sutherland's creative process.[265] The *Head of Christ* lithograph is presented in this exhibition in the original frame as when it was displayed at the Redfern Gallery.

Correspondence between the original owner of the *Head of Christ* lithograph and Sutherland sheds fascinating light on how the lithograph was received by viewers just ten years after its creation. The original owner of this lithograph, G.G. Walker of Oxfordshire, wrote a letter to the artist at Sutherland's residence in France:

> Since last writing to you, about a year ago, I have purchased a "Head of Christ", one of the pictures in mixed media (lithograph and chalks) of which I am told you produced twelve. In good daylight the chalks glow beautifully on the black background, creating a most attractive and satisfying effect. You may be interested to know that of the friends who have seen it, the younger people of my son's age — in their twenties — are the ones who have been quickest to respond to its magic and have expressed the wish to have it on their own walls — the dual attraction of distinguished art and Jesus Christ superstar? [Note: The musical "Jesus Christ Superstar" was first staged in 1971, three years before this letter was written.]
>
> I find that having a great memento of the head of the Coventry tapestry makes no less agonizing the desire to have some original relating to the foot, i.e. the Crucifixion, the jewel of the cathedral...I hope

you can manage to produce a small drawing for me, however simple. I believe you produced twelve drawings in lithograph and chalk on this theme at the same time as the heads but I am told these never come on the market nowadays — and I have certainly tried hard enough to seek any out.[266]

Sutherland replied to Walker's request a few months later:

The study to which you refer certainly is in mixed media and was shown in connection with the book which was published by the Pallas Gallery on the Tapestry of Coventry for certain friends. Evidently you have come across one of these specially done things.

I have not forgotten the question of the drawing which I promised you, and I have put aside a Crucifixion sketch but I would rather wait and see whether I can do something a little more definitive & better.

Please have patience.[267]

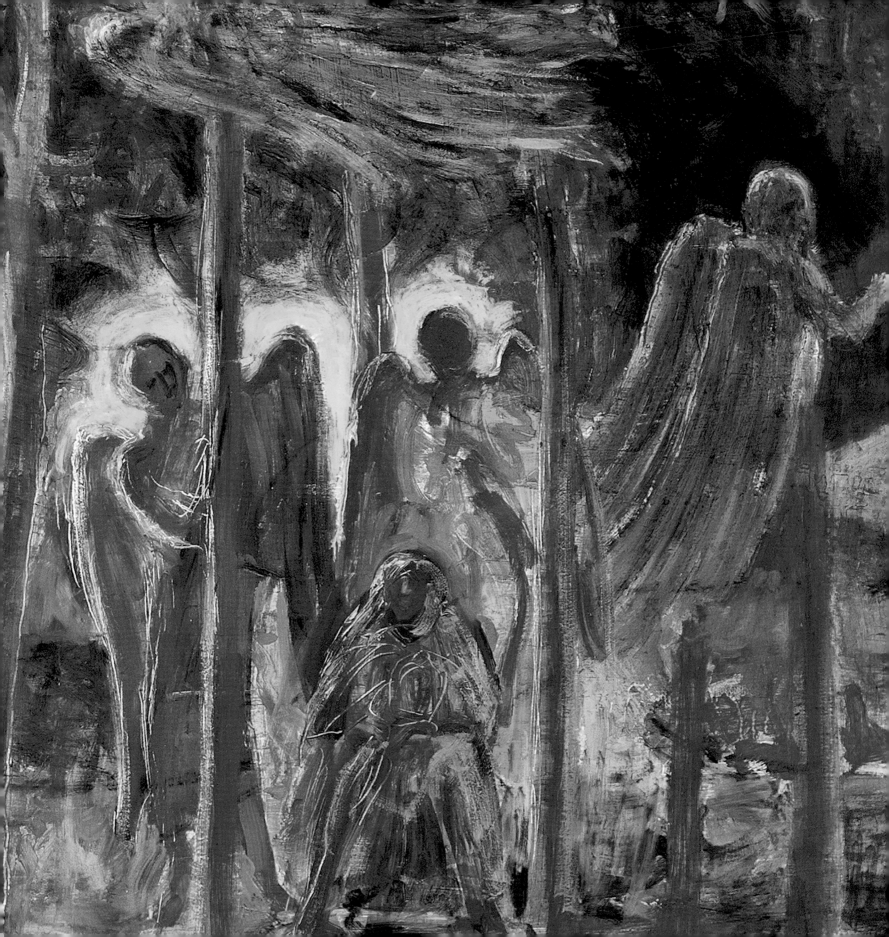

Christopher Le Brun is a contemporary English painter, sculptor, draftsman, printmaker, and set designer. Le Brun studied at the Slade School of Fine Art and the Chelsea School of Art in London in the 1970s, and was a visiting lecturer at the Brighton, Slade, and Wimbledon Schools of Art from 1976 to 1983. He was a prizewinner in 1978 and 1980 in the John Moores exhibitions at the Walker Art Gallery in Liverpool, and has exhibited in multiple major surveys of international art. In 1984 he made designs for a revival of *Ballet Imperial* (choreographed by George Balanchine) at the Royal Opera House, Covent Garden. From 1987 to 1988 he received the D.A.A.D. (German Academic Exchange) award from the German government, which enabled him to live and work in Berlin for a year. Le Brun is a former trustee of Tate, the National Gallery, London, and the Dulwich Picture Gallery, and was elected to the Royal Academy in 1996 and in 2000 became the Royal Academy's first Professor of Drawing.

Le Brun's beautiful paintings reference the mythological and dream-like imagery of nineteenth-century French Symbolist painters such as Puvis de Chavannes and Gustave Moreau, as well as twentieth century painterly abstraction with his expressive handling of paint. From an early stage in his career, Le Brun developed a strong connection to the landscapes of Turner, Claude, and Poussin, and to the pastoral landscapes of Paul Nash and Graham Sutherland. Le Brun's dream-like images create a counterbalance between the tension and repose of figures in a poetic landscape and a rich dialogue between figuration and abstraction. Le Brun identifies the tension between his abstract and figurative work as a timeless tension, with abstraction an essential but implicit feature of the history of art, rather than a feature specifically unique to twentieth century painting.[268]

Study for the Good Samaritan, 1995
Study for the Prodigal Son I, 1995
Study for the Prodigal Son II, 1995
Study for the Parables, 1995

The four beautiful paintings by Christopher Le Brun in this exhibition, *Study for the Good Samaritan*, *Study for the Prodigal Son I*, *Study for the Prodigal Son II*, and *Study for the Parables* (all 1995, and signed and dated on the reverse) were created for Liverpool Cathedral, the largest Anglican cathedral in Europe and one of the greatest achievements of the architect Giles Gilbert Scott. Born in London into a Roman Catholic family of architects, Scott was lauded for his blending of Gothic tradition with Modernism, creating landmarks such as Battersea Power Station, and perhaps best known for his design of the iconic red telephone box. The competition for a design for Liverpool Cathedral was announced in 1902, and the young architect Scott won the competition in 1903. Despite the major delays caused by the First World War, the high altar, chancel, and eastern transepts were completed and the Cathedral was consecrated in 1924. The Cathedral as a whole was not completed until 1978, a testimony to the faith and determination of the people of Liverpool.

Liverpool Cathedral actively commissions artists to create works of visual art to teach, inspire, and challenge worshippers in this sacred space, including paintings and sculpture by five Royal Academicians: Craigie Aitchison, Tracey Emin, Elisabeth Frink, Christopher Le Brun, and Adrian Wiszniewski. In 1995, five principal contemporary British painters were invited to submit ideas for two paintings to be installed above the choir stalls in Liverpool Cathedral. The paintings were to be based around the text from Mark 4:2, "He taught them many things by parables," and to be representational. A panel was composed of the Dean of the Cathedral, members of the Cathedral Chapter, and the Trustees of the Jerusalem Trust (one of the Sainsbury Family Charitable Trusts). The Jerusalem Trust was established by Sir Timothy Sainsbury and Lady Sainsbury with the goal of promoting the Christian faith through grants to charitable projects in the United Kingdom and abroad. One of the Trustees' areas of focus is contemporary

Christopher Le Brun (Born 1951)
Study for the Prodigal Son II, 1995 (detail)
Oil on board, 24 x 42 inches

Christian art, working to continue and revive the tradition of commissioning works of art for cathedrals and churches to create places of beauty as an expression of Christian worship and to educate viewers about the Christian message. The Liverpool Cathedral panel commissioned Christopher Le Brun to paint *The Good Samaritan* and *The Prodigal Son* (both 1995-96, 8 feet x 14 feet 8 inches), two subjects that have a long history in Western art. The finished paintings of *The Good Samaritan* and *The Prodigal Son* enhance the beauty of the choral music coming from the choir just below them and work extremely well with the Cathedral's Gothic Revival architecture, particularly with the tree designs in the great east window, the rich colors of the stained glass windows, the leaf motif in the carvings surrounding the choir, and the warm pink of the sandstone.[269] The panel also commissioned the artist Adrian Wiszniewski to paint *The Good Samaritan* (1995) and *The House Built on Rock* (1995) for the nave. Wiszniewski, born in Glasgow in 1958 and brought up Catholic, has been interested in religion from an early age. He studied at the Mackintosh School of Architecture and the Glasgow School of Art. Wiszniewski designed *The House Built on Rock* to represent Faith and *The Good Samaritan* to represent Charity.[270] Le Brun designed *The Good Samaritan* to represent Mercy and Compassion and *The Prodigal Son* to represent Forgiveness and Homecoming. Overall, the Liverpool Cathedral panel commissioned the magnificent paintings to provide new insights into Christ's teachings in parables, to enhance people's understanding of the parables, and to be major additions to contemporary art. The Bishop of Liverpool dedicated the paintings on Easter Sunday in 1996.[271]

Le Brun's four fully worked studies for this commission, including *Study for the Good Samaritan*, *Study for the Prodigal Son I*, *Study for the Prodigal Son II*, and *Study for the Parables*, are presented together in this exhibition to bring out the visual relationships between each picture. By not presenting the faces of specific people in these sketches, the artist enables the viewer to enter into the narrative and become the characters. *Study for the Good Samaritan* and the final painting *The Good Samaritan* are both based on Luke 10:25-37. In these two works, the Good Samaritan is approaching from the direction of the altar at the front of the Cathedral. He reaches out his arm towards the naked victim who had been attacked by robbers who lies in the foreground. (In the sketch, it is possible to see the pentimenti from the earlier placement of the victim towards the left next to a tree.) The Good Samaritan's horse eagerly waits behind him, pawing the ground, to carry the injured man to safety. The road curves out of the picture space towards the inn that can be seen perched on a hill in the distance. The priest and Levite who did not stop to help the victim can be seen walking towards the inn, with their backs turned towards the victim and the Good Samaritan. A lake physically separates the space of the Good Samaritan and the victim from the priest and the Levite. The vertical, carefully spaced tree trunks echo the Cathedral's high columns and the tree designs in the east window, and break the canvas up into meditative spaces. A beautiful light-streaked sky fills the background, and brilliant hints of light come from the inn and infuse the landscape. In the final painting, Le Brun has emphasized the beautiful and timeless sunset-colored robes of the Good Samaritan who appears as if he is an angel from an Edward Burne-Jones canvas.

Study for the Prodigal Son I, *Study for the Prodigal Son II*, and the final painting, *The Prodigal Son*, are all based on Luke 15:11-32. The study *The Prodigal Son I* and the finished painting *The Prodigal Son* are very similar. In these works, Le Brun was especially inspired by the verse from this parable (Luke 15:20), "But while he was still a long way off, his father saw him."[272] The artist emphasizes this distance in the painting through the long road that winds towards the viewer from the faraway land from which the Prodigal Son has traveled.

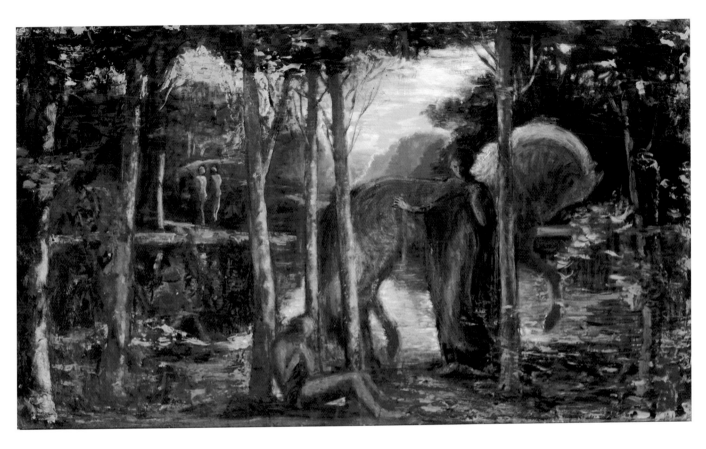

The Prodigal Son approaches his father with an attitude of despondency, his head bowed. However, the father, who wears a beautiful red robe, quickly moves towards his younger son with his arms outstretched in love and welcome. The mother appears at the left in a golden yellow top and skirt, and also raises her arms in joyful welcome, standing next to the family home to which the Prodigal Son is returning. The family dog jumps up to greet him in eager recognition. There are several important variations between this study and the finished painting. In this study, the father grasps one of the arms held out by his younger son, the son's other arm held out partway in a pleading gesture. In the final painting, the Prodigal Son

Christopher Le Brun (Born 1951)
Study for the Good Samaritan, 1995
Oil on board, 24 x 42 inches

has dropped both of his arms down by his sides in a pleading gesture. In addition, in the final painting, the contrast between the glorious red robes of the father and the tattered rags of his son becomes even more pronounced. Lastly, in the finalized painting Le Brun added a rider on a horse on a bridge at the middle right, who suggests the figure of the Good Samaritan and his horse in the previous painting. This rider encourages the viewer to pause, like him, and contemplate

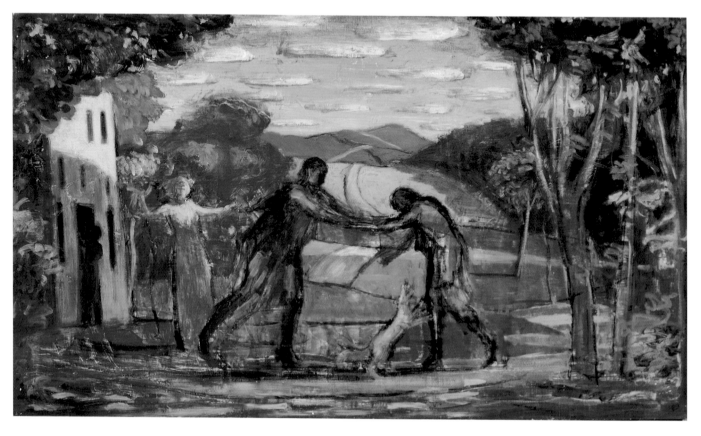

Christopher Le Brun (Born 1951)
Study for the Prodigal Son I, 1995
Oil on board, 24 x 42 inches

the parable. The motifs of the white horse and of the horse and rider, observed in three of these four sketches and in both of the finalized paintings, are a recurring motif in Le Brun's *oeuvre*. Le Brun also added the figure of the elder brother to the finalized painting, who draws back from the celebratory welcome and remains partially hidden behind a tree on the right. The figure of the elder brother perhaps poses the question of whether the viewer identifies more with the joy and forgiveness of the father or the anger and resentment of the older brother.

Study for the Prodigal Son II represents a very different presentation of this parable from the finalized painting. In this canvas, Le Brun carefully structured the narrative of the parable into three distinct spaces. At the left, the Prodigal Son rides away from home on a tall white horse. In the center, surrounded by angels, he sits crouched and starving in a despairing attitude, his arms held up to his head, after having squandered his money. At the right, he is on the pathway home, with his joyful parents running down the road to greet him. Two angels flank the canvas at left and right, while the

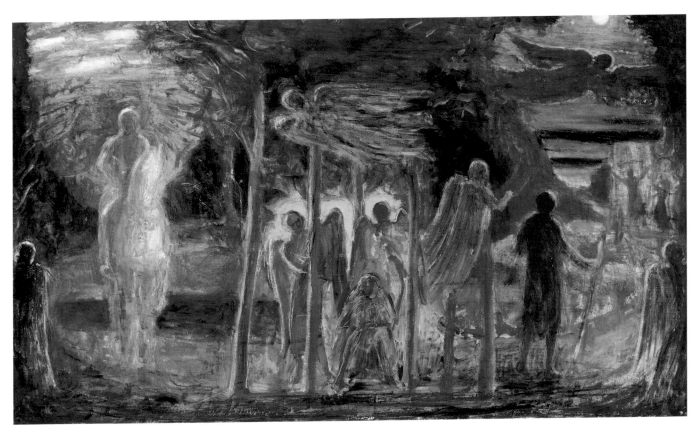

Christopher Le Brun (Born 1951)
Study for the Prodigal Son II, 1995
Oil on board, 24 x 42 inches

angels soaring overhead and standing behind the central fig-ure of the Prodigal Son reveal God's continuous protection and care. The relationship of Le Brun's artwork to that of the nineteenth-century paintings of Puvis de Chavannes is per-haps strongest in this canvas, with the tall, slender figures of the main character and the ethereal angels.

The final sketch, *Study for the Parables*, exhibits Le Brun's initial idea of combining the Parable of the Good Samaritan and Parable of the Prodigal Son into one canvas, with an additional parable included as well. In *Study for the Parables*, the artist creates four balanced and distinct sections of the canvas, the trees in the center dividing the canvas into left and right sections, and the line of sand around the lake divid-ing the canvas into upper and lower sections. The study can be read counterclockwise, beginning in the upper left quad-rant, which depicts Christ teaching the parables from a boat, as related in Mark 4:1-2: "Again Jesus began to teach by the lake. The crowd that gathered around Him was so large that He got into a boat and sat in it out on the lake, while all the people were along the shore at the water's edge. He taught

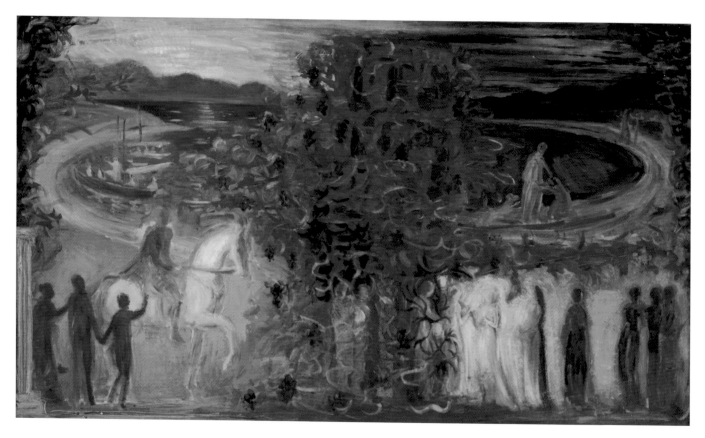

Christopher Le Brun (Born 1951)
Study for the Parables, 1995
Oil on board, 24 x 42 inches

them many things by parables." In the lower left quadrant, the Prodigal Son leaves home mounted on his tall white horse, while his mother, father, and older brother wave him a sorrowful goodbye (with the small family dog peeking out behind the mother's skirts). To the lower right Le Brun depicts the Parable of the Ten Virgins as related in Matthew 25:1-13. The figures of the women to the right (the five foolish virgins) are presented in dark silhouettes, indicating that they have

let their lamps run out of oil, while the figures of the women to the left (the five wise virgins) are illuminated by a brilliant yellow light. Their slender, shadowy figures, the dream-like mysterious landscape setting, and the loose, visible brushstrokes reveal the richness of the heritage of Puvis de Chavanne and French Symbolism in Le Brun's work. Above the women, in the upper right quadrant, Le Brun depicts the scene of the return of the Prodigal Son. The Prodigal Son kneels down in front of his father, who embraces his son. The family dog is behind the father and leaps up with joy. Le Brun's love of the phrase from this parable, "But while he was still a long way off, his father saw him," is communicated

through the figure of the mother, farther behind on the path, indicating that the father saw his son coming from a long distance away, and ran to meet him, reaching him before the mother. The length of the Prodigal Son's journey and a long passage of time are communicated through the curving line of sand around the lake, and through the beautiful clear light of dawn on the upper left and the brilliant orange and red of the sunset in the upper right. The almost fluorescent colors used by Le Brun in the sunset resonate with the rich brilliance of the colors in the nineteenth-century Symbolist works by Gustave Moreau. *Study for the Parables* reveals to the viewer how Le Brun simplified the rather complex, busy imagery of this canvas into the stronger compositions of the two finalized canvases.

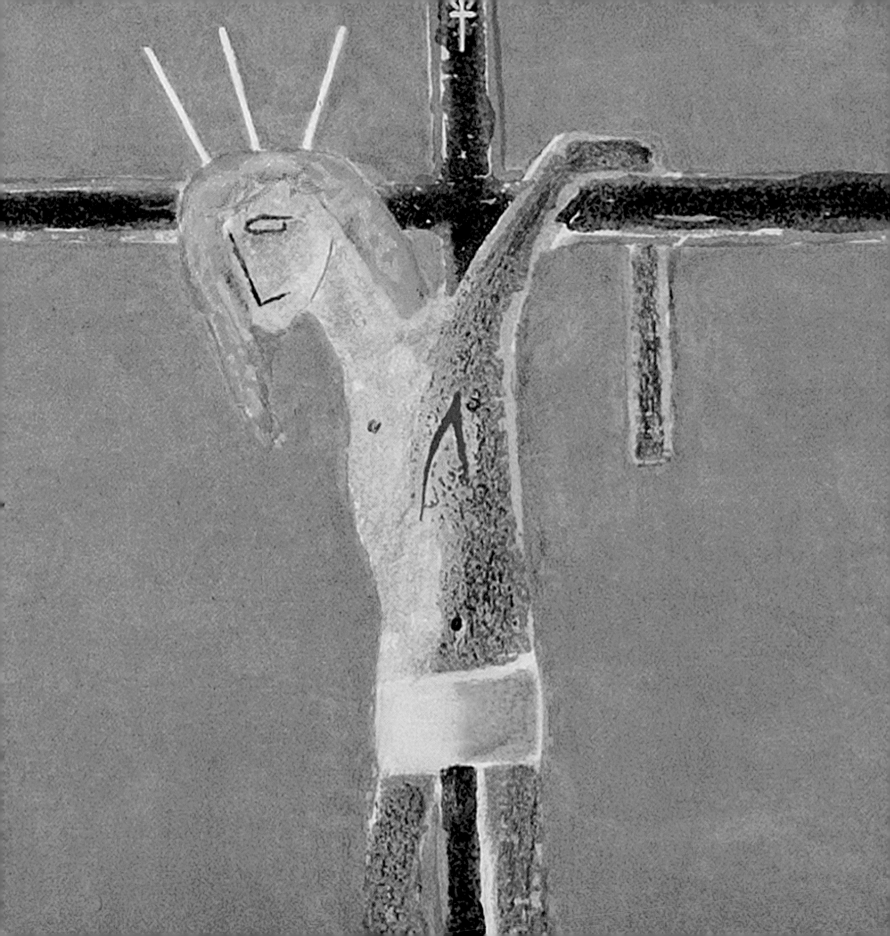

Craigie Aitchison's paintings and prints of religious themes, landscapes, portraits, and still-lifes are characterized by startlingly minimal compositions, beautiful shapes, and intense colors, creating images of poetic simplicity and beauty with vivid immediacy. After studying law in Edinburgh and London in the 1940s, Aitchison attended the Slade School of Fine Art in London, where he was influenced by the work of the visiting artist L.S. Lowry. In 1955 Aitchison was awarded the British Council Italian Government Scholarship for painting and traveled to Italy, where he visited Orvieto, Assisi, Arezzo, Venice, and the great Giotto fresco cycle in the Arena Chapel at Padua. Witnessing the clear light of Italy and viewing the Italian Gothic and Renaissance paintings (especially the works of Piero della Francesca and Domenico Veneziano) in the churches that originally commissioned them were major influences on Aitchison. In 1988 Aitchison was elected a Member of the Royal Academy of Arts.

Aitchison was commissioned in 1997 to create a series of four *Calvary* paintings for the chapel of St. Margaret in Truro Cathedral (facilitated by the Jerusalem Trust, as were the works discussed earlier by Christopher Le Brun). In 1998 the Dean and Chapter of Liverpool Cathedral commissioned Aitchison to paint a *Crucifixion*.[273] Aitchison's interest in religion began at an early age. During his childhood, his father gave an ornate communion table to the United Free Church in Falkirk in memory of Aitchison's grandfather, the Reverend James Aitchison, who had been a United Free Church clergyman and Minister of the Erskine Church in Falkirk from 1875 to 1930. However, there was much criticism by the elders of the church regarding the table's "Catholic" ornament. Aitchison believed that this criticism encouraged his father to introduce his sons to churches of other denominations, in order to reveal alternative modes of worship, and the artist remembers being especially fascinated by the candles,

decorations, and ceremonies of the Catholic Church. This fascination grew over the course of the artist's career, and Aitchison furnished his home with multiple religious objects, including a holy water stoup by the front door, ecclesiastic candles, plates from the Westminster Cathedral shop, and crucifixes in his studio.

Pink Crucifixion, 2004
Body of Christ (Red Background), 2008

Aitchison painted the subject of the Crucifixion frequently throughout his professional life, creating timeless, luminous, and icon-like images that centralize the main drama of the Crucifixion. His visual interpretation of the subject of the Crucifixion is extremely different from his contemporaries, Francis Bacon and Graham Sutherland, who both focused on depicting anguish and horror. Instead, Aitchison's images of the Crucifixion communicate serenity, contemplation, and compassion. All of the artist's images of the Crucifixion are personal interpretations of what he described as "the most horrific event."[274] In his religious paintings, Aitchison mostly focused on creating images of the Crucifixion, creating only a few other works of Nativities, Lamentations, and images of saints, the artist stating, "I think the story of the Crucifixion is one of the most exciting in the Bible."[275] Aitchison remembered being amazed by the presentation of the Cross in Salvador Dali's *Christ of St. John of the Cross* (1951) in Glasgow. The artist's interest with the subject of the Crucifixion was also particularly shaped by an event during his education at the Slade. Aitchison remembered copying a *Crucifixion* by Rouault and being approached by the instructor William Townsend, who dismissed the subject of the Crucifixion as "too serious a subject" for Aitchison to attempt.[276] This provoked Aitchison, and encouraged him to approach this subject with even greater dedication.

In *Pink Crucifixion*, Christ appears as a slim figure with a

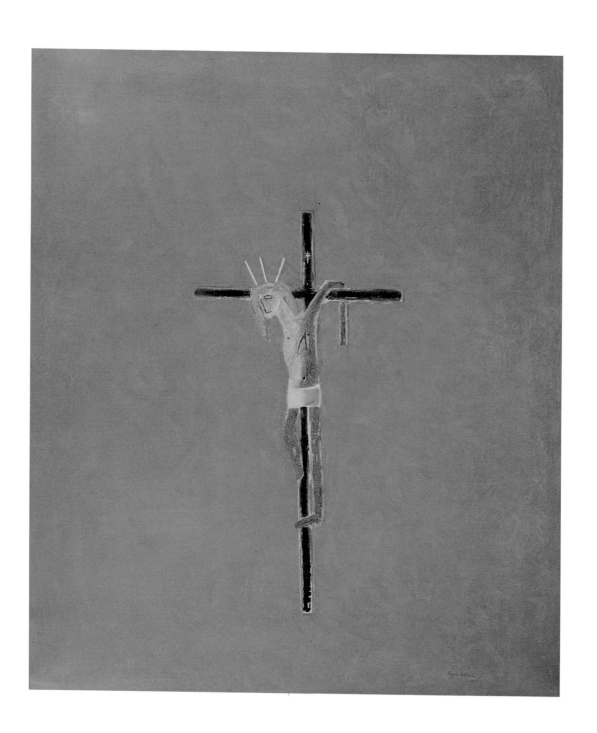

pink cloth around his waist, and hangs on a Cross set at the very front of the picture space. The background is composed of a vibrant shade of pink with a subtle texture and soft edges to the paper. There are no attendant figures or indications of a landscape setting. In his other Crucifixion paintings, Aitchison often used dogs, sheep, birds, and angels to serve as witnesses and mourners. The artist wrote, "The animals are meant to be upset, concerned. It's as though the animal is walking along and is suddenly amazed and horrified and looks up. But there are Crucifixions I've done where the animal is sitting at the foot of the Cross completely resigned."[277] Bold colors of pink, orange, and sky blue, combined with the incredibly simplified forms, encourage the viewer to actively engage the image. Aitchison always painted the figure of Christ from his imagination, and not from a model, instead looking to the various crucifixes in his studio. This work is an etching, a technique in which acid is used to incise the metal printing plate. The artist signed his work "Craigie Aitchison" at the lower right, and it is numbered as print "31/50" at the lower left.

In *Pink Crucifixion*, Aitchison communicates the broken, suffering nature of Christ on the Cross, with Jesus' right leg terminating halfway down His calf. In his images of the Crucifixion, Aitchison often presented the figure of Christ with no arms or with only one leg as a means of poetic simplification, to have a part stand in for or to suggest the whole, and not to diminish the human or spiritual meaning of the work. In *Pink Crucifixion*, the artist only depicted one of Christ's arms, which is folded limply over one arm of the Cross. A gash appears where the spear pierced His side. Jesus' small navel points to the humanity of Christ as born of Mary, while a small white Cross depicted on the top of the main Cross emphasizes Christ's divinity. Three white lines emanating from Christ's head suggest the Crown of Thorns. Christ's skin appears speckled and given a texture almost like sand, and

His face is given through minimal lines. The raised head of Jesus is depicted with reddish-orange hair (one of the many colors for Christ's hair that Aitchison used in his numerous Crucifixion scenes). This color brings to mind the color of Jesus' hair as depicted in the Pre-Raphaelite painting by John Everett Millais, *Christ in the House of His Parents* (1849-50), in which Millais perhaps referred to Irish immigrants in England.

Aitchison completed *Body of Christ (Red Background)* only a year before his death in 2009. The starkness, simplicity, and utter sorrow of this work are powerfully communicated by eliminating narrative detail to create a symbol of spiritual isolation of incredible emotional power. The small dimensions of *Body of Christ (Red Background)* demonstrate how Aitchison created intimate, delicate interpretations of the Passion. The limp head of Christ hangs down with a sorrowful countenance. Horizontal and vertical slits of brown paint compose His eyes, mouth, nose, and hair. There is only a faint hint of the horizontal arms of the Cross and the arms of Christ, thus emphasizing the position of the viewer at the foot of the vertical Cross. Only Christ's left foot can be seen, as His right foot has been left abruptly unfinished, communicating the brokenness of Christ's body and a sense of absolute anguish.

The vibrant red of the background in *Body of Christ (Red Background)* symbolizes Christ's blood shed for the viewer and the sacrament of the Eucharist. The artist kept this work in his own collection because the unusual red color of the background made the work special to him. The brilliant jewel-like colors used in Aitchison's Crucifixion scenes communicate his intense engagement with the subject, and reveal a variety of visual sources, including the work of Henri Matisse, who, like Aitchison, loved the light of the Mediterranean. The colors also suggest the use of jewels on Medieval reliquaries, and the golds and blues of Byzantine art. In *Body of Christ (Red Background)*, Christ is given a tan body, a yellow Crown of Thorns, a white cloth around His middle, and white legs and

Craigie Aitchison (1926-2009)
Pink Crucifixion, 2004
Etching on paper, 30 x 25.87 inches

feet. The yellow paint of the Crown of Thorns has trickled down, like blood and tears, emphasizing the sorrow of this piece. The artist has made white scratches in the paint over Christ's face and around His hair, communicating the violence of His death.

The thinness of the paint in *Body of Christ (Red Background)* (characteristic of Aitchison's working methods) reveals the texture of the canvas and suggests visually the medium of fresco, in which pigment is applied to wet plaster, becoming directly absorbed into the plaster and keeping the texture of the plaster. This visual similarity between Aitchison's oil painting and the medium of fresco reveals the artist's love of the Early Italian Renaissance frescos of Piero della Francesca, which Aitchison had visited during his time in Italy. The beautiful flat planes of color in both *Body of Christ (Red Background)* and *Pink Crucifixion* also communicate the artist's love of the artwork of Gauguin. During his childhood, Aitchison's father purchased reproductions of Gauguin's paintings for their home, and the artist remembered being struck by the clarity of the flat planes of bright color. Throughout his career, the artist's brushstrokes grew more fluid and the edges of objects grew softer, as can be observed in *Pink Crucifixion* and *Body of Christ (Red Background)*. Although Aitchison was influenced by Giotto from an early stage, his work avoids the linearity of Giotto's work, instead creating shapes through edges defined by radiant light to focus on the inner light of the figure of Christ.

Craigie Aitchison (1926-2009)
Body of Christ (Red Background), 2008
Oil on canvas, 12 x 10 inches

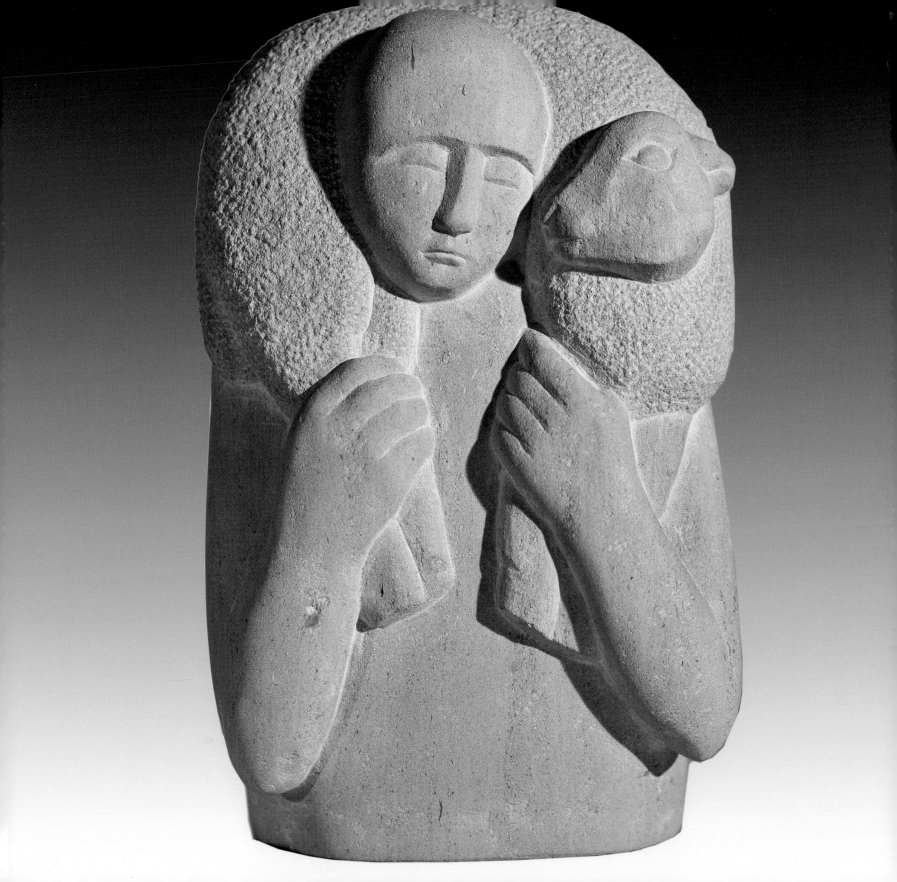

Sara Wilkinson is a contemporary sculptor who focuses on creating figurative stone and wood sculptures. She was born in 1954 and grew up in Cornwall and Devon in the southwest of England. She trained as a nurse and received a degree in English before studying cabinet making and woodcarving at the London College of Furniture (now part of London Guildhall University). Wilkinson has exhibited furniture at the Morley Gallery at Morley College in London and sculpture and woodcarving at the Celebration of Craftsmanship & Design exhibition in Cheltenham. She has published on furniture making and woodcarving, including her book *Figure Carving in Wood: Human and Animal Forms* (Lewes, East Sussex: Guild of Master Craftsman Publications Ltd., 2004).

Wilkinson's sculpture is influenced by her childhood in Cornwall, where the landscape shaped her love of natural materials and enjoyment of working with wood and stone.[278] Wilkinson attended school at a convent in Cornwall where the dramatic natural landscape created a beautiful setting for the peacefulness of daily life. She admires the rich legacy of early-twentieth century carving of English artists, particularly Eric Gill, and incorporates a similar stylized approach to the human figure in her carvings. Wilkinson encourages contemporary carvers to draw inspiration from the long legacy of European figure carving and to examine ecclesiastical figurative carving, as religious institutions historically provided the most employment for carvers. Wilkinson believes that Medieval ecclesiastical wood carvings provide the most relevant and interesting examples of work for contemporary sculptors to observe, as the tools used in the Medieval era were nearly identical to the tools used today, if somewhat heavier.[279]

Wilkinson's religious upbringing is reflected in the subject of her sculpture, *The Good Shepherd* (signed underneath by the artist, "SW"). The subject of this carving is taken from John 10:1-18, and particularly reflects Christ's words in verses 14 and 15: "I am the good shepherd; I know my sheep and my sheep know me — just as the Father knows me and I know the Father — and I lay down my life for the sheep." The subject also alludes to the Parable of the Lost Sheep (Luke 15:4-6):

> Suppose one of you has a hundred sheep and loses one of them. Doesn't he leave the ninety-nine in the open country and go after the lost sheep until he finds it? And when he finds it, he joyfully puts it on his shoulders and goes home. Then he calls his friends and neighbors together and says, "Rejoice with me; I have found my lost sheep."

In Wilkinson's sculpture, Christ carries a lamb across his shoulders, demonstrating His care and love for His followers, and how He takes the place of the sacrificial lamb to make the final and ultimate offering as the "Lamb of God, who takes away the sin of the world" (John 1:29).

The subject of Christ as the Good Shepherd has a long tradition in the history of Western art, and can be observed in many examples of Early Christian Art, such as the painted ceilings of the catacombs in Rome, in Roman sarcophagi, and in the free-standing sculpture *The Good Shepherd* in the Vatican Museums (late third or early fourth century).[280] Indeed, the quiet grace of Wilkinson's sculpture and the gentle sorrow on Christ's face echo these much earlier depictions of the Good Shepherd.

The Good Shepherd reveals Wilkinson's love of the material of stone and her absorption and concentration in creating a beautifully finished work. As a sculptor, Wilkinson prefers to work only on a scale in which she can comfortably use hand tools. In *The Good Shepherd*, as in many of her other fine sculptures, Wilkinson carved the work out of a single block of stone and finished the sculpture, including the stylized coat of the lamb, using hand tools. In her sculptural practice,

Sara Wilkinson (Born 1954)
The Good Shepherd, c.2005
Stone, 12 (height) x 8 (width) x 6 (depth) inches

Wilkinson believes that neither a tooled nor a smooth finish is "wrong" as long as it suits the style of the carving.[281] *The Good Shepherd* beautifully contrasts the smoothness of the surface of the Shepherd to the stippling of the lamb's coat. Indeed, the tactile nature of the stippling and the small scale of the sculpture create a sense of intimacy and a desire by the viewer to hold the sculpture.

In *The Good Shepherd*, Wilkinson creates a feeling of tranquility through the balanced unity of the figures of the Good Shepherd and the lamb, through their gentle and expressive countenances, and through the elimination of superfluous detail and vulnerable pieces that could break off. The sculpture's curves work together as a whole, strengthening this sense of unity. The lamb's head is curved around, rather than outstretched, showing trust and creating a compact shape. Its body is draped across the Shepherd's shoulders and its feet are held tightly against the Shepherd's body, rather than cut free from the figure. Wilkinson emphasizes the front view of *The Good Shepherd*, and keeps the detail on the back very sketchy. The understated facial features of the Shepherd and lamb can be observed in the elimination of the Shepherd's ears and hairline. Wilkinson especially stresses the eyes as the facial feature to be noticed first and which she believes should hold the viewer's attention. The downcast eyes of the Shepherd indicate His gentle sorrow, contrasting with the lamb's wide trusting gaze, and accentuating the unspoken communication between the Shepherd and the lamb. The Shepherd's flat, long nose, wide, deep brows, and thin, sorrowful mouth suggest the long lines of the facial features of figures in ancient Cycladic sculpture.

Wilkinson keeps obvious symbolism and clues to the story of the Good Shepherd to a minimum, the strong protective arms of the Shepherd, His peaceful face, and the trusting uplifted face of the lamb being all that is necessary to impart the religious theme. By doing so, the artist directs attention to the subject matter of the trusting relationship between the Shepherd and the lamb, and the focal point of the action of the Shepherd holding the lamb. The nature of this focal point also provided the artist with an opportunity to concentrate on the Shepherd's hands, a feature that she enjoys carving, and which she believes should be as expressive as faces. The beautifully rounded forms of the Shepherd's arms and hands are proportionally quite large compared with His head, and are dominant features of the carving. They emphasize how the Shepherd holds the stylized lamb firmly and confidently so that it looks quite at home in His arms.

Preparatory drawing forms a vital component of Wilkinson's sculptural practice and enables her to become familiar with her subject and to observe the subject from multiple angles. She rarely makes a maquette and instead is an advocate (as were Eric Gill, Barbara Hepworth, and many early-twentieth century English sculptors) of direct carving in both stone and wood. Because of the inherently different techniques of composing a maquette (in which the model is built up using a malleable material, such as clay) and of carving (which involves the removal of solid material to "discover" the figure within the stone or wood), Wilkinson believes that a chunky and solid stone carving should not resemble a clay sculpture. She encourages artists to recognize the possibilities and limitations of their materials, to make sure the figure is in sympathy with the material, and to stay as close as possible to the original subject.[282]

SELECTED BIBLIOGRAPHY

Aitchison, Craigie. *Craigie Aitchison: Recent Paintings*. London: Albemarle Gallery, 1989.

Alley, Ronald. *Graham Sutherland*. London: Tate Gallery, 1982.

Andrew, Lambirth. *Craigie Aitchison: Out of the Ordinary*. London: Royal Academy of Arts, 2003.

Ballantine, James. *The Life of David Roberts, R.A. Compiled from his Journals and Other Sources*. Edinburgh: Adam and Charles Black, 1866.

Bell, Keith et al. *Stanley Spencer RA*. London: Royal Academy of Arts, 1980.

Bell, Keith. *Stanley Spencer: A Complete Catalogue of the Paintings*. London: Phaidon Press Limited, 1992.

Berthoud, Roger. *Graham Sutherland, A Biography*. London: Faber and Faber Limited, 1982.

Bourbon, Fabio. *The Life, Works, and Travels of David Roberts R.A.* New York: Rizzoli, 2000.

Causey, Andrew. *Edward Burra*. London: Arts Council of Great Britain, 1985.

Causey, Andrew. *Edward Burra, Complete Catalogue*. Oxford: Phaidon, 1985.

Collins, Judith. *Eric Gill: The Sculpture*. New York: The Overlook Press, 1998.

Curtis, Penelope. *Barbara Hepworth*. London: Tate Gallery Publishing, 1998.

Epstein, Jacob. *Epstein: An Autobiography*. London: Vista Books, 1963.

Finaldi, Gabriele et al. *The Image of Christ*. London: National Gallery Company Limited, 2000.

Gale, Matthew, and Chris Stephens. *Barbara Hepworth: Works in the Tate Gallery Collection and the Barbara Hepworth Museum St. Ives*. London: Tate Gallery Publishing, 1999.

Gill, Eric. "Mass for the Masses." *Secular and Sacred*. London: J.M. Dent, 1940.

Gill, Eric. "Plain Architecture." *Beauty Looks After Herself*. Freeport, New York: Books for Libraries Press, Inc., 1966.

Gill, Eric. *An Autobiography*. New York: Biblo and Tannen, 1968.

Gill, Eric. *Art*. New York: Devin Adair, 1949.

Gill, Eric. *Art-Nonsense and Other Essays*. London: Cassell & Co., Ltd., 1929.

Glew, Adrian. *Stanley Spencer: Letters and Writings*. London: Tate Publishing, 2001.

Guiterman, Helen, and Briony Llewellyn. *David Roberts*. Oxford: Phaidon Press Limited, 1986.

Hepworth, Barbara. *Carvings and Drawings*. London: Lund Humphries & Co., Ltd., 1952.

Hepworth, Barbara. *Drawings from a Sculptor's Landscape*. New York: Frederick A. Praeger, Publishers, 1967.

Hyman, Timothy, and Patrick Wright, eds. *Stanley Spencer*. London: Tate Publishing, 2001.

Larkworthy, Peter. *Clayton and Bell, Stained Glass Artists and Decorators*. London: The Ecclesiological Society, 1984.

Le Brun, Christopher. *Christopher Le Brun*. London: Booth-Clibborn Editions, 2001.

Leder, Carolyn. *Stanley Spencer: The Astor Collection*. London: Thomas Gibson Publishing Limited, 1976.

MacCarthy, Fiona. *Eric Gill: A Lover's Quest for Art and God*. New York: E.P. Dutton, 1989.

Pearce, Barry. *Sidney Nolan*. Sydney: The Art Gallery of New South Wales, 2007.

Pople, Kenneth. *Stanley Spencer: A Biography*. London: Collins, 1991.

Révai, Andrew, ed. *Christ in Glory in the Tetramorph: The Genesis of the Great Tapestry in Coventry Cathedral*. London: The Pallas Gallery, 1964.

Robinson, Duncan. *Stanley Spencer*. London: Phaidon Press Limited, 1993.

Rothenstein, John. *Edward Burra*. London: The Tate Gallery, 1973.

Scott, William Bell. *Autobiographical Notes of the Life of William Bell Scott, H.R.S.A., LL.D.*, edited by W. Minto. New York: Harper & Brothers, 1892.

Shewring, Walter, ed. *Letters of Eric Gill*. New York: Devin-Adair Company, 1948.

Silber, Evelyn, *The Sculpture of Epstein, with a Complete Catalogue*. Cranbury, New Jersey: Associated University Press, 1986.

Silber, Evelyn, and Terry Friedman. *Jacob Epstein, Sculpture and Drawings*. Leeds: W.S. Maney and Son in association with The Henry Moore Centre for the Study of Sculpture, 1989.

Sim, Katharine. *David Roberts R.A. 1796-1864, A Biography*. New York: Quartet Books Limited, 1984.

Smith, Alison, ed. *Watercolour*. London: Tate Publishing, 2011.

Smith, Geoffrey. *Sidney Nolan: Desert & Drought*. Melbourne: National Gallery of Victoria, 2003.

Stephens, Chris, ed. *Barbara Hepworth, Centenary*. London: Tate Gallery Publishing, 2003.

Underhill, Nancy, ed. *Nolan on Nolan: Sidney Nolan in his own Words.* New York: Penguin Group Inc., 2007.

Vaughan, Keith. *Journal & Drawings 1939-1965.* London: Alan Ross, 1966.

Verdon, Timothy. *Mary in Western Art.* Manchester, Vermont: Hudson Hills Press, 2005.

Wilkinson, Sara. *Figure Carving in Wood: Human and Animal Forms.* Lewes, East Sussex: Guild of Master Craftsman Publications Ltd., 2004.

Yorke, Malcolm. *Eric Gill, Man of Flesh and Spirit.* London: Constable and Company Limited, 1982.

Yorke, Malcolm. *Keith Vaughan: His Life and Work.* London: Constable and Company Limited, 1990.

NOTES

[1] Katharine Sim, *David Roberts R.A. 1796-1864, A Biography* (New York: Quartet Books Limited, 1984), 61.

[2] Katharine Sim, *David Roberts R.A. 1796-1864, A Biography* (New York: Quartet Books Limited, 1984), 61.

[3] Helen Guiterman and Briony Llewellyn, *David Roberts* (Oxford: Phaidon Press Limited, 1986), 47.

[4] James Ballantine, *The Life of David Roberts, R.A. Compiled from his Journals and Other Sources* (Edinburgh: Adam and Charles Black, 1866), 47.

[5] Fabio Bourbon, *The Life, Works, and Travels of David Roberts R.A.* (New York: Rizzoli, 2000), 6-10.

[6] *Quarterly Review*, LXXVII (1846): 500.

[7] Friedrich Rahlves, *Cathedrals and Monasteries of Spain*, translated by James C. Palmes (New York: A. S. Barnes and Co. 1966), 215-8.

[8] James Ballantine, *The Life of David Roberts, R.A. Compiled from his Journals and Other Sources* (Edinburgh: Adam and Charles Black, 1866), 44.

[9] Katharine Sim, *David Roberts R.A. 1796-1864, A Biography* (New York: Quartet Books Limited, 1984), 67-68.

[10] *The Gallery of Modern British Artists* (London: Simpkin and Marshall, 1835).

[11] John Weale, ed., *Quarterly Papers on Architecture* (London: George Woodfall and Son, 1844), 7.

[12] Francis Turner Palgrave, *Gems of English Art of this Century* (London: George Routledge & Sons, 1869), 81.

[13] Katharine Sim, *David Roberts R.A. 1796-1864, A Biography* (New York: Quartet Books Limited, 1984), 67.

[14] Gustav Friedrich Waagen, *Treasures of Art in Great Britain*, Vol.I (London: John Murray, 1854), 387.

[15] William Thackeray, *Men of the Time, or Sketches of Living Notables* (London: David Bogue Fleet Street, 1853), 376.

[16] For more information on Scott's life and work, see William Bell Scott, *Autobiographical Notes of the Life of William Bell Scott, H.R.S.A., LL.D.*, ed. W. Minto (New York: Harper & Brothers, 1892).

[17] Other founding members of the Brotherhood included James Collinson, William Michael Rossetti, Frederic George Stephens, and the sculptor Thomas Woolner.

[18] The Author of "Modern Painters" [John Ruskin], "The Pre-Raphaelite Artists," *The Times*, May 30, 1851, 8.

[19] Letter to James Leathart, c.1861, quoted in Hilary Morgan and Peter Nahum, *Burne-Jones, the Pre-Raphaelites and their Century* (London: Peter Nahum, 1989).

[20] Algernon Charles Swinburne, "Memorial Verses on the Death of William Bell Scott," in *The Poems of Algernon Charles Swinburne in Six Volumes*, Volume VI, 249-252 (London: Chatto & Windus, 1904).

[21] Letter to James Leathart, c.1861, quoted in Hilary Morgan and Peter Nahum, *Burne-Jones, the Pre-Raphaelites and their Century* (London: Peter Nahum, 1989).

[22] For a discussion of Orientalism and British artists traveling to the Holy Land in the nineteenth century, see Nicholas Troman, "The Holy City," in *The Lure of the East: British Orientalist Painting*, 162-197 (New Haven: Yale University Press, 2008).

[23] For more information regarding the Pre-Raphaelite use of typological symbolism, see George P. Landow, *William Holman Hunt and Typological Symbolism* (New Haven: Yale University Press, 1979).

24 Alison Smith, ed., *Watercolour* (London: Tate Publishing, 2011), 13-15, 23, 106-107.

25 My thanks to Joanna Buddle, Churchwarden at St. Saviour's, Pimlico, for her help with this information.

26 Peter Larkworthy, *Clayton and Bell, Stained Glass Artists and Decorators* (London: The Ecclesiological Society, 1984), 14.

27 Peter Larkworthy, *Clayton and Bell, Stained Glass Artists and Decorators* (London: The Ecclesiological Society, 1984), 17, 19, 21.

28 Tate Archive, 733.3.5, 38.

29 Henry Lamb to Richard Carline, May 10, 1924. Tate Archive, Box 8216.

30 Alexander Robertson, "The Leeds Town Hall Decoration Scheme," *Leeds Arts Calendar*, no. 74 (1974): 16-22.

31 Keith Bell, *Stanley Spencer: A Complete Catalogue of the Paintings* (London: Phaidon Press Limited, 1992), 101.

32 Keith Bell, *Stanley Spencer: A Complete Catalogue of the Paintings* (London: Phaidon Press Limited, 1992), 77.

33 Timothy Hyman and Patrick Wright, eds., *Stanley Spencer* (London: Tate Publishing, 2001), 62.

34 Letter from Stanley Spencer to Florence Image, June 25, 1920. Tate Archive Microform 11.

35 From a notebook by Stanley Spencer from 1936, quoted in *Sir Stanley Spencer, R.A. 1891-1959: A Collection of Paintings and Drawings* (London: Piccadilly Gallery, 1978), catalogue entry number 16.

36 Adrian Glew, *Stanley Spencer: Letters and Writings* (London: Tate Publishing, 2001), 197.

37 Tate Archive, 733.3.193.

38 Timothy Hyman and Patrick Wright, eds., *Stanley Spencer* (London: Tate Publishing, 2001), 154.

39 Letter to Edward Marsh 1913 from Christopher Hassall, quoted in Christopher Hassall, *Patron of the Arts: A Biography of Edward Marsh* (London: Longmans, 1959).

40 Adrian Glew, *Stanley Spencer: Letters and Writings* (London: Tate Publishing, 2001), 143-144.

41 Keith Bell, *Stanley Spencer: A Complete Catalogue of the Paintings* (London: Phaidon Press Limited, 1992), 441.

42 Adrian Glew, *Stanley Spencer: Letters and Writings* (London: Tate Publishing, 2001), 143-144.

43 Carolyn Leder, *Stanley Spencer: The Astor Collection* (London: Thomas Gibson Publishing Limited, 1976), 11.

44 Carolyn Leder, *Stanley Spencer: The Astor Collection* (London: Thomas Gibson Publishing Limited, 1976), 11-12.

45 Letter to Hilda, November 24, 1948, quoted by A. Gormley, "The Sacred and Profane in the Art of Stanley Spencer," in *Stanley Spencer*, 21-23 (London: Arts Council, 1976).

46 Tate Archives, 733.3.6.

47 Adrian Glew, *Stanley Spencer: Letters and Writings* (London: Tate Publishing, 2001), 143-144.

48 Letter to Hilda, January 20, 1948. Tate Archive, 733.2.375.

49 Keith Bell, *Stanley Spencer: A Complete Catalogue of the Paintings* (London: Phaidon Press Limited, 1992), 498-9.

50 Keith Bell, *Stanley Spencer: A Complete Catalogue of the Paintings* (London: Phaidon Press Limited, 1992), 438.

51 Tate Archive, 733.3.1.

52 Keith Bell, *Stanley Spencer: A Complete Catalogue of the Paintings* (London: Phaidon Press Limited, 1992), 101-104.

53 Please see the entry for *Washing Up* for a description of the *Church-House* project.

54 Keith Bell, *Stanley Spencer: A Complete Catalogue of the Paintings* (London: Phaidon Press Limited, 1992), 203-207.

55 Quoted in Maurice Collis, *Stanley Spencer* (Harvill Press, London 1962), 163.

56 Carolyn Leder, *Stanley Spencer: The Astor Collection* (London: Thomas Gibson Publishing Limited, 1976), 9-10.

57 Adrian Glew, *Stanley Spencer: Letters and Writings* (London: Tate Publishing, 2001), 200.

58 Timothy Hyman and Patrick Wright, eds., *Stanley Spencer* (London: Tate Publishing, 2001), 30.

59 Carolyn Leder, *Stanley Spencer: The Astor Collection* (London: Thomas Gibson Publishing Limited, 1976), 13.

60 Timothy Hyman and Patrick Wright, eds., *Stanley Spencer* (London: Tate Publishing, 2001), 158.

61 Timothy Hyman and Patrick Wright, eds., *Stanley Spencer* (London: Tate Publishing, 2001), 32.

62 Stanley Spencer, "Devotional: Domestic Scenes, Seven New Drawings by Stanley Spencer," *The Saturday Book* (October 1946).

63 Tate Archive, 733.3.1.

64 Stanley Spencer, "Devotional: Domestic Scenes, Seven New Drawings by Stanley Spencer," *The Saturday Book* (October 1946).

65 Keith Bell, *Stanley Spencer: A Complete Catalogue of the Paintings* (London: Phaidon Press Limited, 1992), 470.

66 Keith Bell, *Stanley Spencer: A Complete Catalogue of the Paintings* (London: Phaidon Press Limited, 1992), 239.

67 Letter to Desmond Chute, November 17, 1926, quoted in John Rothenstein, *Stanley Spencer: The Man* (London: Elek, 1979), 21-22.

68 Keith Bell, *Stanley Spencer: A Complete Catalogue of the Paintings* (London: Phaidon Press Limited, 1992), 247, 256, 279-300.

69 Adrian Glew, *Stanley Spencer: Letters and Writings* (London: Tate Publishing, 2001), 202-203.

70 Keith Bell, *Stanley Spencer: A Complete Catalogue of the Paintings* (London: Phaidon Press Limited, 1992), 376 Note 46.

71 Keith Bell, *Stanley Spencer: A Complete Catalogue of the Paintings* (London: Phaidon Press Limited, 1992), 271-272.

72 *Scotsman*, July 2, 1936.

73 Keith Bell, *Stanley Spencer: A Complete Catalogue of the Paintings* (London: Phaidon Press Limited, 1992), 300.

74 Kenneth Pople, *Stanley Spencer: A Biography* (London: Collins, 1991), 70.

75 Keith Bell, *Stanley Spencer: A Complete Catalogue of the Paintings* (London: Phaidon Press Limited, 1992), 278.

76 Stanley Spencer to Desmond Chute, c.1927, letter no. 52, Stanley Spencer Gallery, Cookham.

77 Adrian Glew, *Stanley Spencer: Letters and Writings* (London: Tate Publishing, 2001), 202.

78 Adrian Glew, *Stanley Spencer: Letters and Writings* (London: Tate Publishing, 2001), 202.

79 Adrian Glew, *Stanley Spencer: Letters and Writings* (London: Tate Publishing, 2001), 202.

80 Adrian Glew, *Stanley Spencer: Letters and Writings* (London: Tate Publishing, 2001), 202.

81 Adrian Glew, *Stanley Spencer: Letters and Writings* (London: Tate Publishing, 2001), 203.

82 Adrian Glew, *Stanley Spencer: Letters and Writings* (London: Tate Publishing, 2001), 203.

83 Adrian Glew, *Stanley Spencer: Letters and Writings* (London: Tate Publishing, 2001), 203.

84 Adrian Glew, *Stanley Spencer: Letters and Writings* (London: Tate Publishing, 2001), 203.

85 Stanley Spencer to Dudley Tooth, October 27, 1944, Arthur Tooth and Sons Archive.

86 Keith Bell, *Stanley Spencer: A Complete Catalogue of the Paintings* (London: Phaidon Press Limited, 1992), 185-201.

87 Quoted in Maurice Collis, *Stanley Spencer* (Harvill Press, London 1962), 194.

88 Keith Bell, *Stanley Spencer: A Complete Catalogue of the Paintings* (London: Phaidon Press Limited, 1992), 374 Note 20.

89 Keith Bell et al., *Stanley Spencer RA* (London: Royal Academy of Arts, 1980), 207.

90 Keith Bell et al., *Stanley Spencer RA* (London: Royal Academy of Arts, 1980), 207.

91 Keith Bell et al., *Stanley Spencer RA* (London: Royal Academy of Arts, 1980), 208.

92 Duncan Robinson, *Stanley Spencer* (London: Phaidon Press Limited, 1993), 101-105.

93 Wyndham Lewis, "Round the London Art Galleries," *Listener*, May 18, 1950, 879.

94 Keith Bell, *Stanley Spencer: A Complete Catalogue of the Paintings* (London: Phaidon Press Limited, 1992), 185-201.

95 See Oliver Fairclough and Emmeline Leary, *Textiles by William Morris and Morris & Co. 1861-1940* (London: Thames and Hudson, 1981), Plate 29.

96 Maurice Collis, *Stanley Spencer* (Harvill Press, London 1962), 139.

97 Tate Archive, 733.3.1.

98 Stanley Spencer to Dudley Tooth, October 27, 1944, Arthur Tooth and Sons Archive.

99 Dudley Tooth to Stanley Spencer, November 27, 1944, Arthur Tooth and Sons Archive.

100 *Daily Telegraph*, April 29, 1950.

101 *Sunday Times*, April 30, 1950.

102 W.T. Oliver, *Yorkshire Post*, April 29, 1950.

103 Eric Newton, *Sunday Times*, May 7, 1950.

104 *Morning Advertiser*, May 1, 1950.

105 Wyndham Lewis, *Listener*, May 18, 1950.

106 A drawing for *Christ Rising from the Tomb* is dated 1940 by the artist, indicating that Spencer had begun thinking about this series much earlier. Keith Bell, *Stanley Spencer: A Complete Catalogue of the Paintings* (London: Phaidon Press Limited, 1992), 504.

107 Keith Bell, *Stanley Spencer: A Complete Catalogue of the Paintings* (London: Phaidon Press Limited, 1992), 203-207.

108 For an excellent history regarding the images of the Virgin of Guadalupe in Mexico, see Donna Pierce, Rogelio Ruiz Gomar, and Clara Bargellini, *Painting a New World: Mexican Art and Life 1521-1821* (Denver: Frederick and Jan Mayer Center for Pre-Columbian and Spanish Colonial Art at the Denver Art Museum, 2004), 33, 79-91, 154-160.

109 Keith Bell, *Stanley Spencer: A Complete Catalogue of the Paintings* (London: Phaidon Press Limited, 1992), 510.

110 Jacob Epstein, *Epstein: An Autobiography* (London: Vista Books, 1963), 56.

111 My thanks to Cheryl Jones, Library and Collections Curator at The New Art Gallery Walsall, for her help with this information. See also Cyril Connolly, "The Sculptor Paints," *The Architectural Review*, LXXI (1932): 101; *Jacob Epstein: Drawings and Sculpture* (Auckland City Art Gallery, 1961), 14-16.

112 Jacob Epstein, *Epstein: An Autobiography* (London: Vista Books, 1963), 143.

113 Richard Buckle, *Jacob Epstein, Sculptor* (Cleveland: The World Publishing Company, 1963), 189.

[114] Richard Buckle, *Jacob Epstein, Sculptor* (Cleveland: The World Publishing Company, 1963), 170.

[115] Evelyn Silber and Terry Friedman, *Jacob Epstein, Sculpture and Drawings* (Leeds: W.S. Maney and Son in association with The Henry Moore Centre for the Study of Sculpture, 1989), 199-200.

[116] Jacob Epstein and Richard Buckle, *Epstein Drawings* (London: Faber, 1962), 20.

[117] Jacob Epstein, *Epstein: An Autobiography* (London: Vista Books, 1963), 143-144.

[118] William Gaunt, "Jacob Epstein and the Old Testament," *The Studio*, vol. 103 (1932): 290-291.

[119] Eric Underwood, *A Short History of English Sculpture* (London: Faber and Faber, 1933), 153-154.

[120] Evelyn Silber and Terry Friedman, *Jacob Epstein, Sculpture and Drawings* (Leeds: W.S. Maney and Son in association with The Henry Moore Centre for the Study of Sculpture, 1989), 46.

[121] *The Nation*, February 14, 1920.

[122] Epstein interviewed in *The Sunday Evening Telegraph*, February 15, 1920.

[123] Louis Osman, "Architect, Sculptor and Client, With Special Reference to Epstein's Madonna and Child," *Architectural Association Journal*, Issue 70 (1954): 10, 17.

[124] Louis Osman, "Cavendish Square — Past and Present," *The Journal of the London Society* (February 20, 1957): 23.

[125] Louis Osman, "Architect, Sculptor and Client, With Special Reference to Epstein's Madonna and Child," *Architectural Association Journal*, Issue 70 (1954): 8.

[126] Louis Osman, "Architect, Sculptor and Client, With Special Reference to Epstein's Madonna and Child," *Architectural Association Journal*, Issue 70 (1954): 10-11.

[127] Louis Osman, "Architect, Sculptor and Client, With Special Reference to Epstein's Madonna and Child," *Architectural Association Journal*, Issue 70 (1954): 10-11.

[128] Louis Osman, "Architect, Sculptor and Client, With Special Reference to Epstein's Madonna and Child," *Architectural Association Journal*, Issue 70 (1954): 10.

[129] Louis Osman, "Architect, Sculptor and Client, With Special Reference to Epstein's Madonna and Child," *Architectural Association Journal*, Issue 70 (1954): 10-11.

[130] Jacob Epstein, *Epstein: An Autobiography* (London: Vista Books, 1963), 235.

[131] Louis Osman, "Architect, Sculptor and Client, With Special Reference to Epstein's Madonna and Child," *Architectural Association Journal*, Issue 70 (1954): 11.

[132] George A. Cevasco, "Epstein's Religious Art," *Studies* (Summer, 1958): 177.

[133] Evelyn Silber and Terry Friedman, *Jacob Epstein, Sculpture and Drawings* (Leeds: W.S. Maney and Son in association with The Henry Moore Centre for the Study of Sculpture, 1989), 262-266.

[134] Louis Osman, "Architect, Sculptor and Client, With Special Reference to Epstein's Madonna and Child," *Architectural Association Journal*, Issue 70 (1954): 11.

[135] Louis Osman, "Architect, Sculptor and Client, With Special Reference to Epstein's Madonna and Child," *Architectural Association Journal*, Issue 70 (1954): 13.

[136] Evelyn Silber, *The Sculpture of Epstein, with a Complete Catalogue* (Cranbury, New Jersey: Associated University Press, 1986), 208-209; Evelyn Silber and Terry Friedman, *Jacob Epstein, Sculpture and Drawings* (Leeds: W.S. Maney and Son in association with The Henry Moore Centre for the Study of Sculpture, 1989), 262-6; Richard Buckle, *Jacob Epstein, Sculptor* (Cleveland: The World Publishing Company, 1963), 340-343.

[137] Louis Osman, "Architect, Sculptor and Client, With Special Reference to Epstein's Madonna and Child," *Architectural Association Journal*, Issue 70 (1954): 18.

[138] Evelyn Silber and Terry Friedman, *Jacob Epstein, Sculpture and Drawings* (Leeds: W.S. Maney and Son in association with The Henry Moore Centre for the Study of Sculpture, 1989), 262.

[139] Anon., "Epstein Group for Cavendish Square," *The Times*, January 10, 1952, 2.

[140] Kenneth Clark, "Cavendish Square Group," *The Times*, May 23, 1952, 12.

[141] Jacob Epstein, *Epstein: An Autobiography* (London: Vista Books, 1963), 235.

[142] Jacob Epstein, *Epstein: An Autobiography* (London: Vista Books, 1963), 236.

[143] Jacob Epstein, *Epstein: An Autobiography* (London: Vista Books, 1963), 236.

[144] Louis Osman, "Architect, Sculptor and Client, With Special Reference to Epstein's Madonna and Child," *Architectural Association Journal*, Issue 70 (1954): 13.

[145] Eric Newton, "Madonna and Child," *The Manchester Guardian*, May 15, 1953, 7.

[146] "Sculpture in the Streets," *The Observer*, June 7, 1953.

[147] Anon., "The Modern Aspect of Christian Art," *The Times*, May 6, 1958, 3.

[148] "Public Sculpture," *The New Statesman*, July 4, 1953.

[149] For an in depth consideration of responses to Epstein's sculpture, see Jonathan Cronshaw, "Carving a Legacy: The Identity of Jacob Epstein (1800-1959)" (PhD diss., University of Leeds, 2010), "Part Three, Madonna and Child (1950-52)," 250-264.

[150] John Bunting, "Reflections of Epstein's Madonna," *Liturgical Arts*, Issue XXIII (February 1955).

[151] Cottie A. Burland, "Sir Jacob Epstein — a Retrospective Comment," *Common Ground* (Winter, 1959): 12-13.

[152] George A. Cevasco, "Epstein's Religious Art," *Studies* (Summer, 1958): 184.

[153] Evelyn Silber and Terry Friedman, *Jacob Epstein, Sculpture and Drawings* (Leeds: W.S. Maney and Son in association with The Henry Moore Centre for the Study of Sculpture, 1989), 46-48, 187.

[154] Basil Spence, *Phoenix at Coventry: The Building of a Cathedral* (London: Geoffrey Bles, 1962), 68.

[155] Eric Gill, *Art* (New York: Devin Adair, 1949), 44.

[156] Eric Gill, *Art-Nonsense and Other Essays* (London: Cassell & Co., Ltd., 1929), 301-302.

[157] Eric Gill, *An Autobiography* (New York: Biblo and Tannen, 1968), 166.

[158] Walter Shewring, ed., *Letters of Eric Gill* (New York: Devin-Adair Company, 1948), 32.

[159] C.R. Leetham, *Ratcliffe College, 1847-1947* (Leicester: The Ratcliffian Association, 1950), 87.

[160] Several of these sketches associated with *Design for Christ the Sacred Heart, Ratcliffe College* are in the Henry Ransom Center collections at the University of Texas, Austin. The Ransom Center drawings include No.1114, *Study for Statue of Our Lady Immaculate, Ratcliffe College* (Five pencil sketches on a single sheet, 10 x 7.5 inches, arms variously placed; Pencil Sketch, 10 x 7.5 inches, left hand clutching robe at waist; Pencil sketch, 10 x 7.5 inches, arms at sides, palms forward; Pencil sketch, 10 x 7.5 inches; and Two pencil sketches on a single sheet, 10 x 7.5 inches) and No.1115, *Study for Statue of The Sacred Heart, Ratcliffe College* (Pencil sketch on tracing paper, 7.5 x 5.6 inches, including a sketch of the head of Our Lady Immaculate; Pencil sketch, 10 x 7.4 inches; and Pencil sketch, 10 x 7.4 inches). My thanks to Peter Mears at the Henry Ransom Center, University of Texas, Austin, for providing this information.

[161] In 1936, Gill also created a related work, *St. Francis* (sandstone, 18 inches in height), for another private college, which is in essence a small-scale copy of *Christ the Sacred Heart.* Terry Cavanagh and Alison Yarrington, *Public Sculpture of Leicestershire and Rutland* (Liverpool: Liverpool University Press, 2000), 266-267, 329.

[162] Terry Cavanagh and Alison Yarrington, *Public Sculpture of Leicestershire and Rutland* (Liverpool: Liverpool University Press, 2000), 266-7. Translation Judith Collins.

[163] Judith Collins, *Eric Gill: The Sculpture* (New York: The Overlook Press, 1998), 200-201.

[164] Michael O'Carroll, *The Alliance of the Hearts of Jesus and Mary: Hope of the World* (Santa Barbara: Queenship Publishing Company, 1997), 17-27, 37-47; James F. White, *Roman Catholic Worship: Trent to Today* (Mahwah, New Jersey: Paulist Press, 1995), 35. See also John F. Murphy *Mary's Immaculate Heart: The Meaning of the Devotion to the Immaculate Heart of Mary* (Milwaukee: The Bruce Publishing Company, 1950).

[165] James F. White, *Roman Catholic Worship: Trent to Today* (Mahwah, New Jersey: Paulist Press, 1995), 82.

[166] C.R. Leetham, *Ratcliffe College, 1847-1947* (Leicester: The Ratcliffian Association, 1950), 87.

[167] Letter written November 27, 1936, quoted in Robert Speaight, *The Life of Eric Gill* (London: Metheun & Co. Ltd., 1966), 284.

[168] A related drawing, *Proposed church at Gorleston-on-Sea, Norfolk* (1938, pencil and watercolor) is in the collections of the University of California, Los Angeles.

[169] Fiona MacCarthy, *Eric Gill: A Lover's Quest for Art and God* (New York: E.P. Dutton, 1989), 279-280.

[170] Original sketches for the fresco are in the library of Notre Dame University, Indiana.

[171] Walter Shewring, ed., *Letters of Eric Gill* (New York: Devin-Adair Company, 1948), 408-409.

[172] Walter Shewring, ed., *Letters of Eric Gill* (New York: Devin-Adair Company, 1948), 414-415.

[173] Walter Shewring, ed., *Letters of Eric Gill* (New York: Devin-Adair Company, 1948), 419-420.

[174] Walter Shewring, ed., *Letters of Eric Gill* (New York: Devin-Adair Company, 1948), 433.

[175] Quoted in Fiona MacCarthy, *Eric Gill: A Lover's Quest for Art and God* (New York: E.P. Dutton, 1989), 280.

[176] Eric Gill, "Mass for the Masses," in *Secular and Sacred* (London: J.M. Dent, 1940).

[177] Eric Gill, "Mass for the Masses," in *Secular and Sacred* (London: J.M. Dent, 1940), 143-155.

[178] Eric Gill, "Plain Architecture," in *Beauty Looks After Herself* (Freeport, New York: Books for Libraries Press, Inc., 1966), 156.

179 Walter Shewring, ed., *Letters of Eric Gill* (New York: Devin-Adair Company, 1948), 414-415.

180 Walter Shewring, ed., *Letters of Eric Gill* (New York: Devin-Adair Company, 1948), 419-420.

181 Walter Shewring, ed., *Letters of Eric Gill* (New York: Devin-Adair Company, 1948), 419-420.

182 Malcolm Yorke, *Eric Gill, Man of Flesh and Spirit* (London: Constable and Company Limited, 1982), 235.

183 Alison Smith, ed., *Watercolour* (London: Tate Publishing, 2011), 16, 146.

184 Tate Gallery Archive, 929.8.1.

185 John Rothenstein, *Edward Burra* (London: The Tate Gallery, 1973), 23.

186 Andrew Causey, *Edward Burra, Complete Catalogue* (Oxford: Phaidon, 1985), 58-62.

187 Alison Smith, ed., *Watercolour* (London: Tate Publishing, 2011), 138.

188 Andrew Causey, *Edward Burra, Complete Catalogue* (Oxford: Phaidon, 1985), 62-66.

189 Andrew Causey, *Edward Burra, Complete Catalogue* (Oxford: Phaidon, 1985), 74.

190 Andrew Causey, *Edward Burra, Complete Catalogue* (Oxford: Phaidon, 1985), 62-66.

191 Another excellent example located in Southern California of the enduring love of British artists during the twentieth century for ancient American visual culture is Henry Moore's massive sculpture, *Reclining Figure* (1951) located at the Orange County Performing Arts Center. Moore found the art of ancient Mexico to be particularly fascinating with its "truth to material," "direct carving," and bold formal expression. His *Reclining Figure* was inspired by an Aztec carving of a Chacmool (A.D. 900-1000, Mexico, Museo Nacional de Antropología, Mexico City) that Moore had discovered in a 1922 book on Mexican art. Dorothy Kosinski, ed., *Henry Moore: Sculpting the 20th Century* (New Haven: Yale University Press, 2001).

192 John Rothenstein, *Edward Burra* (London: Tate Gallery Publications, 1973), 14.

193 Burra, letter to Barbara Ker-Seymer from Granada (April-September 1933), Tate Gallery Archive, 974.2.2.

194 Andrew Causey, *Edward Burra* (London: Arts Council of Great Britain, 1985), 119.

195 Reproduced in *Edward Burra* (London: Hayward Gallery, 1985), 119, figures xxv, xxvi.

196 Letter to Anne Burra, May 1937, Tate Gallery Archive, 939.2.1.

197 Andrew Causey, *Edward Burra, Complete Catalogue* (Oxford: Phaidon, 1985), 65-66.

198 Xavier Bray et al., *The Sacred Made Real: Spanish Painting and Sculpture, 1600-1700* (London: National Gallery, 2009).

199 Andrew Causey, *Edward Burra, Complete Catalogue* (Oxford: Phaidon, 1985), 70.

200 *Judith and Holofernes* was commissioned by the Arts Council for a large painting on a subject of Burra's choice for the Festival of Britain exhibition "Sixty Paintings for '51." Andrew Causey, *Edward Burra: Complete Catalogue* (Oxford: Phaidon, 1985), 70.

201 Andrew Causey, *Edward Burra: Complete Catalogue* (Oxford: Phaidon, 1985), 70.

202 Timothy Verdon, *Mary in Western Art* (Manchester, Vermont: Hudson Hills Press, 2005), 53-55.

203 *Edward Burra* (London: Hayward Gallery, 1985), 128.

204 Timothy Verdon, *Mary in Western Art* (Manchester, Vermont: Hudson Hills Press, 2005), 38-40.

205 "Edward Burra," *Glasgow Herald*, March 7, 1952.

206 Noel Barber, *Conversations with Painters* (London: Collins, 1964), 80.

207 Keith Vaughan, *Journal & Drawings 1939-1965* (London: Alan Ross, 1966), 190.

208 Malcolm Yorke, *Keith Vaughan: His Life and Work* (London: Constable and Company Limited, 1990), 255-284.

209 Keith Vaughan, *Journal & Drawings 1939-1965* (London: Alan Ross, 1966), 116.

210 *Picture Post*, March 12, 1949.

211 Keith Vaughan, *Journal & Drawings 1939-1965* (London: Alan Ross, 1966), 82-83.

212 Malcolm Yorke, *Keith Vaughan: His Life and Work* (London: Constable and Company Limited, 1990), 55-56.

213 Letter to Norman Towne, November 9, 1943, quoted in Malcolm Yorke, *Keith Vaughan: His Life and Work* (London: Constable and Company Limited, 1990), 56.

214 Keith Vaughan, *Journal & Drawings 1939-1965* (London: Alan Ross, 1966), 82.

215 Keith Vaughan, "Painter's Purpose," *Studio* (August 1958): 53.

216 Keith Vaughan, *Journal & Drawings 1939-1965* (London: Alan Ross, 1966), 190.

217 Keith Vaughan, *Journal & Drawings 1939-1965* (London: Alan Ross, 1966), 190.

218 Barbara Hepworth, *Drawings from a Sculptor's Landscape* (New York: Frederick A. Praeger, Publishers, 1967), 11.

219 Barbara Hepworth, *Drawings from a Sculptor's Landscape* (New York: Frederick A. Praeger, Publishers, 1967), 17.

220 Margaret Gardiner, *Barbara Hepworth: A Memoir* (Edinburgh: Salamander Press, 1982), 18.

221 Edwin B. Mullins et al., *Barbara Hepworth Exhibition 1970* (Hakone, Japan: Hakone Open-Air Museum, Japan, 1970), unpaginated.

222 Barbara Hepworth, *Drawings from a Sculptor's Landscape* (New York: Frederick A. Praeger, Publishers, 1967), 15-16.

223 Barbara Hepworth, *Carvings and Drawings* (London: Lund Humphries & Co., Ltd., 1952), unpaginated, Chapter 5 "Rhythm and Space 1946-1949."

224 Penelope Curtis, *Barbara Hepworth* (London: Tate Gallery Publishing, 1998), 36-37.

225 Barbara Hepworth, *Carvings and Drawings* (London: Lund Humphries & Co., Ltd., 1952), unpaginated, Chapter 5 "Rhythm and Space 1946-1949."

226 Chris Stephens, ed., *Barbara Hepworth, Centenary* (London: Tate Gallery Publishing, 2003), 51.

227 Letter from Barbara Hepworth to E.H. Ramsden, April 4, 1943, Tate Gallery Archive, 9310.

228 Barbara Hepworth, *Carvings and Drawings* (London: Lund Humphries & Co., Ltd., 1952), unpaginated, Chapter 6 "Artist in Society 1949-1952."

229 Barbara Hepworth, *Drawings from a Sculptor's Landscape* (New York: Frederick A. Praeger, Publishers, 1967), 10.

230 Letter to Herbert Read, December 30, 1946, Sir Herbert Read Archive, University of Victoria, B.C.

231 November 27, 1967, Tate Gallery Acquisitions files.

232 Matthew Gale and Chris Stephens, *Barbara Hepworth: Works in the Tate Gallery Collection and the Barbara Hepworth Museum St. Ives* (London: Tate Gallery Publishing, 1999), 20.

233 Interview Sally Begbie, The Rodd, 1992, quoted in Nancy Underhill, ed., *Nolan on Nolan: Sidney Nolan in his Own Words* (New York: Penguin Group Inc., 2007), 288.

234 Sidney Nolan to M.P. Ferrandiere, Cambridge, April 13, 1951, David Jones Limited Archives.

235 Sidney Nolan to Albert Tucker, Cambridge, June 23, 1951, Albert Tucker Papers.

236 Sidney Nolan to Albert Tucker, Cambridge, April 1, 1951, Albert Tucker Papers.

237 Sidney Nolan to Albert Tucker, Cambridge, April 1, 1951, Albert Tucker Papers.

238 Sidney Nolan to Peter Bellew, Sydney, December 31, 1951, Jinx Nolan Papers.

239 Letter to Sunday Reed, late 1943, quoted in Nancy Underhill, ed., *Nolan on Nolan: Sidney Nolan in his Own Words* (New York: Penguin Group Inc., 2007), 254.

240 Interview Bernard Smith, April 1962, quoted in Nancy Underhill, ed., *Nolan on Nolan: Sidney Nolan in his Own Words* (New York: Penguin Group Inc., 2007), 254.

241 Elwyn Lynn, *Sidney Nolan's Ned Kelly* (Canberra: Australian National Gallery, 1985).

242 Elwyn Lynn Papers, Art Gallery of New South Wales, from a tape recorded April 21, 1978 and from phone conversations in 1978, quoted in Nancy Underhill, ed., *Nolan on Nolan: Sidney Nolan in his Own Words* (New York: Penguin Group Inc., 2007), 267.

243 Nancy Underhill, ed., *Nolan on Nolan: Sidney Nolan in his Own Words* (New York: Penguin Group Inc., 2007), 454.

244 Barry Pearce, *Sidney Nolan* (Sydney: The Art Gallery of New South Wales, 2007), 48.

245 Artist's diary, March 24, 1952, quoted in Barry Pearce, *Sidney Nolan* (Sydney: The Art Gallery of New South Wales, 2007), 162.

246 Peter Fuller, "Sidney Nolan and the Decline of the West: A *Modern Painters* Interview with Sir Sidney Nolan," *Modern Painters*, Vol.1, No.2 (Summer 1988).

247 Hugh Curnow, "The Pain and the Glory," *The Bulletin*, March 20, 1965.

248 Peter Fuller, "Sidney Nolan and the Decline of the West: A *Modern Painters* Interview with Sir Sidney Nolan," *Modern Painters*, Vol.1, No.2 (Summer 1988).

249 Charles Osborne, *Masterpieces of Nolan* (London: Thames and Hudson, 1975).

250 Roger Berthoud, *Graham Sutherland, A Biography* (London: Faber and Faber Limited, 1982), 56.

251 Andrew Révai, ed., *Christ in Glory in the Tetramorph: The Genesis of the Great Tapestry in Coventry Cathedral* (London: The Pallas Gallery, 1964), 78-80.

252 Letter to Hussey, n.d., quoted in Walter Hussey, *Patron of Art: The Revival of a Great Tradition Among Modern Artists* (London: Weidenfeld and Nicolson, 1985), 50.

253 Graham Sutherland, "Thoughts on Painting," *The Listener*, XLVI (1951): 377-78.

254 Letter to Hussey, October 3, 1944, quoted in Walter Hussey, *Patron of Art: The Revival of a Great Tradition Among Modern Artists* (London: Weidenfeld and Nicolson, 1985), 52.

255 "Thoughts on Painting," *Listener*, September 6, 1951, vol.46, no.1175, 378.

256 *K-Z*, was a booklet issued in German at the end of the war by the Allies to show the German people the atrocities of the camps. *K-Z: Bildbericht aus fünf Konzentrationslager*, Supreme Headquarters, Allied Expeditionary Forces, 1945.

257 Graham Sutherland letter to Edwin Mullins in the *Daily Telegraph Magazine*, September 10, 1971, no.359.

258 Walter Hussey, "A Churchman Discusses Art in the Church," *Studio*, vol.138, no.678 (September 1949): 95.

259 Douglas Cooper, *The Work of Graham Sutherland* (London: Lund Humphries, 1961), 34.

260 *Braque, Rouault*, Tate Gallery, London, April-May 1946.

261 Andrew Révai, ed., *Christ in Glory in the Tetramorph: The Genesis of the Great Tapestry in Coventry Cathedral* (London: The Pallas Gallery, 1964), 89.

262 Roger Berthoud, *Graham Sutherland, A Biography* (London: Faber and Faber Limited, 1982), 205; Andrew Révai, ed., *Christ in Glory in the Tetramorph: The Genesis of the Great Tapestry in Coventry Cathedral* (London: The Pallas Gallery, 1964), 103.

263 Andrew Révai, ed., *Christ in Glory in the Tetramorph: The Genesis of the Great Tapestry in Coventry Cathedral* (London: The Pallas Gallery, 1964), 58.

264 Ronald Alley, *Graham Sutherland* (London: Tate Gallery, 1982), 21.

265 Roger Berthoud, *Graham Sutherland, A Biography* (London: Faber and Faber Limited, 1982), 222, 258.

266 Letter dated March 6, 1974. Collection of Howard and Roberta Ahmanson.

267 Letter dated July 18, 1974. Collection of Howard and Roberta Ahmanson.

268 Bryan Robertson, "Christopher Le Brun and Bryan Robertson: A Conversation," in Christopher Le Brun, *Christopher Le Brun*, 222-229 (London: Booth-Clibborn Editions, 2001).

269 Liverpool Cathedral Press Release, "Contemporary Paintings for Liverpool Cathedral," March 26, 1996.

270 *The House Built on Rock* was inspired both by Liverpool Cathedral, which is built on a rock, and by the sea, which is only twenty minutes from Liverpool. The painting depicts a British family scene by the seaside. The artist based this painting on Matthew 7:24-29. Liverpool Cathedral Press Release, "Contemporary Paintings for Liverpool Cathedral," March 26, 1996.

271 Liverpool Cathedral Press Release, "Contemporary Paintings for Liverpool Cathedral," March 26, 1996.

272 Liverpool Cathedral Press Release, "Contemporary Paintings for Liverpool Cathedral," March 26, 1996.

273 Lambirth Andrew, *Craigie Aitchison: Out of the Ordinary* (London: Royal Academy of Arts, 2003), 7-19.

274 Lambirth Andrew, *Craigie Aitchison: Out of the Ordinary* (London: Royal Academy of Arts, 2003), 16.

275 Lambirth Andrew, *Craigie Aitchison: Out of the Ordinary* (London: Royal Academy of Arts, 2003), 16.

276 Lambirth Andrew, *Craigie Aitchison: Out of the Ordinary* (London: Royal Academy of Arts, 2003), 9.

277 Craigie Aitchison, *Craigie Aitchison: Recent Paintings* (London: Albemarle Gallery, 1989), 5.

278 Sara Wilkinson, *Figure Carving in Wood: Human and Animal Forms* (Lewes, East Sussex: Guild of Master Craftsman Publications Ltd., 2004), 115.

279 Sara Wilkinson, *Figure Carving in Wood: Human and Animal Forms* (Lewes, East Sussex: Guild of Master Craftsman Publications Ltd., 2004), 3-21.

280 Gabriele Finaldi et al., *The Image of Christ* (London: National Gallery Company Limited, 2000), 12-13.

281 Sara Wilkinson, *Figure Carving in Wood: Human and Animal Forms* (Lewes, East Sussex: Guild of Master Craftsman Publications Ltd., 2004), 47.

282 Sara Wilkinson, *Figure Carving in Wood: Human and Animal Forms* (Lewes, East Sussex: Guild of Master Craftsman Publications Ltd., 2004), 38.

Twentieth Century British Art from the Ahmanson Collection
Text by Lyrica Taylor

ISBN: 0-9742683-3-X

Project Manager: Ann Hirou
Book Design: Reynolds Wulf Inc.
 Robert Reynolds, Letha Gibbs Wulf
Printing: Cenveo Graphic Arts Center
Photography: Robert Walker

Printed and bound in the United States of America